The MONOCLE Book of

GENTLE LIVING

A guide to slowing down,
enjoying more and being happy.

First published in the United Kingdom in 2020 by
MONOCLE and Thames & Hudson Ltd,
181A High Holborn, London, WC1V 7QX
thamesandhudson.com

First published in the United States of America in 2021 by
MONOCLE and Thames & Hudson Inc,
500 Fifth Avenue, New York, New York, 10110
thamesandhudsonusa.com

MONOCLE is a trading name of Winkontent Limited

© 2020 Winkontent Limited of Midori House,
1 Dorset Street, London, W1U 4EG

British Library Cataloguing-in-Publication Data
A catalogue record for this book is available from
The British Library

Library of Congress Control Number: 2020939956

For more information, please visit *monocle.com*

This book was printed on paper certified
according to the standards of the FSC®

Edited by *Josh Fehnert*
Foreword by *Tyler Brûlé*

———

Designed by *Monocle*
Proofreading by *Monocle*
Typeset in *Plantin*

———

Printed by *Firmengruppe Appl*

Printed and bound in Germany

ISBN 978-0-500-97110-9

Contents

Foreword

Tyler Brûlé, MONOCLE's editor in chief: *thoughts on gentle living*

How about we start with an understatement? This book has come together at a most exceptional moment in modern history. While MONOCLE has long championed taking the slower, more considered road in life, we didn't think we'd be editing this volume while much of the world ground to a halt. We also didn't consider that so much of what we'd been planning to commission would be so relevant for so many people dotted around so many countries around the world.

To date we've produced more than 150 magazines and nearly 50 books (there are currently another three on the go for the coming year) but never have we developed, designed and edited an edition of this scale almost entirely from our kitchen counters, coffee tables, sun loungers or side tables. Fortunately the last round of checks and tweaks came together at Midori House and via a special delivery to our HQ in Zürich. But it was no simple task to nudge this manifesto on gentler living to the presses in Germany.

Inside, you'll find a set of themes that build on the essays, reports and ideas that have filled our pages and story meetings over the past few years. Yes, we believe that you should think twice before you rip out a kitchen and start again; that it's important to invest in a couple of pairs of shoes that can be properly resoled rather than binned; and that there's always room for an extra chair around the dinner table – particularly if it's at home. But you'll

also find that this book takes a few moral, philosophical and political turns along the way as well.

We feel that there needs to be more time away from screens and that reading from paper is a good thing – so too is a well-placed note. And no, using paper is not a bad thing so long as you also learn how to source it properly and go about recycling it properly. Which brings us to another key theme: learning to take a breath and move on.

Learning how to stop the cycle of constantly calling others out and publicly shaming (cue myriad digital platforms and fast fingers) is not only necessary for ensuring that we can shift to a more polite society but also reminds us that there's value in a quiet word, a well-placed phone call or even a good old letter to the opinion page of a journal of record – *Die Zeit, The Sunday Times* and *Les Echos* might all want to hear from you. To this we'd add mastering the forgotten art of forgiveness and recognising that it's essential to accept apologies and put the mistakes of others behind you.

While this edition finds its way to the top of your favourite stack of books, we'll be swimming in a nearby lake, feeding the goats, wandering in the woods, having a dance, tending to the garden or enjoying a decadent mid-afternoon nap.

Introduction

We're an optimistic bunch here at MONOCLE but, given the challenges the world is facing, you'd be forgiven for thinking that the future isn't *quite* what it used to be.

On the whole, we're healthier than ever before but we're also anxious and overwhelmed. Yes, all those Sunday-morning emails have made us more "efficient" but they are leaving us distracted. Better technology hasn't enabled better conversations – in fact, there's been a spike in selfishness and bad manners, and worse behaviour online. For all its triumphs, technology hasn't done much for the humanity of day-to-day life. Instead, anonymity and instant replies have made comment boards and social media sour; people are quick to blame one another and the narratives about which they're squabbling lack nuance.

Put another way, most of us carry a world of opportunity on our smartphones but we're so consumed by alerts and notifications that we don't always see the busy crossroads ahead. And yet, there's another way; a gentle reorientation, a lifting of the chin by a few degrees that offers a more hopeful perspective. Things could be looking up.

Since launch, MONOCLE has been a champion of taking things slow – of considering your options, turning off your devices and taking the time to enjoy what's important. We've long suggested that if you dig a little deeper you'll find reasons to be cheerful, stories worth sharing and bright ideas waiting to be seen and seized upon.

We've clocked a subtle rebalancing taking place among the people who we've met and interviewed around the globe since we launched in 2007. It seems to be finally dawning on leaders, entrepreneurs and civilians – like us – that our lives and livelihoods could do with a rethink.

Sometimes the fixes are simple and personal: to run, dive into a lake, sleep more or set aside some time with the people who make us happy. Maybe it's about eating food from producers who are proud of its provenance or building spaces into cities that respect older residents and value younger ones. It could be about jobs and workplaces that make us feel as though we can flourish and belong. So how about taking a few moments away from the crush to flick through the pages of a book with a few gentle suggestions about living better?

During a shouty, finger-jabbing time in history, we've done our bit to argue for a new, kinder etiquette and a generosity with time, hospitality and forgiveness. Now our editors have brought all this together in one simple book.

The Monocle Book of Gentle Living is a handbook for a new decade and beyond; a book that helps you think about how to slow down, reconnect, make good things happen, do something you care about and discover nice places and extraordinary people along the way. Naturally, it also knows when to wear a cheeky smile. The future, remember, isn't what it used to be – it's what we make it. It's time to turn the page.

How to live a gentler life

A few thoughts on slow pleasures,
quiet rethinks and small changes that
might just improve your life.

How to live a gentler life

We think it's time you were a little kinder to yourself, those around you and the world. That said, there's still the thorny issue of how to go about it. Unlike most books on the matter, we're not suggesting you sell up or jack in your job just yet – though these moves may indeed make you happier in the long run. We'll come to that in good time. For now, though, we'd like to keep it simple and encourage you to kick back, take stock and make some easy decisions for once.

You don't need to get a pager or dust off a fax machine but how about leaving your phone outside your bedroom at night? Or dropping off the radar for an afternoon, safe in the knowledge that your time is your own again? You don't need to enrol at Le Cordon Bleu to learn a few simple recipes. Nor do we think you should aspire to live like a minimalist monk (unless, of course, you fancy it). Maybe we should all start by buying fewer – but better – things? Fixing, learning and listening a little more? It's time for a quiet revolution. Will you join us?

A gentle manifesto
Take it easy

So, let's start slow. Here are fifty fanciful fixes that can help recalibrate everything from your relationship with your phone to your family and neighbourhood.

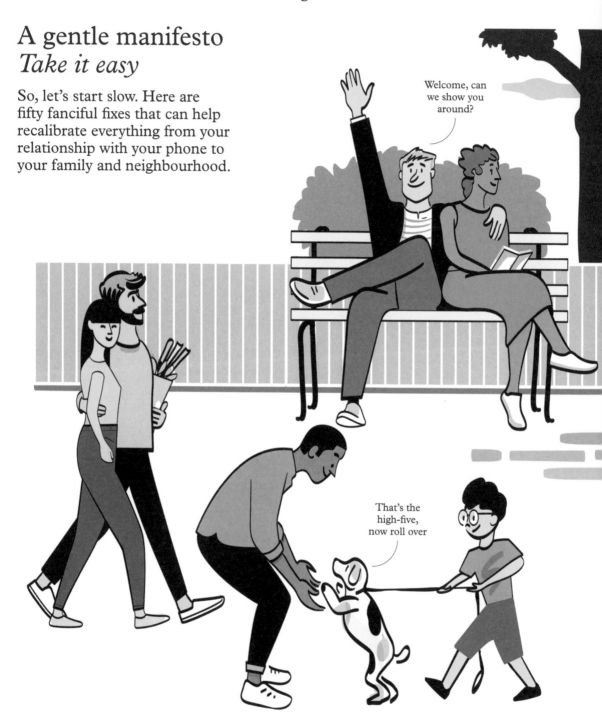

1.
Meet the neighbours
Make new friends

With a bottle of wine, an offer of a hand and a proper smile. It's nice to be nice and to know someone has your back as well as your adjoining wall.

2.
Go to the market
Eat local

Buy local, meet the traders, heed their advice and eat better because of it. Fancy used to mean food flown in from abroad; now we're realising the honesty and potential of goods that are proudly produced nearby.

3.
Get a dog – or a pack
Four legs good

It's odd but dogs can add humanity to our lives and workplaces. Having a friendly dependent means companionship, exercise and fun. So go on, join the pack.

4.
Be positive
(as in optimistic)
Look on the bright side

Count your blessings, the world is full of interesting people, ideas waiting to be discussed and businesses yet to be founded. Don't believe the doomsayers and the dullards.

5.
Do something nice
(anonymously)
Just rewards

Put in a good word or say thank you because someone deserves it, not because you want them to know how pleasant you are. It's different.

6.
Pocket a paperback
Pick a page turner

Do you need to check the headlines again? Can't that email wait? The small act of pocketing a paperback, ready and waiting in moments of down time, offers inspiration and escapism.

7.
Do a job you love
Aim for a satisfying 9 to 5

No child dreams of being an actuary – great if you grew into it but bad if you're trapped. You don't need to be an astronaut but maybe you want to do something with your hands or just work close enough to home to walk to the office.

8.
Get a workplace that works
Create creature comforts

Whether this is your home office or an HQ that needs to make an impression, don't skimp on creating a space that makes people happy to arrive at work. How you treat the team says a lot.

9.
Build an archive
Collect collective memories

The internet is vast but feels small; the same sites, ideas and articles shared and forgotten. For real inspiration an archive can be a lifetime's work. Treasure the design book from Mexico City or the back issue from Beirut.

10.
Take notes (in a notebook)
Put pen to paper

The act of writing helps fire synapses and feed creativity. We remember more of what we scribble than what we type and isn't it nice to doodle in the margins or have something jotted down?

11.
Repair, reuse and value what you have
Give it a second life

Think twice before you throw something away. Can you glue it, resole it or turn up the hem? Buy stuff that, when "broken", you might just be able to fix.

12.
Check your tone
Think twice and move on

Life's too short for online rants, anonymous comments and bitter retribution enacted by bots. Take a deep breath and delete the snarky comment or pissy email – you'll feel better for it.

13.
Sleep well
Sweet dreams

Leave your phone in another room and give yourself time away from it to recover. Breathe deeply then doze off. You'll wake feeling better for it, believe us.

14.
Be careful with the news you consume
No news is good news

Too many heavy headlines crush a mood, too many sites publish "facts" that aren't true or the full story. Read and listen to fewer but better media outlets (and a soundtrack that gets you excited). Radio can still be the most intimate medium.

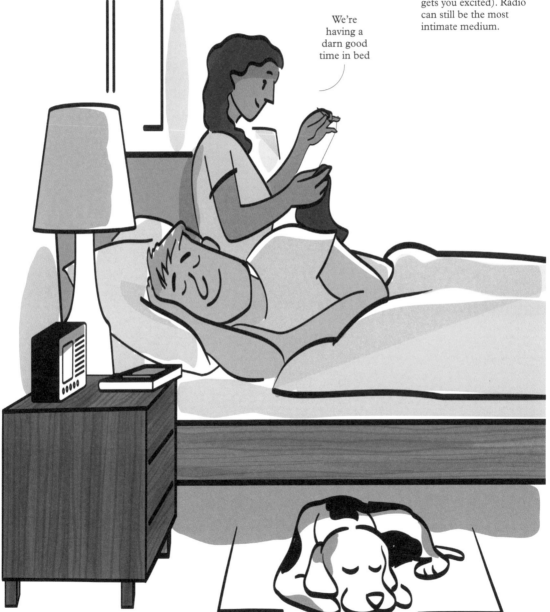

buzz

15.
Feather your nest
Make a house a home

A home may not be for life but it should be for living in, so invest in things that make you appreciate being there. Once the latch clicks shut your home becomes your own version of the world.

16.
Take a dim view
Get the light right

LEDS have a tendency to make everyone look undead and ugly. Ditch the ghoulish get-up and opt for some lamps with shades, incandescent bulbs and as much natural light as possible. Oh, you flatterer.

17.
Look up (put down your phone)
Time to switch off

You're at a crossroads (metaphorically and physically). Don't get blindsided by being glued to your emails. The world beyond your screen is pretty fetching.

18.
Buy things once but well
Made for life

A good chair, lamp or jacket can last a lifetime. Get a cheap one and it will fall apart. What you save in money could end up costing the planet, literally.

19.
Fill your home with natural materials
Good wood

Glass, plastic and steel are go-to city building blocks. But why? Opt for wood, textiles and stone to soften your home in a way that will age gracefully.

20.
Surround yourself with things you like
Have your fill

Pity the minimalist monk who threw away his worldly possessions and sits staring at a white wall. It's OK to own things.

21.
Send a letter, postcard or present
Blast from the past

A physical missive is not only a pleasure to receive, it's also great fun to rediscover years down the line. It marks a moment in time better than a message filed away on a phone that you'll no longer own in a few months.

22.
Have a side project
Invest in personal growth

It's great to be a specialist but being too consumed by one thing can make you a bit of a bore. It's OK to be the doctor who likes bikes or the builder who's writing a play. In fact it's excellent. These hobbies can be fulfilling and fun and maybe even help to point your career in an exciting new direction.

23.
Learning should be lifelong
Golden oldies

Learning should continue long after you've left school. And there's still time to gain new skills after retirement too – to dance, join the lawn bowls club or get creative with your hands.

24.
Keep learning: a language, a skill, a discipline
Learn your lessons well

A few words in a native tongue shows willingness and tenacity. It's even more impressive if you keep it up and get good.

25.
Always take the window seat
Learn to look

There's so much to see. Even if it's the hundredth time you've made that flight you might glimpse something new on the descent or simply indulge in a daydream with the sunlight on your eyelids. It's a cliché that travel is a state of mind but let's just say that it's hard to see the world from the middle seat of the plane.

26.
Get back to nature
Take a hike

It's simple but shocking how infrequently it happens – connecting with the natural world. Getting outdoors is calming, can provide inspiration and offers a break from the back-lit screen.

27.
Get out on the water
It's better by boat

Travel by boat, even if it's not the quickest option. We're thinking more craft for two than cruise but a pedalo would do.

Show us your doggy paddle, then

28.
Strip off and swim
Make a splash

Do you want to be someone who spent their life on the sidelines, in the shallow end or, worse, inside at the bar? There's time for that when the sun goes in. Come on in, the water's fine.

29.
Cycle somewhere
A move in the right direction

To work? To the forest? To the village just beyond town? It's gratifying to get somewhere on your own steam. Also, to relish that fresh air.

30.
Find a hideaway
Change of perspective

An apartment in Arles? A cottage in Cumbria? Doesn't matter – just find somewhere you feel safe and comfy that gets you away from home. A change of scenery and chance encounters will revive you and offer perspective.

This grass is making me feel rather mellow

31.
Grow something
It's nice to nurture

A sunflower, split peas, some tomatoes, a lumpy turnip. It's fulfilling to cultivate life, look after things and see the mysterious force that propels small seeds into plants. It's also humbling to help life into being and rewarding to watch our efforts take root and grow.

32.
Climb a tree
Branch out

In Germany, *Waldschule* (forest schools) bring up kids in the wild and don't worry about scraped knees. In Norway many ski to school. Don't always do the sensible thing. Climb a tree and don't be afraid to bend the rules now and again. Keep off the grass? But it looks so inviting.

33.
Eat outside
Live your best alfresco life

In the shade of a tall tree sounds nice. Pick a spot to picnic but watch out for predators and pack sunscreen if you're fair of complexion.

34.
Plant a tree
Put down roots

It's a metaphor. Good things take time and care to bear fruit. Also fruit is tasty.

35.
Draw or paint something (or someone)
Paint with passion

Learning to paint can be playful. Try a life-drawing class – worst-case scenario you'll have plenty to talk about afterwards.

36.
Invest in a pair of good shoes
Best foot forward

Snappy footwear helps get you from A to B, keeps you looking smart and shows an attention to detail that others will appreciate.

I'm off to turn over a new leaf

37.
Rethink your commute
Pick a path less trodden

Might a cycle or walk lift your mood more than a packed train carriage? What's down that road you'd never even noticed before? Shake things up.

38.
Go off radar
Time to take a break

Don't abandon your family but do abandon your routine now and then for a lunch break in the sun with a book. Leave your phone off for a while and concentrate, even if it's just on being away from your desk.

Time to take the road less travelled

39.
Join a club
We're better together

One reason the Danes are the happiest nation on Earth is the prevalence of club membership. From sauna clubs (*au naturel*) to board games and architecture appreciators, doing things in groups is better fun and binds a community. Your roll.

40.
Support a team
Be a good sport

Maybe you're not up for joining the running club but that shouldn't stop you supporting it. The town football team may be useless but a bit of shared interest can cement bonds and get neighbours singing to the same tune.

41.
Go to a museum on your lunch break
Feed your soul

Or a gallery after work? Fit in time to get lost, encounter the unexpected, meet new people and see works of art that challenge and inspire.

Someone found passion among the pharaohs' pots and pickled cats

42.
Watch a life-affirming film
Picture perfect

Our attention is so divided that this is one of the few ways to completely shut off from other distractions and immerse ourselves in someone else's point of view.

43.
Take the scenic route
Take the long way round

To your friend's wedding, parents' house or car. There's much to commend the long way and what it lacks in efficiency it makes up for in serendipity and charm. Enjoy the journey.

44.
Support your local restaurant
Nurture your neighbourhood

It's nice to meet the neighbours, buoy those in an independent business and nod to people you know. You'll be sorry when it's vacant or tricky tenants move in.

45.
Buy a dining table and spend time with people around it
Fork out

Invest in a space where you and your family can sit in the morning and digest the day at night. TV dinners just aren't the same.

46.
Stock your pantry
Ready meals

It's nice to be prepared if someone pops round unannounced. We'd recommend having some olives, pulses, chickpeas, pasta and oils on hand to rustle up something impromptu. Keeping a nice bottle of white from Ticino in the fridge won't hurt either.

47.
Perfect a dish
Mix it up

Sunday morning galettes? A one-pot Japanese curry? It can be as simple or complex as you like but try to add a new recipe to your repertoire every month, two if you can. It's the simplest way to increase your quality of life, ensure your diet is good and varied, and have some fun in the kitchen too.

48.
Be positive (as in sure)
Know your mind

Go on, have an opinion. Not a mean one. Just be passionate and sincere. It's neither fun nor comfortable to sit on the fence.

49.
Give away some time
Tune in

To your loved ones and to those you don't know. It could be as simple as really listening to what someone is saying rather than nodding before they're done and rushing off to your next meeting.

50.
Start something: a company, a club, a collection
Time to take the plunge

This is the most important bit: do something with these tips. This is a handbook of humble but practical advice – ideas to heed rather than read and then ignore. A gentle nudge now might just change your whole life for the better. Read on to find out how.

CHAPTER 2

Have a good home

Ideas on everything from making
a pleasant entrance to keeping cosy
and prioritising privacy.

Have a good home

The way we live may be shifting but the checklist for the ideal home hasn't changed much over the years. Whatever its proportions or surroundings it should feel secure, comforting and offer a refuge from the outside world. The reassuring click of a lock behind us is the signal that we're back. We can relax. But what makes a house a home? What alchemy turns a corner into a nook, a desk into a workplace or a dining table into a gathering point for the household? Well, not much more than a little care and attention as it turns out – oh, and a few plants perhaps.

Ignore the self-satisfied minimalists who try to make you feel bad for having a few books and paintings and chairs (they must be bored staring at four white walls, after all). Go ahead and collect things on your travels and delight in what you own, put the new bits next to the old and start a collection if it brings you joy. You won't have a hope of living more gently until you come to terms with the place where you rest your head. So, whether it's making the most of the light or bringing in the breeze (and switching off the air conditioning), a gentler life starts at home.

The importance of home
House style

Our homes can make us happy. They can bring joy to those who dwell there and, when done well, to guests and neighbours too. But where to start when it comes to making your own? We mull over the significance of the spaces in which we hunker down and show why furnishing bit by bit – with natural materials and the right light – is the best way to approach any house.

The act of home-making is one of life's greatest pleasures. We're not talking about labouring in the sun and laying bricks all day – although, of course, that's an option for those who enjoy such pursuits. Instead, we're talking about turning a residential blank canvas into a portrait of those who call it home. Your four walls might be humble, grand or irregular (you might be too) but with a little effort you can turn them into a space that represents and embellishes you.

While it's personal taste that makes the best homes, there are universal rules worth following when it comes to creating a good residence. Location is one thing but the way your home makes you *feel* should be the top priority. Across these pages we've highlighted houses in both urban and rural spots but what they all share is a connection to their surroundings and contents. Often the gentlest way to do things is the best way – using brash design to fight against the vernacular of your neighbourhood or the beauty of the countryside beyond your walls rarely (if ever) works.

Instead, let the outside filter in: from the breeze to the light and the views. Wide windows, big balconies and cared-for terraces all play their part in amplifying the bounty of nature, while in the city homes with beautiful but compassionate designs offer cover from the crush beyond. Whether you're acquiring a previously built home or starting from scratch, think carefully about the materials that will make up the environment in which you'll spend your days and nights. Above all, you want them to age well and gracefully – even if that's more than you can say for yourself.

Typically it's natural materials that fare most finely with care: timber trimmings or an oak parquet floor will not only look great but their intrinsic properties can add to the wellbeing of residents. Clay or plaster walls are breathable and can cool down a space in a more sustainable manner than a noisy and wasteful air-conditioning unit. And when it comes to the kitchen, no matter how clumsy your cooking is you'll struggle to destroy a polished marble counter. If you do, remember that bumps and bruises tell good stories too: the perfect home isn't ever truly perfect in that sense.

Kitting out a house takes time, so trust your instincts and only acquire the things you need and adore. Prioritise longevity in the furniture you find and you're halfway there. And when you're done, don't be afraid to mix it up – as life chops and changes, your house should too.

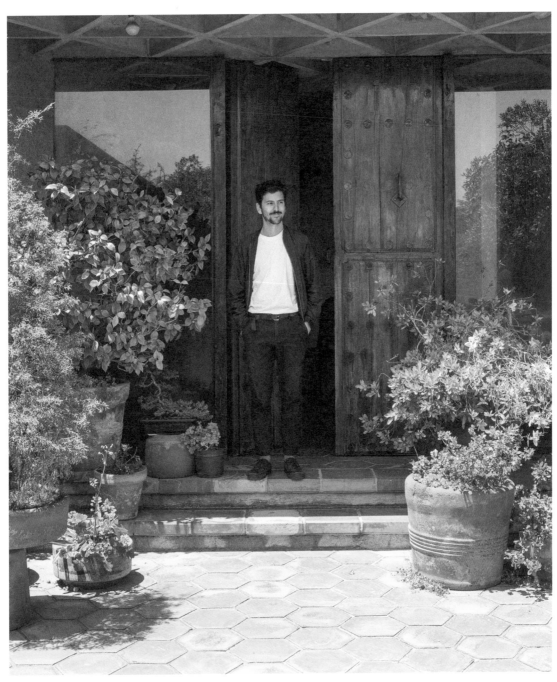

Make an entrance
Take time to find a door
that makes an impression
or a fetching knob-and-
knocker combo. What about
some optimistic potted
plants? Relax, you're home.

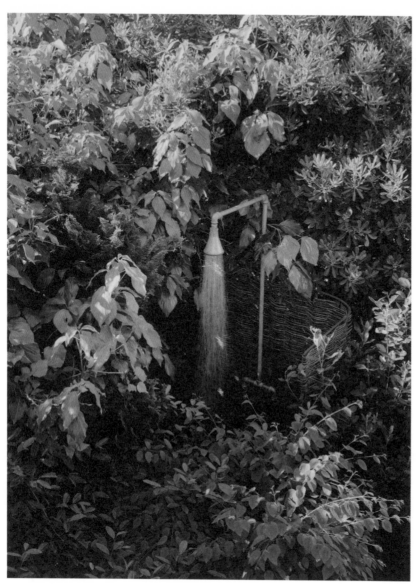

Keep something back

The frontiers of privacy have been shoved back by a culture of oversharing. Your time at home isn't your own if you're responding to emails in bed. And that sense of being watched isn't aided by a rash of glass-and-steel towers with plate-glass windows, or by our cities becoming busier and homes shrinking in size. At the end of the day, it can be rewarding to sequester yourself in the study or curl up on a sofa. Celebrate spaces that aren't overlooked by the neighbours, plastered on social media and where you don't find yourself checking your inbox.

A nook in which to read? A nozzle in the garden? It's your call – and your choice whether or not you answer.

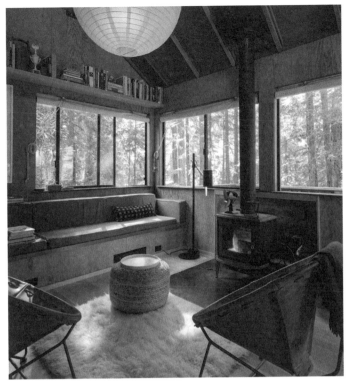

Act natural (inside)
Soft finishes, throws and cushions muffle noise and feel nice. A kick of colour and pattern add some personality too.

Act natural (outside)
Wood creates a dialogue with its surroundings and gains a patina that improves with age. It's natural, renewable and better for the environment too.

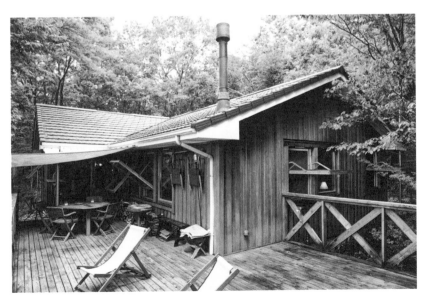

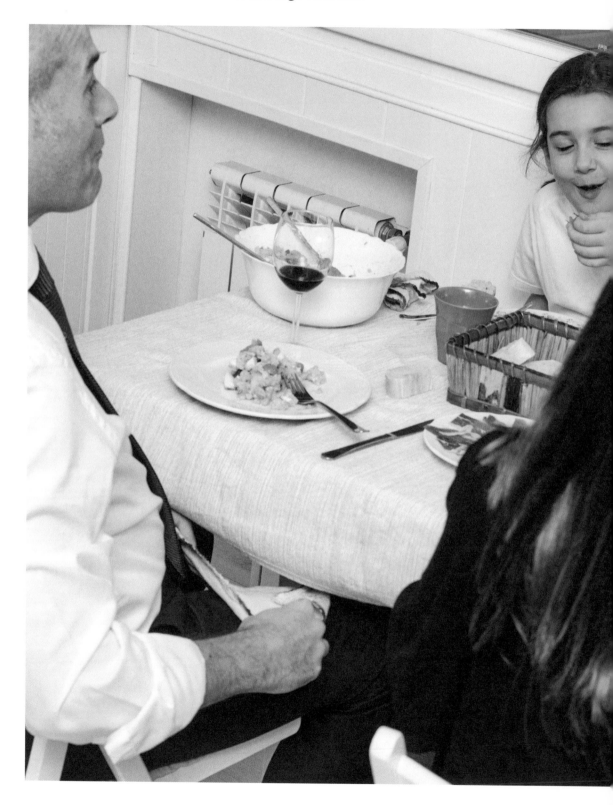

Encourage table talk
The dining table is the perfect example of how any home is made up of hardware and software – the things we have and the way we use them. To be clear, we're not telling you to go out and buy a brand-new dining table, we're just wondering if you've considered using yours more? (Incidentally, if you are in need, you can get a great fold-away number from British brand Ercol for your compact city apartment or something stately from B&B Italia or Minotti if you have more room.) Here's the rub: neither means much if you're sitting on the sofa chomping to the churn of the TV. There's nothing sadder than a never-used dining table. When it is used, it's one of the simplest ways to gather as a household, break bread, talk and digest the day together.

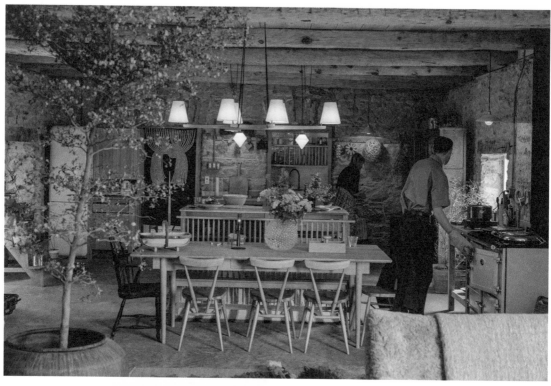

Create a kitchen you want to spend time in Not for its fancy finishes or expensive units. Try crockery you care for, glasses that gleam and chairs to chew the fat on.

Have a light-bulb moment (or two)

Cheap, low-energy light bulbs are making us ill – or at least they're making us look it. You know what we're talking about: those ones that put everything – and everyone – in a deeply unflattering light, that blue-ish pall cast from strip-lights or over-zealous LEDs. Well, we take a dim view. Instead, our homes ought to be calming spaces with lamps, shades and a few low-wattage bulbs. Be soothed by a more mellow, yellow glow.

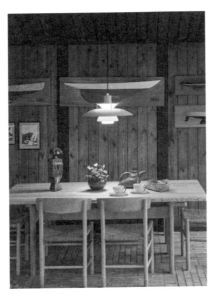

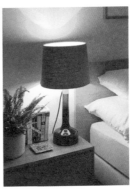

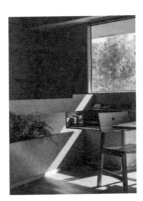

Seize some windows of opportunity

Not the floor-to-ceiling kind beloved of luxury developers but modest ones that still let in plenty of light.

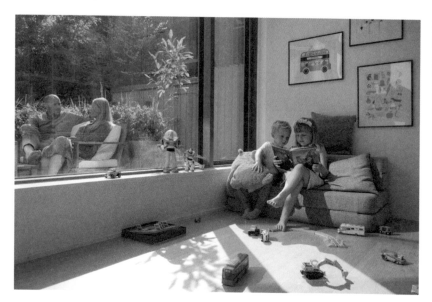

Play fair
Don't be too precious.
We get it that you're a
grown-up but make some
space for the kids to play,
put up their pictures, mess
around and build a den.
After all, it's their house too.

**Buy art that gets
you grinning**
We can't all own an
Old Master or pick up
a piece that will double
in value as soon as it
leaves the showroom.
But hang on, would you
want to? What's the fun
in a picture mounted
behind bullet-proof
glass? Art can be an
emotional investment,
whether or not it's
financially lucrative.
How about a portrait that
makes you smile? A print
that catches your eye or
a landscape that leaves a
lasting impression? It's not
naïve to say that first and
foremost, you should buy
art you adore.

Think something old, something new
Things needn't be box-fresh. Take those
naff plates you inherited, the ashtray you
nabbed and your favourite scratchy LP,
and you're halfway there. Create spaces
that reflect your life story – fun, but not
too polished.

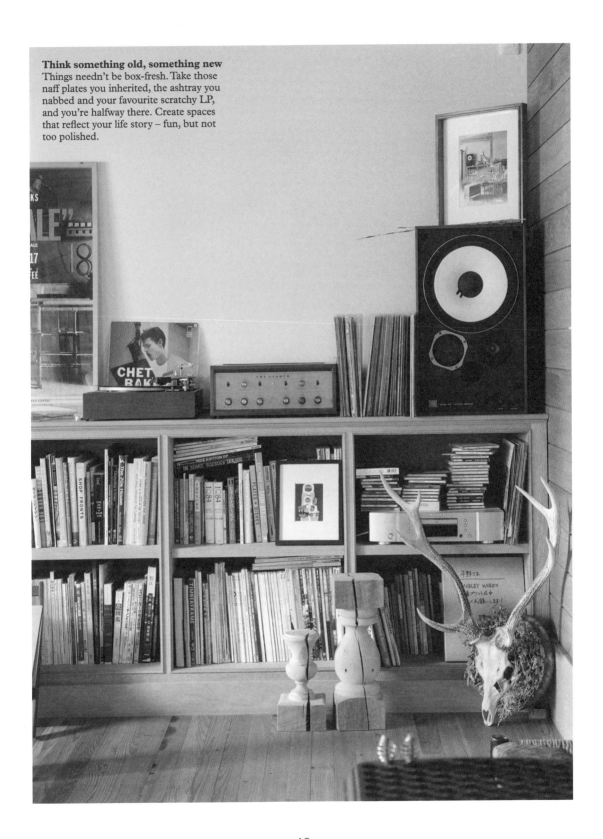

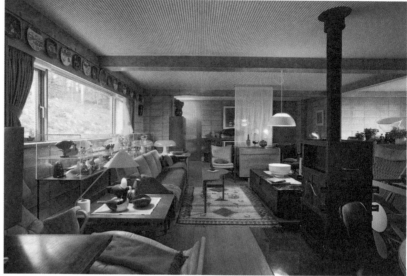

Mix and match
What we surround ourselves with defines us and how we feel. Building a home isn't about making everything match – it's as much a collection built over time that mirrors our moods and the moments we value. So *do* buy books that catch your eye on holiday and trinkets that tell a tale. They might not be to everyone's taste but that's sort of the point. If they are to yours, don't fret.

Create a cosy corner
A place to reflect on the day, doze off, delight in a film (we're not snobby if you get your kicks from low-brow flicks). Sometimes all you need is a space to unwind.

Have a desk of your own
The working-from-home revolution sounded good, especially when we thought it would mean that the work week might blend with the weekend and our new jobs would be making (and then eating) sourdough bread. But it didn't happen – and we haven't ended up being able to do our jobs from the beach with a cocktail in hand either. Instead, our commitments chase us into every corner of the house, which is supposed to be the place where we unwind. Having a desk to work at, a stack of books for reference and some smart stationery can help you stay focused and confine your job to one place. Optional but desirable extras include some greenery, a breeze, a good lamp and somewhere comfy to sit. We need spaces to think; places to retreat to. Now, what time do you clock off?

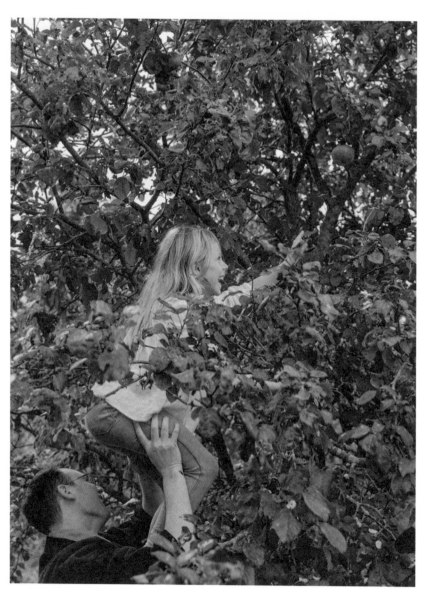

Go green (outside)
Once upon a time, mowing the lawn was seen as the way to tend your patch but today it's all about letting nature bloom. Plant trees and things you can eat at that table of yours and as an added bonus, hopefully you'll enjoy visits from passing critters and birds.

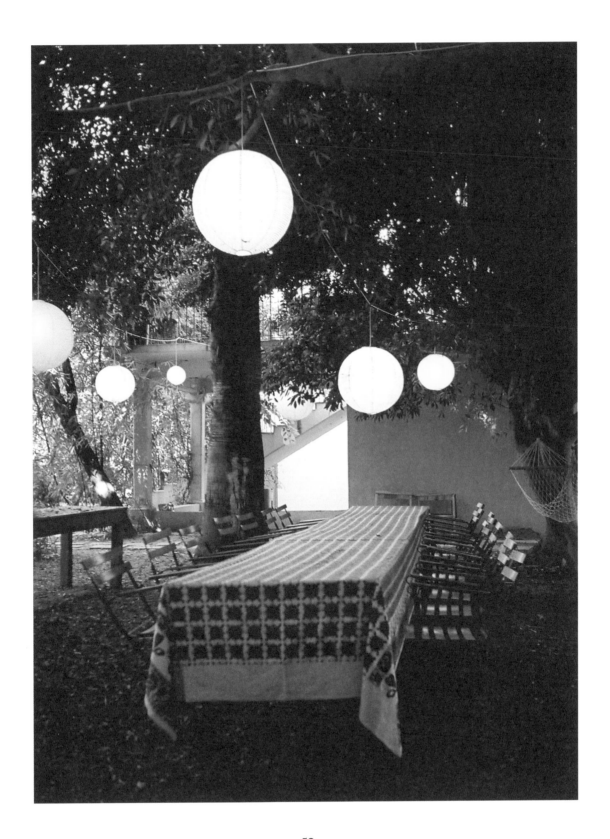

Go green (inside)
Pot, propagate, grow,
repeat. Looking after plants
improves air quality, fosters
a tranquil mood and blurs
the boundary between
indoors and out.

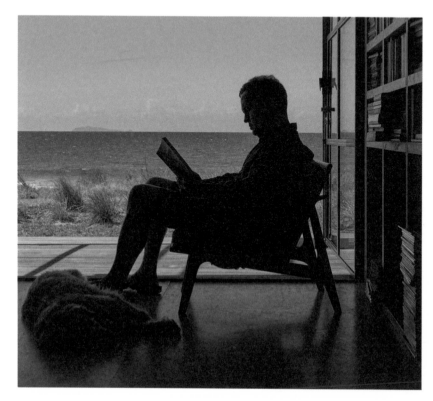

But also, get out
Have a home away from
home – a place that feels like
a refuge. There are plenty
of low-key escapes that are
gentle on the planet as well
as your mood.

And go wild
Whether it's a guileless boxer dog waiting to greet you at the door or a cat condescending to curl up on your lap, the animals with which we share our homes and lives can (ironically) add a lot of humanity to a house. Fancy a snuggle?

The importance of craft
by Fiona Wilson

Craft can adorn a home. Surround yourself with things that have integrity and in which you find pleasure – a good purchase should last a lifetime. Nowhere is craft more revered than in Japan, where making things is more than just a career, it is tradition, passion and duty.

For all its bullet trains and neon lights, Japan is, at heart, a nation of craft. Up and down the country thousands of men and women are diligently pursuing the same crafts as their forebears: rice farmers in Kyushu still make the swirling brown-and-cream Onta ceramics that their great-grandparents did; residents of the pretty town of Mino in Gifu prefecture continue to make traditional Japanese *washi* paper by hand, hanging the sheets out to dry like freshly pegged washing; and Okinawan weavers make *bashofu* (textiles made from local plant fibres).

Much of the craft map of Japan remains intact, dictated by whatever local material nature threw a region's way: forests of Akita *sugi* (cedar) sustained families of *magewappa* (bentwood) makers, while deposits of coal and sand allowed northern Iwate to develop as a centre of cast iron; 900 years on its iron kettles and implements are still sought after. Rivers brought the clean water that were required for some crafts, while the soil offered up a diversity of clays that dictated the look and feel of each regional style. One glance at Japanese pottery and anyone versed in the subject will be able to identify where it comes from.

Some skills simply grew out of the quiet periods in the agricultural cycle. The *kokeshi* (cylindrical wooden dolls) that are now so fashionable were originally wrought by farmers in the long winter months in Japan's north when fields lay dormant.

Japan has many famous artist-craftsmen who have inherited illustrious titles: the 15th successive head of a famous family kiln in Kagoshima said that as a young man he resisted joining the family business but came to realise it would have been "rude to my ancestors, including my father". Such is the importance of craft that the most distinguished practitioners are identified by the government and awarded the title of "Living National Treasures".

And yet, Japan has always had a parallel tradition: *mingei* (folk art), humble daily objects and textiles, executed with as much skill as any exalted art. *Mingei*, once overlooked in favour of mass-produced alternatives, is now in vogue, admired for its timelessness and longevity. In an age when sustainability is on everyone's lips, goods made by hand from natural materials get better with age and with care will last a lifetime.

Opposite, you'll find a short directory of global firms, large and small, which make products that are built to last.

HOMEWARE

1.
Teixidors
Spain

Teixidors revives ancient Spanish tradition by making throws, cushions and bedding that are handwoven from natural materials.
teixidors.com

2.
Serax
Belgium

From architect Vincent van Duysen to fashion designer Ann Demeulemeester, Antwerp-based Serax collaborates with some of the biggest names in Belgian design to create smart homeware.
serax.com

3.
Dusen Dusen Home
USA

Fashion designer Ellen van Dusen launched her homeware line in 2015, transferring the brightly coloured prints that had made her womenswear popular to everything from bedspreads to dog beds.
dusendusen.com

4.
Svenskt Tenn
Sweden

A Swedish mainstay founded in 1924 by Estrid Ericson, who later recruited designer Josef Frank. Frank's camp nature-inspired patterns fizz with colour and spark.
svenskttenn.se

5.
Situ Studio
New Zealand

Everything from interior designer Rosa Milne's Queenstown-based brand is designed and handmade in New Zealand, from ceramic teapots to linen cushions and woollen blankets.
situstudio.co.nz

KITCHENWARE

6.
Crane
France

Crane's sturdy cast-iron pots and pans are produced in a French foundry that uses vitreous enamel to guarantee a lifetime of use.
cranecookware.com

7.
Kinto
Japan

Japanese brand Kinto started out as a wholesaler of tableware before developing its own line of products. Today it makes everything from glass teacups to delicate porcelain bowls.
kinto-europe.com

8.
David Mellor
UK

David Mellor became famous in the 1960s for his cutlery designs. Today the business is run by his son and stocks a covetable range of tableware and kitchenware.
davidmellordesign.com

9.
Sambonet
Italy

This northern-Italian brand was founded in 1856 by goldsmith Giuseppe Sambonet. Today it produces sharp cutlery and winsome tableware and has created collections with several Italian design icons.
sambonet.it

10.
Sargadelos
Spain

Galician porcelain manufactory Sargadelos works with local artists to produce its signature blue-and-white designs, which are inspired by traditional motifs.
sargadelos.com

LIGHTING

11.
Ago
South Korea

Yoo Mars' brand works with artisans in Seoul to produce lamps that are designed in collaboration with studios including Sweden's JWDA.
agolighting.com

12.
Marset
Spain

Barcelona's family-run Marset made its first lamp in 1976. It produces playful, often experimental designs, the most famous of which is perhaps its mushroom-shaped portable FollowMe lamp.
marset.com

13.
David Pompa
Mexico

In his Mexico City studio David Pompa designs simple but striking pendant lighting using brass, copper and grey *fiorito* stone.
davidpompa.com

14.
Articolo
Australia

Designer Nicci Green's Melbourne-based brand uses mouth-blown glass to produce unique lamps, pendants and sconces, all of which are made by Australian artisans.
articololighting.com

15.
Nemo
Italy

This Milanese company may have been founded in 1993 but it produces designs from some of the biggest names in mid-century modernism, from Charlotte Perriand to Vico Magistretti and Franco Albini.
nemolighting.com

FURNITURE

16.
Ercol
UK

Tuscan-born furniture-maker Lucian Ercolani established Ercol in the UK in 1920. His passion for the well-made is evident in everything from oak tables to Italian-ash armchairs.
ercol.com

17.
Time & Style
Japan

Founded by brothers Ryutaro and Yasushi Yoshida in 1990, Time & Style works with some 200 craftfolk to make furniture using timber sourced from the forests surrounding its factory in Asahikawa.
timeandstyle.co.jp

18.
Kann
France

This family-run company produces furniture inspired by mid-century designers. A team of carpenters, welders, upholsterers, painters and weavers make their creations by hand in Lebanon.
kanndesign.com

19.
Atelier Two Plus
Thailand

After graduating from Sweden's Konstfack, Ada Chirakranont and Worapong Manupipatpong returned to Thailand to set up a studio focused on cane stools, screens and sofas.
ateliertwoplus.com

20.
USM
Switzerland

Haller, the signature product line of this Swiss manufacturer of modular furniture, stacks and adapts well as your home changes over time.
usm.com

Extend your home beyond the front door
Cities without limits

Our homes aren't just the buildings we inhabit, they're also the streets that lead us there, the neighbourhoods that ground us and the urban interventions that improve our health, air quality and experiences as we navigate them. A gentle life is one lived on street level and ideally at strolling pace: with stops at shops we admire, a wave from the knowing barista, clean air and public transport that whisks us from home to work and to see people we care about.

The push for a more sustainable life means small but meaningful changes that combine our efforts (to recycle, to be considerate, to buy from independent businesses) with city halls that treat us like adults. Here's a checklist for how cities can be a little less rough on their residents.

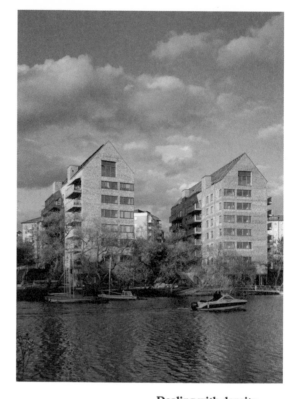

Dealing with density
Too many new-builds are ugly, charmless glass-and-steel behemoths. What about investing in timber towers that look good and make us feel better as property developer Folkhem do in Stockholm. We need to create spaces that can adapt, that generations can share and that bring joy to residents as well as profits for the developers behind them.

Parks and recreation
From expansive new recreational areas to pocket-parks and gardens on waste-land around the world, green spaces improve our air quality, offer a place to run or laze and create shared spaces to enjoy.

Wayfinding and walking
The Legible London signage (designed by Applied Wayfinding and Lacock Gullam) is one scheme that shows how to navigate a city's streets with ease.

A sense of history
Good cities balance the need for new with an appetite to maintain, repurpose and rethink their stock. This could be reusing a bauhaus shell or an art deco factory to create a narrative between the past and future. Cities shouldn't look the same.

Places to replenish
Zürich has crystalline waters by the lake-full but its 1,200 fountains (from the grand to the odd) offer thirst-quenching, face-splashing spaces that help keep residents refreshed.

Planting beyond our borders
Potting a few plants outside your home or tending the patch beyond your property is an act of faith that radiates out and helps beautify streets – a concept the Japanese call *jisaki engei*. What could you do to enhance the space around you?

CHAPTER 3

Make time to...

Read, dance, draw, delight and escape.
How to stay dry in the digital deluge.

Make time to...

Sorry to be the one to tell you this but you need to get out more. To exhibitions, screenings, bookshops, festivals or your peculiar friend's ill-advised ventriloquist show. It's not always about what you see, sometimes it's about the attitude and having the openness to embrace life. It's hard to find inspiration in an inbox. Also, as the world gets its so-called ideas from social media it's desperately important to connect to something more tangible, see things in situ and understand the light and shade.

Most things are nuanced and many deeply exciting, so – to paraphrase Walt Whitman – don't take them at second-hand. Oh, and while we're at it, you can't "complete" an art gallery. We need to avoid the idea that culture is a tick-list because it stops us getting lost in it. So take time to do things that are rewarding, the stuff that broadens your horizons and creates (offline) connections with others, your own thoughts and wider culture. Consider the fact that no one ever found happiness staring at their watch and that your inbox will fill up again tomorrow no matter what you do with it today. Follow us.

Turn the page
Read more

The endless scroll of ever-updating websites is a grim metaphor for human progress in the digital age – we finish one thing and another takes its place. But books can help: they allow us to focus and to reason, and they offer windows into the minds and curiosities of others. Sure, they're full of ideas, inspiration and empathy (occasionally rubbish too) but even the longest ones have something that the internet can't mimic – a beginning, a middle and, blissfully, an end.

First things first – this invocation to read more isn't about making you feel bad for not finishing *The Fountainhead* or *Ulysses* or your friend's 1,000-page manuscript (although maybe you *could* lie and say you got further than page seven). Instead it's about celebrating the act of taking time to read. Why? Well, it's fulfilling, fun and good for you, and doing so in print helps you to retain information better than on a screen. Crucially, for the purpose of this book, reading offers a simple method of escape (and time travel and excitement) that costs less than a bottle of wine or a packet of smokes (as George Orwell argues somewhat punctiliously in his essay *Books v Cigarettes*). Without sounding too much like a jabbering literature teacher, there really are other worlds to discover in books – secret lives and arcane jokes and plenty to enlighten, enrage, unsettle and challenge us. Taking time with an old paperback offers some release from the information bombarding us from back-lit screens. As long ago as the 1930s, British-American poet TS Eliot suggested that we were "distracted from distraction by distraction" and books – highbrow, lowbrow or in-between – break the cycle of multitasking and can allow us time to reflect, imagine and learn. Hopefully, in some modest way, the book that you're holding proves the point.

Don't take the easy road
It skimps on the details

Time-poor readers are flocking to apps that offer shortcuts purporting to unlock the secrets lurking in lengthy books. One touts easy-to-digest summaries of more than 2,000 works of non-fiction; the précis of each is available as a 15-minute write-up or commute-length listen. Then there's the dubious claim that (all?) CEOs read more than 60 books a year. Right.

But here's the problem: those CEOs probably became successful because they thought better of always taking the easy road. Your inspiration might be hiding in a sentence buried in the middle of a book that you've been meaning to pick up. So be wary, chaptered chunks are made to be ticked off, not taken in. Blink and you might miss it.

Don't bin the back issues
They've got it covered

Magazines are made for now but what about the publications of yore? The back issues can be tactile time machines. Take March 1997's UK edition of *Vanity Fair*, which featured Liam Gallagher and Patsy Kensit looking hot but hungover in a Union Jack bed on the cover. Or *The Face* from that same year, which has the sweetest and most natural cover shot of the Spice Girls – a group who snarled or pouted as if their career depended on it.

When you're building a library, there's a question you have to ask yourself: are you keeping something or are you just not throwing it away? Have an eye on the present and think: "Can I live with this?" But also an ear cocked to the future: "Can I live without it?" Print still makes an impression.

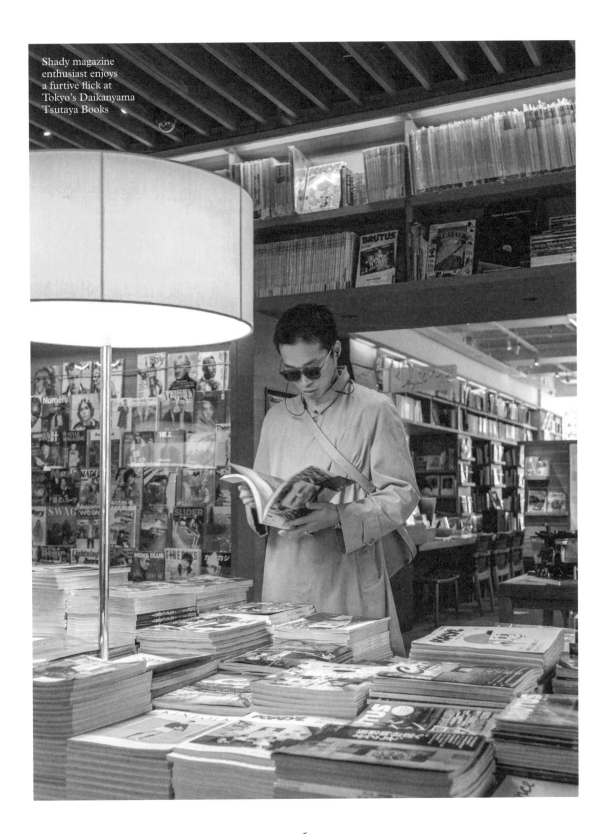

Shady magazine
enthusiast enjoys
a furtive flick at
Tokyo's Daikanyama
Tsutaya Books

Build a library
Page turners

Having your own library isn't about stuffy, leatherbound books. It could just be a modest bedside pile. It's about keeping a paper trail of where you've been and what you were thinking at the time. Read on for our starter kit of classics and more surprising finds.

1

2

1.
My Family and Other Animals
Gerald Durrell

Durrell's family home in Corfu is filled with two and four-legged creatures.

2.
Life is Good
Alex Capus

An ode to memory and marriage, whipped up with Capus's lively style.

3.
The Pocket Atlas of Remote Islands
Judith Schalansky

Schalansky casts readers away to fifty far-flung isles.

4.
James and the Giant Peach
Roald Dahl

Life is peachy (or is it?) for James Trotter until he's left with his wicked aunts.

5.
The Hearing Trumpet
Leonora Carrington

This surrealist artist's prose becomes more brilliantly bizarre as it goes on.

6.
Falling off the Map
Pico Iyer

An evocative and jovial chronicle of Iyer's travels to the loneliest and most eccentric places on Earth.

7.
Prisoners of the Sun
Hergé

One of more than 20 titles in *The Adventures of Tintin*.

8.
The Summer Book
Tove Jansson

An old lady and her granddaughter holiday on a Finnish island where time slows and great truths set in like summer rain.

9.
Now We Are Six
AA Milne

Wise young Christopher Robin wants to stay six forever – and who wouldn't when you have Winnie the Pooh as your chief adviser? An ageless poem for an endless childhood.

10.
Modern Nature
Derek Jarman

A diary of the artist, writer and film-maker's garden on the barren coast of Dungeness and a meditation on his life.

11.
Vacationland
John Hodgman

The pitfalls of family holidays are offset by Hodgman's witty nostalgia for his own trips around the US.

12.
The Famished Road
Ben Okri

This lengthy Man Booker-winning novel paints a portrait of post-colonial Nigeria and family ties.

13.
Gigi and the Cat
Colette

The great French author's turn-of-the-century tale of a courtesan-in-training comes complete with lobsters and lace.

14.
The Little Virtues
Natalia Ginzburg

In 11 powerful and poignant essays, the Italian writer lays bare everything from married life to her husband's death.

15.
One Hundred Years of Solitude
Gabriel García Márquez

A masterful multi-generational story of the Buendía family and their town of Macondo.

16.
Far Out isn't Far Enough
Tomi Ungerer

The graphic designer and author swaps 1970s New York for a simpler life in Nova Scotia with his wife.

17.
The Wind in the Willows
Kenneth Grahame

In Ratty's words: "Believe me, my young friend, there is nothing – absolutely nothing – half so much worth doing as simply messing about in boats."

18.
Dona Flor and Her Two Husbands
Jorge Amado

Dona Flor remarries after her husband dies – only to have him reappear again.

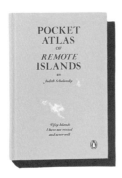

POCKET
ATLAS
OF
REMOTE
ISLANDS
BY
Judith Schalansky

*Fifty Islands
I have not visited
and never will*

3

ROALD
DAHL

James and the
Giant Peach
Illustrated by
QUENTIN BLAKE

4

Leonora
Carrington
The Hearing
Trumpet

5

Falling *off the* Map
SOME LONELY PLACES OF THE WORLD
PICO IYER

6

THE ADVENTURES OF
TINTIN
PRISONERS OF
THE SUN

7

The
Summer Book
Tove Jansson

8

NOW

WE ARE SIX

A. A. Milne

9

DEREK
JARMAN
MODERN NATURE

THE JOURNALS OF DEREK JARMAN

10

NEW YORK TIMES Bestselling Author
John Hodgman
Vacationland

True Stories from Painful Beaches

11

BEN OKRI
THE
FAMISHED ROAD

12

PENGUIN BOOKS
GIGI *and*
THE CAT

COLETTE

13

*The
Little
Virtues*

NATALIA
GINZBURG

14

One
Hundred Years
of Solitude

GABRIEL GARCÍA
MÁRQUEZ

15

Far Out isn't Far Enough
Life in the Back of Beyond
Tomi Ungerer

16

THE WIND
IN THE
WILLOWS

KENNETH GRAHAME

17

DONA FLOR AND
HER TWO HUSBANDS
A moral and amorous tale
JORGE AMADO

18

Visit a small museum
See less but better

We've got something to clear up. You can't 'do' a museum. This expression is part of a broader problem in which culture and inspiring ideas are limited to things to be crowbarred into a forbidding schedule. So here's an idea, go to a gallery and see one painting – really look at it. Give yourself permission to take your time over things. Oh and start small. Here are four of our editors' favourite mini museums.

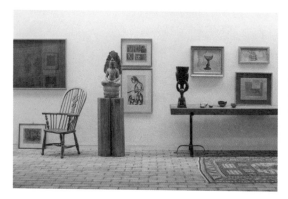

1.
Kettle's Yard
Cambridge, UK

Kettle's Yard in Cambridge was once the home of art collector Jim Ede. Moving to the historic university city in 1956 with his wife Helen, he restored four derelict cottages and strung them together to form a single house that he filled with his collection of early 20th-century art. "Jim never saw it as a museum," says director Andrew Nairne. "It was his home and he wanted to prove that contemporary art can be appreciated in a domestic context too; not a sanctified space where art sits beautifully yet is detached from the viewer."

The atmosphere is intimate and unstuffy, with visitors encouraged to sit on the exhibits – from antique to design-classic chairs – and admire the idiosyncratically placed works of art, which are just as Ede left them. A painting by Lowry hangs on the wall just above the floor, while Henri Gaudier-Brzeska's enigmatic vorticist sculpture "Bird Swallowing a Fish" sits on a huge tree trunk surrounded by stones at its base. Students are even invited to borrow works from a dedicated loan collection to add a splash of colour to their rooms.

2.
Nezu Museum
Tokyo, Japan

For all its bustle, Tokyo can still surprise with pockets of serenity. The Nezu Museum, home to an outstanding collection of Japanese and East Asian art, is one such place. Set in the middle of the city in an exquisite garden filled with stone lanterns, Buddhist statues and wooden teahouses, it was once a well-kept secret. A new building by Kengo Kuma, which opened in 2009, brought the museum to the attention of a fresh audience. The renowned architect created a new sense of drama, drawing visitors into the garden through a bamboo-lined walkway and glass-walled entrance.

The Nezu's core artworks were amassed by businessman Kaichiro Nezu, who bought this land in Aoyama in 1906. His son, Kaichiro Junior, opened the museum in what was the family residence in 1941 – and his grandson, Koichi, the current director, continues the work today. The collection now comprises 7,400 pieces ranging from calligraphy to ceramics. The necessary darkness of the galleries, a protective cloak for the delicate works within, provides a startling contrast to the vivid green outside.

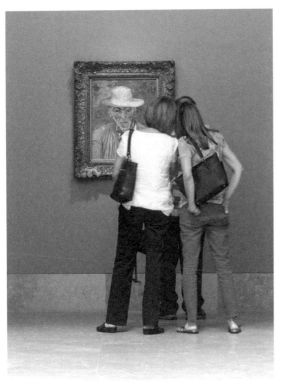

3.
Norton Simon Museum
Los Angeles, USA

Pasadena, a city just northeast of downtown Los Angeles, is home to one of the greatest (albeit not the biggest) art collections in the US. Comprising everything from old masters to impressionists, the Norton Simon Museum also keeps paintings by household names such as Cézanne, Van Gogh and Renoir. Although only about 1,000 works are on display at any one time, the collection counts some 12,000 pieces in total.

The modernist building was given a tweak in 1999 by Frank Gehry but the sculpture garden was transformed the most – from a striking but stark outdoor space into an oasis of paths meandering around a large pond, with several nooks that invite people to slow down and linger among the art. Featuring a series of 20th-century bronze sculptures, the garden also lends itself to hosting alfresco drawing classes. Its rebirth was overseen by landscaper Nancy Goslee Power, who conjured up a colour-popping take on Monet's Giverny garden in Normandy but reimagined it for southern California with cedars and cypress trees.

4.
Fondation Carmignac
Porquerolles, France

For those used to consuming art in white cubes, often weighed down by a heavy bag and the stresses of urban life, Fondation Carmignac attempts to provide a remedy. Located on Porquerolles, a wild island on the southern French coast, the gallery was built by investment giant Edouard Carmignac to house his collection of art and photojournalism. At first glance the foundation is unassuming: a typical French farmhouse with blue-painted shutters reached by a dirt road through eucalyptus forests. But it opens up into a subterranean gallery displaying an encyclopaedic collection of 20th-century art.

There's plenty of pop art – including Warhol's portraits of Lenin and Chairman Mao, and a huge Lichtenstein – as well as works by Rothko and Richter and a portrait of Carmignac by Basquiat. After soaking it all up, guests are encouraged to explore the gardens, which are part of a national park. Discover huge sculptures by Nils-Udo, Gonzalo Lebrija and others before hopping back on the ferry and crossing the azure waters to the mainland.

:h a film outdoors
Reel deal

The movies are excellent for escapism and the growth in outdoor cinemas around the world is (weather permitting) a welcome next act. Here we profile our favourite venues and offer some suggested viewing.

Winters in Berlin are long and grey. But when spring unfurls and its citizens emerge from *Winterschlaf* (hibernation), all the things that make the city great are set back in motion. Outdoor clubs and public pools are among the attractions that first reopen their doors but, for many people, the most exciting thing is still to come: *Freiluftkino* (open-air cinema) season.

The city boasts more than 20 open-air cinemas, from a wooden amphitheatre in a leafy glade in Hasenheide park to one in the courtyard of Spandau's public library, where you can rent a hot-water bottle if you get chilly. Berliners have long recognised that there are few better ways of enjoying a summer's evening than gathering with friends to watch a film alfresco – and all the better if you can bring a bottle or your own picnic.

But not all cities have nailed the concept. In London, for example, the offering is largely made up of gimmicky rooftop spaces that charge people excessive prices to watch bad *X-Men* movies. The beauty of an open-air cinema should be its ability to bring everyone together, not just those willing to pay a fortune for a warm lager.

This is where Paris's open-air cinema at Parc de la Villette excels. Its July and August screening programme attracts a cross-section of society, all of whom come to watch everything from Studio Ghibli classics to old Jacques Tati comedies and the latest blockbusters. Parisians flock in their thousands to the park's lush lawns to catch these free showings. As dusk descends and a hush falls over the crowd, there's a feeling of communal excitement that's not easy to find on such a scale.

FIVE GENTLE FILMS

1.
My Neighbour Totoro (1988)
Directed by Hayao Miyazaki

Two girls left alone one summer learn the lore, law and lure of nature from a magical bear-like sprite.

2.
Il Postino (1994)
Directed by Michael Radford

A perfectly engineered Italian charm machine about a boy, a girl, breathtaking landscapes – and stamps.

3.
2 Days in Paris (2007)
Directed by Julie Delpy

A comedy about a Franco-American couple returning to Paris to meet the girlfriend's eccentric parents.

4.
Hunt for the Wilderpeople (2016)
Directed by Taika Waititi

This heartwarming (if darkly comic) film follows a boy and his adopted father who are stranded in the New Zealand wilderness.

5.
Faces Places (2017)
Directed by Agnès Varda

Veteran documentarian Agnès Varda's final film follows her travels around France with artist JR.

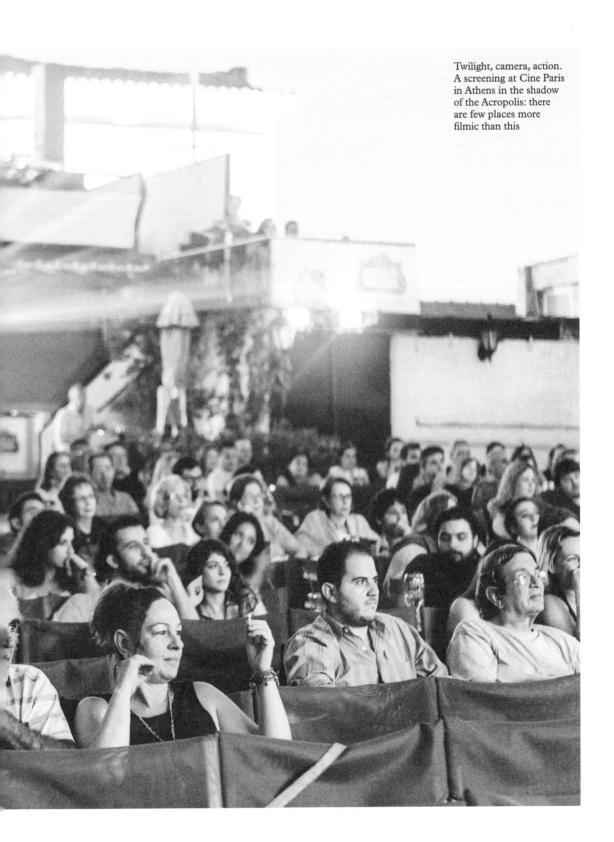

Twilight, camera, action. A screening at Cine Paris in Athens in the shadow of the Acropolis: there are few places more filmic than this

Listen more
Hear us out

To hear what's said and to seek answers from others is a life skill that we all need to practise. Listening means engaging rather than waiting for your chance to speak up. It means being in the moment and holding your tongue.
Did you catch that?

1.
Listen to the radio
by Tom Edwards

Why does the radio carry such power? Well, people need voices they can trust but they also need a sense of connection. Radio delivers such togetherness, especially when live: a spellbinding blend of immediacy, intimacy and humanity.

Everyone has prompts that summon up memories; this speaks to the potency of audio to capture truth and emotion. It might be the host who knows what to whisper in your ear when you wake up or the broadcast that readies your whirring brain for rest. Some radio tidbits evoke gentle times: take light-music maestro Ronald Binge's "Sailing By", which heralds the late-night shipping forecast on BBC's Radio 4.

How does radio do this? It's about what it leaves unsaid – the audio equivalent of the white space that makes good design great. To engage people's imaginations there's a pact between the broadcaster and the audience to fill in those gaps. That's why radio is capable of delivering emotional impact. Radio forges companionship, a real bond between speaker and listener. So forget the digital realm and reach for the dial.

2.
Listen to live music
by Holly Fisher

For many of us, the first experience of a concert coincides with a pop star's arena tour – venues we're unlikely to visit again as grown-ups. But the excitement of the spectacle remains. Walk past a venue that's about to open its doors to the fans queuing outside and you'll feel a palpable sense of anticipation as micro-communities come together in one room with their idols.

There's a lot to love about live music: the moment the crowd is snug enough for you to feel uninhibited – and limber enough for dancing. The collective frisson as the melody kicks in. Watching the joy of another fan as the opening of an anthem is played. The whoosh of glee on the big choruses that sound even better en masse.

Our relationship with live music matures over the years. What all gig-goers retain, though, is a soft spot for the communal experience: getting lost in the crowd and not knowing who you might meet. That feeling of joy, melancholy, bliss. It's the sensory overload: chills up the spine, thwacking bass. When else can you get away with shouting your head off and dancing with strangers?

3.
Listen with others
by Chiara Rimella

Volume regulation for background music in a bar is a subtle art: too low and people will feel as though their conversation is being overheard; too loud and they'll probably struggle to converse at all. None of this matters in a Japanese *jazz-kissa*: at these purpose-built listening bars, vinyl comes first and chitchat second.

Tokyo's original *jazz-kissa* were born in the 1950s as places where the country's cool cats would lend their ears to the latest US releases. Nowadays listening to those records at home on your own isn't quite as hard (or expensive) as it was back then but the appeal of a low-lit space where you get to sit down with a glass of whisky and let yourself be surrounded by music remains just as alluring.

Outside of Japan, entrepreneurs have exported the model abroad for their own nation's audiophiles to enjoy but the Japanese original (with its ban on loud chatter) is still the best. Some people consider the rule draconian but it is, in fact, what makes these places so charming. Stripped of any obligation to entertain your friends for the evening, you can all give in completely to the pleasure of listening.

For those who have a passion for vinyl, heading to a listening bar in Tokyo is something of a ritual – but these are not places to boast about your own niche knowledge. Just pay a cover charge, grab a seat and let the music do the rest. The house decides which records are spun from their extensive repertoire. And although no words are spoken the experience is strangely social – after all, appreciation and emotion can be amplified when shared, and we needn't fill every moment with noise just for the sake of it.

4.
Listen to a talk
by Sophie Grove

Why step out on a cold, wet night to attend a talk when you can download and listen to one from the comfort of your own home? You'll have to check your coat and wait for a glass of warm white wine. There will be creaking chairs, latecomers dangling sodden umbrellas and the inevitable long-winded rhetorical question from the floor that leaves the audience bristling.

But none of these things deters us from turning up. Quite the opposite – our congregation adds to the sense of purpose. Whether it's a PechaKucha (the format devised by Tokyo-based KDA architects that restricts presentations to exactly six minutes and 40 seconds) or a long, searching reminiscence, talks have an important role to play in our lives. When we come together and listen, engage and spar we're fulfilling something human.

Although a seminar on Meret Oppenheim's fur teacup, the principles of hyperbolic geometry or the origins of the *majolica* tile might not change the world, it's important to remember that the tradition of public discussion is fundamental. The history of our democracies has been formed by curated talks in French Enlightenment salons and vigorous debate in the coffee houses of Vienna.

To sit among an assembly of willing participants and listen to an expert is nearly always worth the effort. There's an uncanny alchemy to any audience. It's as if the physical act of turning up with dozens of others sharpens the mind and compels us to concentrate. We enjoy the hush before events begin, the tension of who might ask a question and the energy of a lively argument. And no matter how heated a debate might get, a face-to-face spat almost always has more humour, accountability and good old manners than any anonymous online storm.

Crowds mass outside
Shakespeare & Company
bookshop in Paris to
be present at a talk.
Gathering is good for us

Have a conversation
Time to talk

We live in an age where some people
don't want a dialogue, don't want to
bridge divides and don't want to hear
what others think or worry about or
need. Luckily they remain a minority
and together we can talk them down.
Because things will only improve if
people start chinwagging.

People used to talk about the art of conversation,
which is just that – an art. It's a thing of beauty
with transformative powers. Conversation can
heal, move, enrich or simply amuse. But only if
you do it well. You need some give and take. You
need to allow silences to be understood, to read
the other person's face and the shifting timbre of
their voice – to take note of that rising current
of emotion cracking their speech.

There's another wise old saying: "A problem
shared is a problem halved." That can be true
too. As we share our burdens they can lose their
weighty power and disappear on the wind. This
is why health professionals worry that modern
life – with its drumbeat of self-checkouts, payment
by app and online banking, not to mention social
media – deprives people of those moments in a
day when they can spark up a conversation. Think
of old people, people who aren't in relationships
and people who are new in town and yet to make
friends: people who are placed on conversation
diets by how the world functions and then you
realise that loneliness blights lives and impacts
mental health. You see, to be gentler, to feel less
tossed around by the tides of life, all we need is a
bloody good chat; to be able to look someone in
the eye and talk. Go on, give it a try.

Learn to...
New skills

Learning something new can feel like a risk but it's all about how you approach it.
A gentle life doesn't mean being the best, it means giving things a go –
and with the right attitude, you'll improve in no time.

1.
Learn to keep a diary
by Beatrice Carmi

A lot has been penned by prominent writers on the importance of keeping a diary. To the literary species the diary is a record for anecdotes, images and overheard conversations to keep in store for future works. But writers aren't the only ones to recognise the benefits of jotting things down.

It helps boost memory and improves sleep and mood. We work and live better in a clean and tidy environment, and the same goes for our mind: it functions better once it has been put in order. Writing is an important exercise that helps us process old thoughts and memories and allows the brain to focus on new ones. It's therapeutic too.

Most days are relatively uneventful, so writing about them might seem frivolous. But to make sense of things we need to find words for them. Don't get fixated on finding something worthy of writing about: often it's only by beginning to write that our brains will reveal what they want to deal with. Don't overthink it. Just buy yourself a good-looking notebook, something you'll want to pick up, and set a few moments each day to commit those fleeting thoughts to paper.

2.
Learn to draw
by Hester Underhill

I never like anything I draw. All my subjects – even the most elegant life model – invariably end up with a funny nose and a Habsburg chin. But I haven't let this stop me from making it a regular habit: you don't have to be a great draftsman (or woman) to reap the rewards of putting pencil to paper.

How much satisfaction you'll glean from the act depends on the expectations you bring to it. If you've taken up drawing because you want to be the next Rembrandt, things might not work out. But if, like me, you're the kind of person who gains a lot from slowing down, drawing will do you the world of good. Its power lies in how absorbing it is: sketching triggers the same brain activity that occurs during meditation. Focussing on what you're drawing enables you to shut out any external stress. It puts a metaphorical cushion between you and your thoughts.

And when you're done, if your sketch is good enough to earn a place on your fridge, great, but if it ends up in the bin that's fine too. So go on, get sharpening those pencils. Remember: it's not about drawing comparisons.

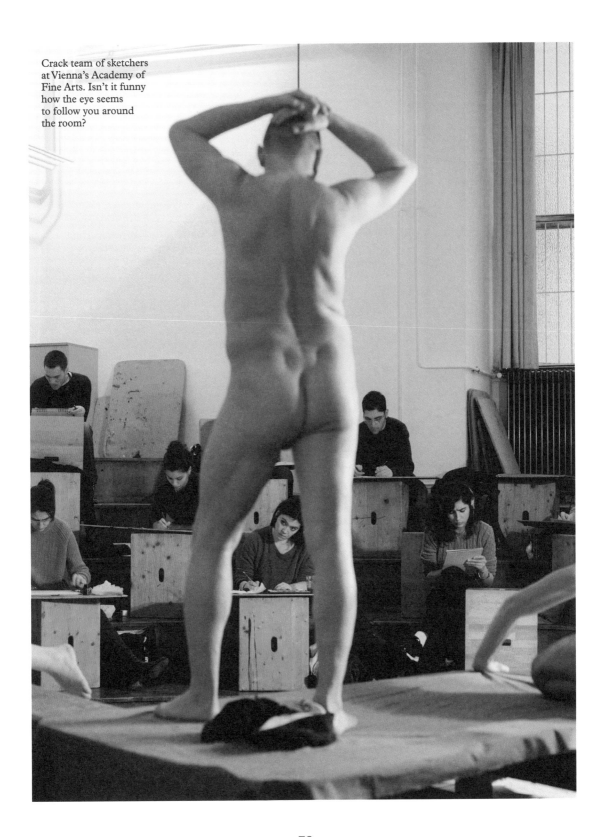

Crack team of sketchers at Vienna's Academy of Fine Arts. Isn't it funny how the eye seems to follow you around the room?

3.
Learn to sing
by Laetitia Guillotin

Singing on your own can be both comforting
and liberating, and yet, a lot of people I know
shy away from having a go, saying they can't sing,
are tone-deaf and all manner of similar excuses.
While it's true that not all of us have Tina Turner's
talent, nor carry off the sexy swagger that Prince
did, we can channel our inner star – and not just
on karaoke night. So, if you're in need of some
extra confidence before you take to the stage solo,
make like me and join a choir.

There are many kinds. The one I'm in dabbles
in pop and rock; we cover Beyoncé, Marvin Gaye
and Elton John. No auditions are required: the
general consensus is that everyone, after all, can
sing. It's a lot of fun but there's also more to it.
Several articles have been published about the
health benefits of singing as part of a group,
suggesting that it reduces stress levels, releases
hormones that increase happiness, enhances
creativity and even maintains a certain level of
fitness. It has been associated with boosting our
immune system too.

Before scientists weighed in, choir singers
already knew there was something special about
their hobby. When you sing with others, you sing
and listen at once, and tuning into the voices
around you helps to connect your emotions with
those of the group. It's easy to feel like you're
part of a bigger whole – and when you get it right
as one unified voice, you might just feel the prickle
of goosebumps.

Singing in a choir can change your life – for
the very reason that it sometimes makes you
forget that you have a life outside it, with all its
responsibilities and worries. It's a lifeline that
never fails to brings joy, a pitch-perfect way to let
go and one I'll never stop singing the praises of.

4.
Learn to play an instrument
by Carlota Rebelo

Don't worry, I'm not going to suggest you
suddenly become *that* person with a guitar
(or bassoon) at a party. But I do want to set
the record straight: while on the surface
learning to play an instrument might seem
the ideal activity for those seeking a crowd's
admiration, it is in truth one of the most
introspective, personal activities you can add
to your routine. There is something oddly
rewarding about playing your guitar (even if
it's out of tune) like nobody's watching – when,
in fact, no one is.

We all feel connected to music and
whether you fancy percussion, wind, brass
or string, being able to play a few notes of
any instrument will take your mind off the
day's troubles and help you focus intensely
on the task at hand – if not get carried away
by it. It's never too late to start and while
some instruments might be easier to learn
than others, there really isn't a "right" one to
get you started – though for your neighbours'
sake, there are certain wind or percussion
instruments that can be rather annoying if
you happen to live in close proximity. What's
important is that you choose something that
will ultimately make you happy.

I would be lying if I said the process isn't
frustrating at times – but having patience is
also a good exercise, and through repetition,
you'll be tinkling along to your favourite
tunes in no time. Perhaps you've been left
scarred by those primary-school music lessons
when, as a kid, you had to jostle with a recorder.
But there is more to life than high-pitched, off-
key notes, and you need less practice than you
think to find out.

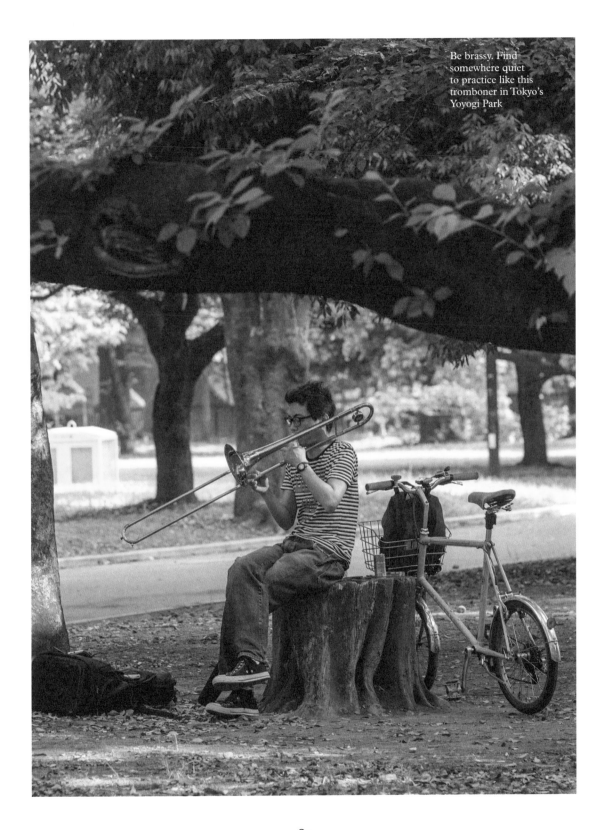

Be brassy. Find somewhere quiet to practice like this tromboner in Tokyo's Yoyogi Park

Collect something
by Robert Bound

Surround yourself with things you admire and you'll feel better and more fulfilled, it's as simple as that. If you've got a penchant for design magazines or ships in bottles, embrace it. Minimalism has had its moment.

In 2016, Sotheby's sold much of the late David Bowie's art collection. The notable thing about it was that it mostly comprised work by less fashionable artists, schools and eras – and none of it was shocking. We shouldn't be surprised. Like any curious collector, Bowie's urge to understand a work or an artist was to attain the sort of intimacy that only ownership can bestow. His collection was honest and deeply personal. It was things that he liked, things that reminded him of things.

Honesty like this is the key to a collection. Collections aren't meant to be tidy résumés. They're not an application letter to the club secretary and shouldn't be a statement of intent. If they are then they're wrong, they're like lying in your diary – who are you kidding? There are some museum-quality collections about which the owners can't stop talking as fans, like these paintings could be sports memorabilia. There are also collections that could've been made by an algorithm, that have been put together like a contractual necessity, the Greatest Hits CD, that have no weirdness, no rough edges, no questionable selections. Collections start as pure interest made actual; they are fascination made concrete, the accidental become material. You can spot the real ones and smell the fakes.

The great artist-collectors can also be surprisingly uncomplicated in their hoards: Warhol and his cookie jars; Hirst and his Walter Potter taxidermy; Peter Blake and his... everything. Collections can be about a desire to see many similar things together or the same thing in different guises – as if to solve the mystery of them, replicate them, marvel at them. What makes us take that pebble from the beach? Keep that archive of *National Geographic*? They're nostalgia mixed with a knowing fooling of the self: that this will come in handy, that you'll refer back to that. At its best, collecting is instinctive, unschooled, innocent.

Liking things is fine but good taste often hinders a collection. The spectre of minimalism haunts private collections gone public and this is wrong. A collection is a collision, not a car but a car crash; so it shouldn't be displayed as if were pristine, with new tyres, for sale. Happily, most people display their treasure troves in their homes, on shelves, in boxes, in bubble wrap in old suitcases. Or they're just pictures, hung on walls – too many, all jumbled up. But you like them that way and you're the boss. They say the key to dancing is to do it like there's no one watching. Bowie might have practised that in the mirror but not the collecting. He did it just because he could.

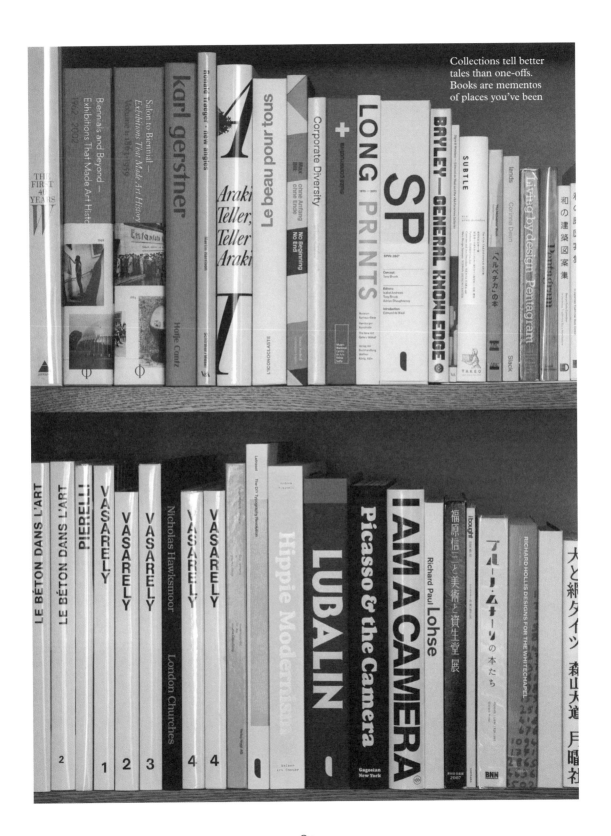

Collections tell better tales than one-offs. Books are mementos of places you've been

Get stuck in
The joy of community

Allotments and community gardens
have long been providing green-
fingered city-dwellers with the
opportunity to tend to their own
patch. Not only do these spaces allow
space-starved urbanites the chance to
grow-their-own but for many they're
a much-needed escape from the crush
of city living. These are peaceful
places to commune with nature and a
chance to get some fresh air and soak
up the sun. They're also vital spaces
for neighbourhoods to come together
and friendships to form over a shared
passion for produce and good grub.

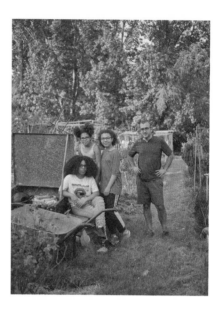

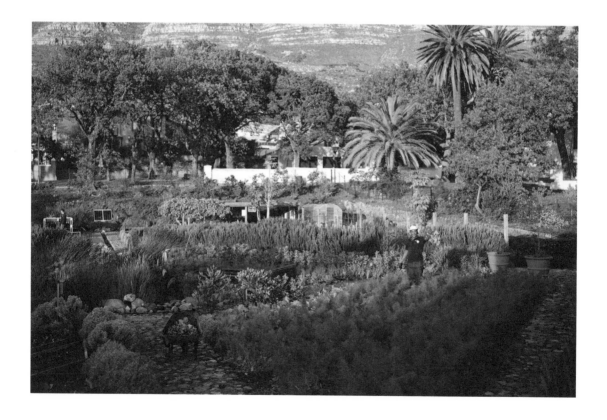

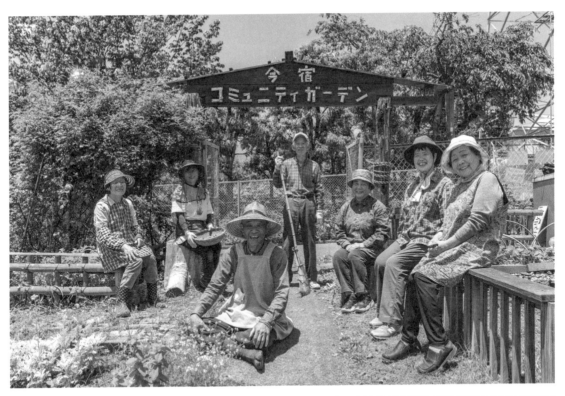

Clockwise from top left: Tariq Khatri and his three daughters at Gun Site Allotments, London; the team at the Imajuku Community Garden in Fukuoka, Japan; Signe Sejlund and Hans Bullitt Fogh take five at their Copenhagen allotment; snipping rosemary from a prime London plot; Table Mountain looms over Oranjezicht City Farm

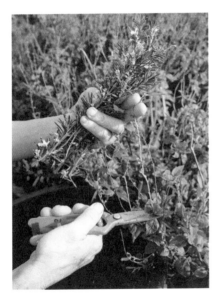

Find your green fingers
Garden variety

So you're ready to transform that barren balcony or bare window sill into the hanging gardens of Brooklyn or Bermondsey? Have you considered what to plant and when? What gear you're going to need and the best kind of vessels in which to sprinkle your seeds? We seek advice from Peter Milne, co-founder of The Nunhead Gardener, a charming garden centre in leafy London.

I.
Window boxes
Plant it here

The first thing to consider before planting your window boxes is how much sun and light they get. "The same as indoor plants, outdoor ones fall into two categories: ones that love a sunny spot and ones that like shade," says Milne. "Do the opposite and you'll just be disappointed because they won't do well."

The Nunhead team recommends something evergreen that won't lose its leaves come winter (the lower-maintenance option that saves a re-planting job when the colder weather comes). Milne's list of crowd-pleasers includes euonymus shrubs, heuchera (a herbaceous perennial), begonias (which flower all summer), plus geraniums and other pelargoniums that love the sun but can hack the shade too.

2.
Seeds of change
Salad days

Is there anything more satisfying than eating something that you've grown from seed? Well, perhaps a couple of things, but salad crops are great to grow and you can pretty much sow them throughout the year – certainly all through the summer. "A lot of them will come up really quickly and you can get quite a few cuts off them and they'll come back," says Milne.

What's more, you don't need rolling fields of space: salad greens can be grown in pots or on windowsills which, incidentally, are a great place to foster a forest of herbs. Milne's choice? "Basil is very easy to grow." Oh, and if you're looking for a splash of colour, there's nothing like sunflowers to bring the cheer.

3.
The undead
Keep the aspidistra flying

Now to the easiest plants to take care of – this one's for you, "forgetful" gardeners. "The top plant that is really un-killable is the aspidistra – its common name is the cast-iron plant," says Milne. "It was popular in Victorian times, surviving despite the fact the houses were dark and drafty, with fires going."

For the outdoors, Liriope muscari (or lily turf) is a hardy grass with "nice blue spikes of flowers that come at the end of the summer and last for a couple of months". Good if your own interest begins to wane then. Milne also likes star jasmine and recommends a few outdoor ferns. "They offer great lushness in exchange for very little care," he says. Treat them like part of the fern-ature.

4.
Bush it real good
Hedging your bets

If you want a little privacy and somewhere for the sparrows to call home, some handsome hedges are in order. "There's a New Zealand native called Griselinia littoralis, which has a broad leaf in a lovely light lime green," says Milne. Aptenia is another bright idea, with reddish flowers that start in the summer and give way to good greenery. Excellent for pollinators, it's great for marking the season's change with a flourish of colour.

More traditional options, such as privet hedges, are easy to shape and train, as is the time-tested yew. And when it comes to a trim? "Be careful not to prune too hard," says Milne, mindful of the clients he's known who hacked too enthusiastically and were left with bald patches.

5.
Tree's company
Grappling with saplings

There's an ancient Greek saying that suggests a society grows great when people with foresight plant trees in whose shade they know they shall never sit. Deep. This image sees trees as a metaphor for our effort and an emblem of hope that the fruit of the labour (or in the case of some trees, actual fruit) will be worth the wait. It's a pleasant idea but the average Athenian garden back then was probably a smidge roomier than city patches today. So be careful where you plant those acorns and ensure there's room for mighty oaks to grow.

"I try to advise customers not to plant a tall tree or too many of them where they'll block the sun," says Milne, who warns of the perils of picking a spot unwisely. Overly large trees inhibit the plants beneath them by sucking up all the water, veiling them from the sun and scoffing all the nutrients from the soil. So think about what you plant. One way to control the height is to keep trees in pots, in which silver birches, Magnolia grandiflora, acers and crab-apple trees do well. Another sure-fire bet that's hardy and thrives in pots is the olive tree. We imagine the Greeks would have approved too.

6.
Gardening gear
Tools you can trust

What kit do you need to keep your garden growing? According to Milne, investing in one of three or four simple items can make all the difference. "Everybody likes a nice decorative watering can and if you want to leave one around I think that's great," he says. "My personal thought, though, is that you're better off with a good, big plastic one so you can water all your plants in one go." Style can compete with substance when it comes to misters too, which Milne explains are great for indoor plants that hail from humid climes but can become frustrating if you have an entire jungle to tend to.

Last up, Milne recommends a decent trowel to help with the re-potting (he favours a stainless-steel model with a wooden handle) and some sharp secateurs too. "Most outdoor plants are going to need some cleaning up at some point," he says. "Dead leaves need cutting off, or if they're perennial then late in winter, before they jump into life, they'll need tidying." So a nice set of secateurs will come in handy – and our pick of the bunch is those made by Gardena (see overleaf – no pun intended).

7.
Best vessels
Container strategies

Hand-thrown and handsome or tidy terracotta? Hole in the bottom or the bigger the better? Milne's rule of thumb when sizing up the seemliest vessel: "For all plants, indoors and outdoors, drainage is key," he says. "No plants like sitting in water." To avoid this, put a layer of gravel or some broken crockery under the soil and make sure the pot has a drainage hole and a saucer underneath it to catch the excess run-off. "Today we generally recommended that people keep their plants in the plastic pots that they arrive in and place them in a decorative pot rather than planting into them directly," says Milne.

Terracotta is the standard but there's no obvious benefit of the material. As long as they're well-drained, your plants will thrive and the material shouldn't affect growth, so you can be free and easy with your decisions. "I did buy some citrus trees for myself and I spoke to the grower and she said to keep them in the plastic pots," says Milne. "I kind of ignored the instruction and put them in something a bit nicer." If the pros can play it fast and loose with the rules then there's hope for the lowliest of home gardeners.

8.
Turf war
Dealing with the grass

OK, enough of the niceties. Sure, gardening is physically and spiritually nourishing but what is it without the bared fangs of rivalry? Take the lawn, or "the grass" as some of us have to call it because of its compact proportions. There we are waving our hose around, trying to make it look a little less like Arizona as our neighbour glances over approvingly. The next day, a sprinkler plays on his grass. Fine. We needed a sprinkler anyway but we can't get the same one so we invest in the sort of thing that the Lawn Tennis Association balks at the cost of. Take that. Or not: it's got too much welly and soaks everything in sight. Our neighbour glances over disapprovingly.

Days go by and Sprinklergate simmers down. Chatting outside, our neighbour arches an eyebrow and very clearly hints that we're growing marijuana on the porch. On the verge of correcting him, we think, "No, that's OK. He'll want some later." Come Friday he's there with some parcel and we offer him a pot with a few scented leaves. We get a thank you and a wink and we've never seen a man happier to be given some Greek basil in our life. Go on, give gardening a go.

Get the gear
What a snip

So you're keen to get your yard in order and tend your borders, baskets and bushes? Well, a few well-made resources will make light work of that for you. Here are some select pieces, from secateurs to a dashing dibber. Can you dig it?

1.
Watering can
by Burgon and Ball

This sturdy five-litre can is made from galvanised steel and finished with a tough powder coating. It comes with a removable, screw-on rose to cover bigger beds more evenly.
burgonandball.com

2.
Twine stand
by Creamore Mill

Fashioned by hand in a woodturning workshop in rural England, this oak design features a built-in blade to cut lengths easily.
creamore.co.uk

3.
Trowel
by Niwaki

Made by a father and son in Niigata, Japan, Niwaki's sturdy trowel is designed for precision planting.
niwaki.com

4.
Dibber
by Creamore Mill

This large, tapered dibber comes complete with gradations for planting seedlings or bulbs at exactly the right depth.
creamore.co.uk

5.
Bulb planter
by Sneeboer

Shove bulbs into beds with ease using Sneeboer's handy stainless-steel number. The company's gardening tools are all hand-forged by craftspeople in the Dutch town of Bovenkarspel.
sneeboer.com

6.
Trowel
by Sneeboer

This fetching trowel has a sharp, stainless-steel head that cuts through soil like a hot knife through butter.
sneeboer.com

7.
Secateurs
by Gardena

Gardena's designs are recognisable for their bright-blue hues. These ergonomic snippers are made in Germany and the team is so certain of their quality that each product comes with a 25-year warranty.
gardena.com

8.
Trug
by Labour and Wait

This London-based shop specialises in practical, well-designed hardware. The trug is no exception: its wooden-handled, lightweight design is good for hauling your pickings indoors.
labourandwait.co.uk

9.
Labels
by Burgon and Ball

These colourful wooden markers will help you tell your clematis from your calendula. The pack comes with a handy pencil so you can mark on the names in your best handwriting.
burgonandball.com

10.
Seeds
by Botanique

Florist and gardening shop Botanique is based in London and it's here that its seeds are packed by hand. The kitchen garden selection includes chilli, mint, basil and thyme.
botaniqueworkshop.com

11.
Plant food
by Botanopia

Keep your greenery looking lush with this organic plant food, made entirely from beet vinasse. Dilute before sprinkling over your plants to encourage healthy growth.
botanopia.com

12.
Seeds
by Labour and Wait

Grow your own veg with these Culinary Quirks seeds from Labour and Wait. The box includes seven different varieties, such as asparagus pea, jersey tree cabbage and drunken woman lettuce.
labourandwait.co.uk

13.
Gloves
by Spear and Jackson

These gloves are part of a collaboration with London's Kew Gardens. Comfortable and durable, they'll protect you from even the thorniest rose bush.
spear-and-jackson.com

14.
Kneeler
by Garden Trading

Keep your knees comfortable while you tend to your patch with this cushioned canvas kneeler from Garden Trading. The brand was founded in 1994 and all its products are designed in the UK studio.
gardentrading.co.uk

15.
Camellia oil
by Niwaki

Made from the seeds of camellia oleifera, this cold-pressed white mineral oil is used widely in Japan for protecting tools from rust. Use it for cleaning your shears and it will form a protective coating.
niwaki.com.

16.
Avocado pit
by Botanopia

This Dutch start-up provides germinated seeds and pits to make it easier for you to grow your own. The avocado pits have been soaked, peeled and set in a warm spot to germinate.
botanopia.com

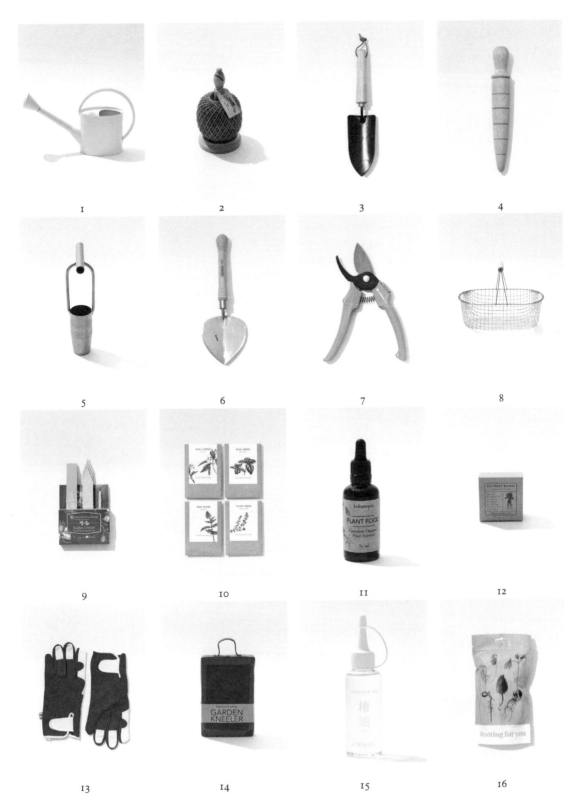

1

2

3

4

5

6

7

8

9

10

11

12

13

14

15

16

Make the most of your patch
Balconies are best

If governments, architects or urban planners wanted to, they could make one affordable intervention to most flats and houses that would improve many people's lives immeassurably: include – or retrofit – some outdoor space. A home can benefit hugely from greenery, natural light and fresh air. Balconies represent semi-social spaces that offer security (in terms of more eyes on the street) and perspective, as well as a little space to unwind, cultivate a few fronds and maybe wave to the neighbours while you're at it.

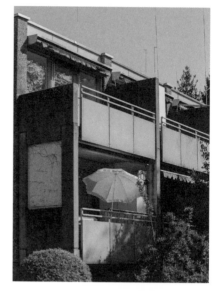

Clockwise from above:
The evening sun on Milanese balconies; taking in the view from an apartment block in Athens; cascading greenery back in Milan

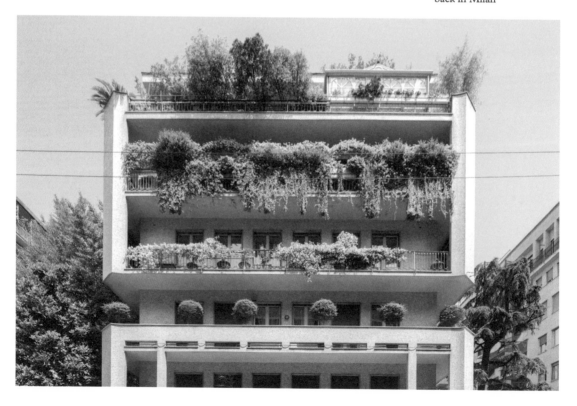

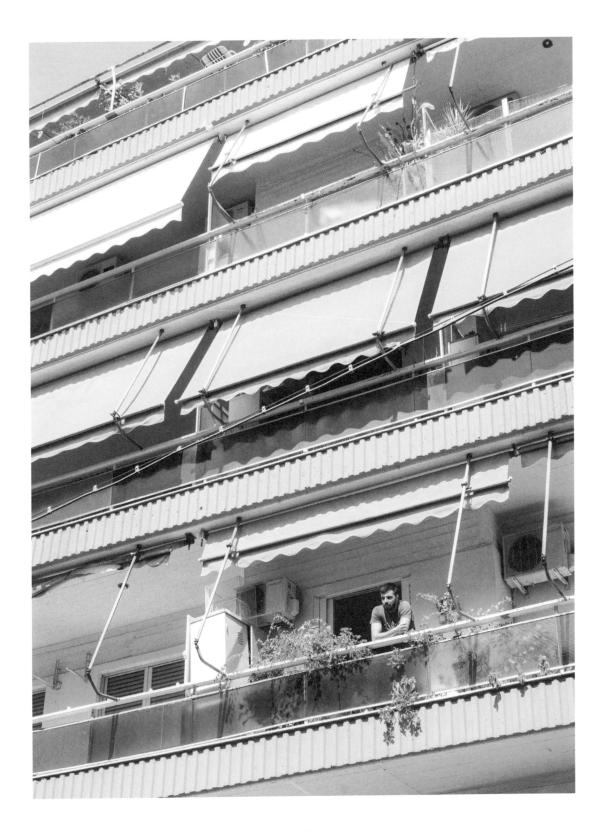

Lastly, have a nap...
Doze off

So you've learned to play the trombone, finished your friend's manuscript, watched a few films and enrolled in a life-drawing class. We've taught you well. And now you must be exhausted. Don't forget to take time for a catnap – this is a guide to a gentler life, after all.

In praise of napping
by Tomos Lewis

Napping can be a mercurial endeavour. It seems, from the outset, deceptively simple: close your eyes, drift off for a targeted period of time, and wake up refreshed and renewed. Eleanor Roosevelt, the former US first lady, swore by napping just before she had an official event to attend or an address to give. Albert Einstein and Salvador Dalí famously pioneered "micro-naps" – falling asleep while holding an object that would slip from their grasp and clang to the floor, waking them up in the process. Those split-second snoozes sharpen the mind, they said.

Advice abounds about the perfect nap. How long should it be? Some say no more than 20 minutes, others say no shorter than 90 minutes, to allow a full cycle of light and deep sleep to unfold. When should you take it? Anytime before 15.00, reports suggest; any later will mess up your night-time sleep. Is it good for you? Yes. Is it bad if you don't or can't nap? No.

The myriad blueprints and nap-related protocols should be taken with a light touch: there is little point in settling down for your allotted snooze only to find that your mind is alive with whether or not you are doing it right. Naps are at their best when they're unintentional: why feel bad when you drift off at the beach or decide to carve up your lunchtime with a short, soft sleep? Choosing to spend a sliver of your day on closing your eyes and getting some rest is a perfectly worthy occupation: why confine it just to the night-time?

'Riposo' time in Rome's Villa Borghese park

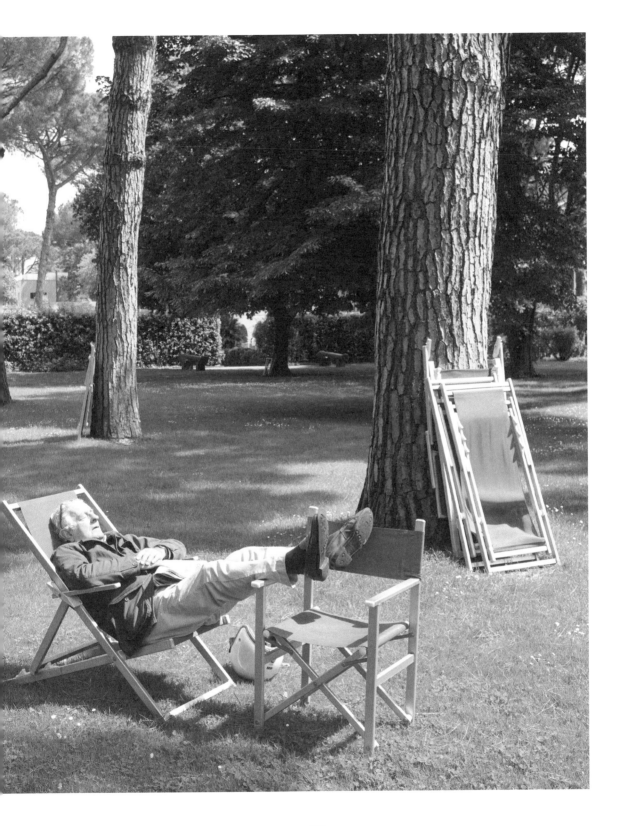

Eat well

On getting back to basics and how
the experience of food can be both
fulfilling and nourishing.

Eat well

Cookbooks say a lot about us. The ones we own and buy hint at our predilections and prejudices, our taste – of course – but also the kind of people we are. Sadly, we're living through a time where food is sometimes reduced to the calorific value it holds – don't make this mistake. What about the power of a meal to transform acquaintances into pals? Or for a market to become a meeting place that binds a neighbourhood? How about the grocery store that vets the food you buy for quality? Knowing where our food comes from *is* important and so is the value of a local restaurant – it makes us happier and healthier. Food nourishes us in ways we can't ignore.

This chapter celebrates the fact that it's nice to eat outdoors, make things the old-fashioned way and entertain at home. These are all gentle interventions that increase our quality of life. There's a reason that the folk who complain about the speed of wifi in cafés will happily wait ten minutes for a drip coffee: we live in a two-speed world. All we need to do is prioritise what we're willing to wait for. So, let's get back to basics and plan a few food-focused improvements.

Back to basics
The simple things

The way we eat is changing and a new bloom of chefs and producers have brought the message of seasonality, simplicity and transparency to the table. We all need to think about the kind of food we want to eat, the waste we're willing to accept and how the whole food system can be a little more nourishing, natural and nice to those who are supported by it. Let's eat.

If there's one foodstuff that shows our collective appetite to get back to basics it's the sudden rise of bread. The daily staple is filling, fulsome and made with inexpensive and widely available ingredients (flour, water, yeast, salt). So far, so unremarkable, but some part of the alchemy involved in getting the time, temperature and rise right has made artisanal bread altogether irresistible. Even as incidences of gluten-intolerance rise good bread has found its way back to the top table. It's not quite a luxury but more an example of how even the simplest aspects of our life can be honed and improved.

The idea of a sourdough loaf was itself a sort of emblem for our editors as we thought about this book and what a gentler life could be. Think of visiting a bakery in the morning, bringing home a still-warm, comforting loaf to enjoy with your loved ones. What about the fact that the baker cared about what went into the bread, took the time to get it right and was paid fairly? Also, doesn't the bakery itself represent a shift back towards community? That's a slice of the good life, all for the cost of a loaf of bread.

Coffee culture
The daily grind

The ritual of a morning cuppa' has become much more than a mug of instant coffee. These bitter beans have been fetishised and fussed over – often by bearded baristas – to the point where they've become an unwitting bellwether of our overall attitudes to what we consume.

Coffee culture is also a sign of the times. Although not yet perfect, transparency and pay for farmers has improved drastically. What's just as intriguing, though, is our behaviour towards it. The upstanding soul who goes to a hip café and moans about the sluggish wifi might happily wait for a drip coffee or for the cinnamon buns to spring from the oven. Remember, we can all choose what's worth waiting for.

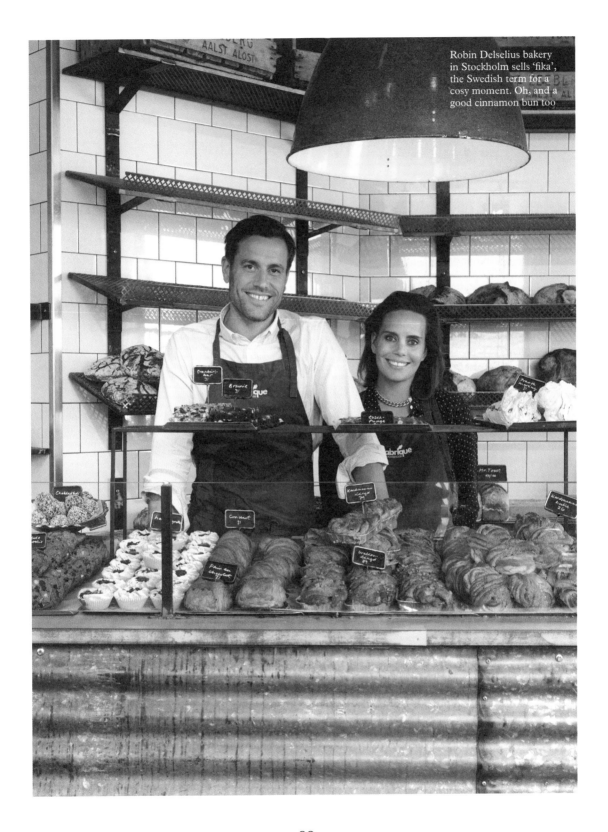

Robin Delselius bakery in Stockholm sells 'fika', the Swedish term for a cosy moment. Oh, and a good cinnamon bun too

Why we need food markets
Basket case

Food markets are almost as old as agriculture itself and they can still anchor a neighbourhood, bring footfall and employment, and make us healthier. To be clear, we're not talking about modish food halls where hipsters pay over the odds for burgers or sink strong cocktails to bad dance music. Instead, the ones we rate offer a year-round reflection of the best seasonal produce from honest and interesting growers.

Whether it's a clearing in a medieval French village that springs into action on a Sunday or a hawker centre in Singapore on a rainy weekday, food markets are theatres of human life that have kept pace with the way we eat remarkably well. What's more, they sum up a way of living – and eating – that can make us happier and healthier. They speak of knowing where your food comes from (knowing your onions as well as the man who sells them to you) and also of a more immediate relationship with our food and the people who produce it. Vegetables that arrive with a little soil on them show a shortness of supply chain that few supermarkets can offer.

Helsinki is a city that recognises its inheritance when it comes to markets. Over the past decade it's ploughed money into reviving its old halls and making sure time-tested traders come back after the re-fits as well as making spaces for small new businesses to cut their teeth. Food firms have attracted customers and created vitality in areas where traditional retail has found it tough, and in this sense markets have a dual purpose: feeding us, yes, but also keeping the shared bits of our cities lively and interesting to inhabit. This is one benefit that's not worth haggling over.

FIVE FINE FOOD MARKETS

1.
Vanha Kauppahalli, Helsinki: Helsinki's oldest market hall houses delis, cheesemongers, butchers and cafés galore.

2.
Hamburg Fish Market, Hamburg: Filled with locals bartering over fresh herring and revellers refuelling after a night out.

3.
Carriageworks, Sydney: A weekly farmers' market in a former rail complex.

4.
Grand Central Market, Los Angeles: Find the finest street food at this downtown landmark.

5.
Mercado Municipal de Silves, Silves: The Algarve's freshest produce.

Bye to 'the big shop'
An ode to deciding daily

One curious phrase that's slipped out of everyday parlance is "the big shop". The concept of buying *everything* you're going to eat for a week, maybe a month, in one fell swoop and usually at a single shop.

In many cities, however, our routines are shifting from that of the hoarder to something more akin to a hunter-gatherer. Something from the fishmonger tonight and the bakery in the morning? An impromptu stop at the grocer's for two ingredients on the way home? No problem at all.

Are we more impulsive than before? Maybe. Worse disposed to supermarkets? A little. Less organised? Perhaps. And what are you having for dinner, again? That's the beauty – we don't need to decide until later.

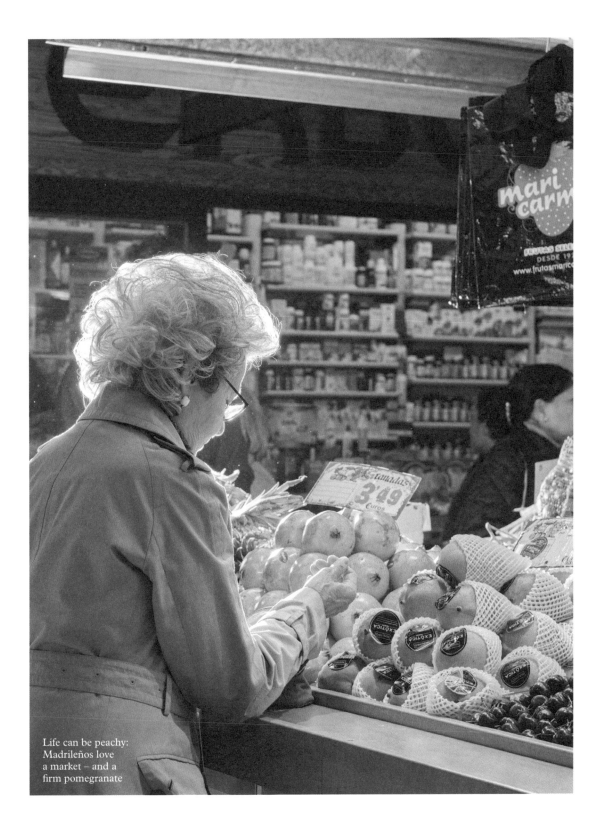

Life can be peachy:
Madrileños love
a market – and a
firm pomegranate

Dining alfresco
Eating out

Whether you're lucky enough to frequent a Beirut beach club, Italian 'bagni' or Viennese 'Heuriger', there's something fulfilling about eating and drinking outdoors. So even if you find yourself dodging the raindrops at a picnic or slapping on the sunscreen at a barbie, remember to digest what's around you as much as what's in front of you.

The German word *Gemütlichkeit* isn't easy to translate – or for that matter as painfully over-used as the Danish word *hygge*. Both denote a sense of deep comfort, ease and hospitality that both countries excel at and which all hosts aim to impart on their guests.

Here's an example. In the city wineries (or *Heuriger*) dotted around Vienna there's a peculiarly homely ritual that seems to sum up the German version of the word. At these simple, seasonal taverns locals loaf under trellises to sip grüner veltliners and rieslings overlooking the terraced vines below. Eating and drinking outside at its best. *Gemütlichkeit* with a side of fresh air and friends – nothing fancy or hifalutin.

At Monocle we've spotted the transformative power of feeding alfresco in reporting from the beach clubs of Izmir to the beer gardens of Munich or the *botecos* of Rio. It's really about being in the moment – rain or shine – whether that's with the warm Aegean lapping at your feet, the Mistral whipping through the cypress trees or a summer rain interrupting your best-laid plans for a picnic in the park. All offer escapes from a life lived indoors and by the clock. So, go on, take to the terrace, order another glass and aspire to the untranslatable. That's *Gemütlichkeit*: get it?

Picnics
Take it easy

As the mercury rises, scenic spots the world over are besieged by an unusual tribe. These relentlessly optimistic (and usually hungry) souls are hell-bent on one thing: that age-old and gloriously idle pursuit of the summer picnic.

Some come armed with cool bags, blankets and stools but it's always the spontaneous and laissez-faire sorts who look like they're having more fun. This no-frills brigade is wise to the fact that the best picnics are less about culinary posturing and more about a down-to-earth experience. Because the allure of the picnic lies in its offer of an increasingly rare kind of freedom: being in the great outdoors with your nearest and dearest, away from the demands of your laptop.

Clockwise from top left: A doughy pretzel, Bavarian-style; lunch by the lake in Munich; an ice-cold 'stein' in a Munich beer garden; lapped by the Med at Pierre & Friends in Batroun, Lebanon; fun with friends, food and wine at one of Vienna's many 'Heuriger'

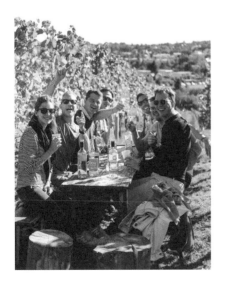

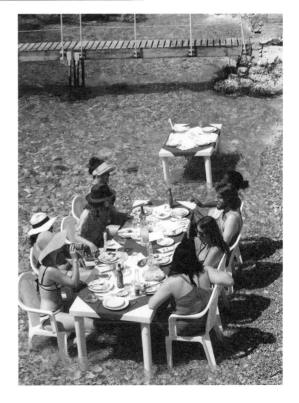

Neighbourhood restaurants
Top tables, close at hand

The best restaurants don't need to beat you over the head with a 'concept', bore you with finicky service or pick your pocket to pay for their pretentious revamp. Instead, they should always have a table, know your name and be a boon to the community they serve. We celebrate the local, the lively and the – happily for us – overlooked.

The news that Café Comercial, a beloved Madrid bar that had served the city since 1887, had closed its doors was as sudden as it was sad. At the time people plastered heartfelt messages onto its façade and, across the patchwork obituary, regular customers likened it to having a room in their homes boarded shut. A citywide debate raged about the future of Madrid's age-old bars, cafés and *tabernas* – and luckily Café Comercial was revived.

In insatiably social Madrid, *tabernas* are a locus of life. A synthesis of an all-hours drinking den and casual restaurant, they work like homely mess halls where traditional fare is plentiful and beer, wine and *vermut* are sipped quickly. Be they retirees reading the paper, rowdy youngsters or workers in impromptu meetings, every facet of city life swirls together with ease. For Madrileños, tabernas are the communal table laden with life's best ingredients: talk, togetherness and tasty food. This is what a neighbourhood restaurant does best.

From Lisbon's lively *tascas* to Melbourne's milk bars, there's a pleasing move away from destination dining and star chefs towards meaningful interactions and friendly unpretentious service. The usual? Yes please.

The art of oversharing
Keep it to yourself

Sharing is one thing if you're giving someone a taste of your main, and quite another if the food's getting cold while you photograph it. Far from being a place in which to escape with a friend, lover or confidant, some restaurants are increasingly settings for impromptu photoshoots.

So in this era of free marketing as restaurants court customers for clicks and strive to be "liked", it's worth finding somewhere a little discreet and then quietly keeping it to yourself. The kind of place where you can feed without being on someone's feed. Now, are you going to finish that?

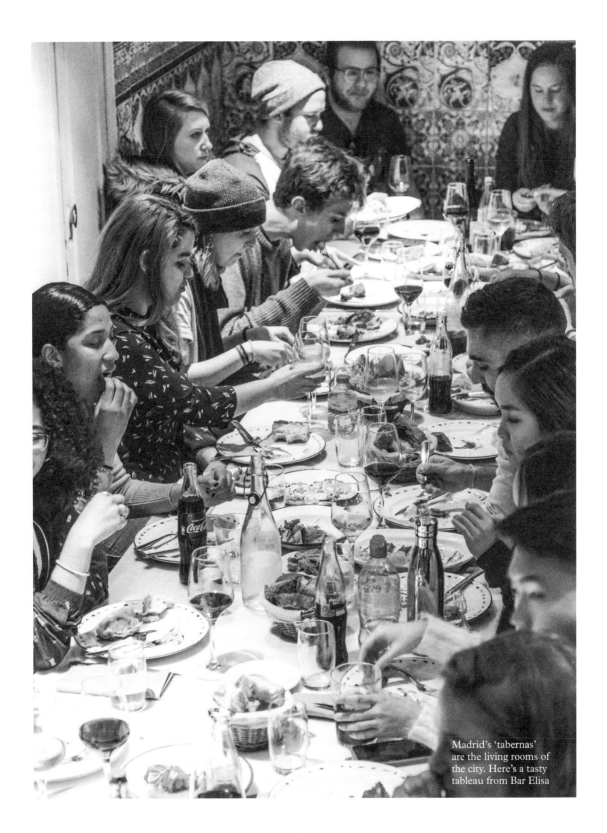

Madrid's 'tabernas' are the living rooms of the city. Here's a tasty tableau from Bar Elisa

Food businesses we admire
Flavourful firms

Ever considered quitting the day job to write about food? Or perhaps you want to bid farewell to the office entirely and start farming, fermenting (things) or flogging fruit and veg? Even if you're not personally considering the good life just yet, these businesses are key to connecting us to good food that's ethically made – often the old-fashioned way.

1.
Sumac magazine
New York

Launching a print magazine about food is tricky: it's a heavily covered topic and a more-than-challenging medium. But Turkish journalist Ali Tufan Koc thinks he's found the recipe for success. He launched the inaugural issue of quarterly food title *Sumac* in 2019 with an investment of €12,000 and a 5,000 print run. Instead of focusing on plates of food or recipes, he uses it as a platform for more profound writing. "Society is more polarised than ever," he says. "I'm interested in food as a tool to create a dialogue."

Over the course of the first issue, *Sumac* – named after the Middle Eastern spice – breaks bread with Hasidic Jews and performance artist Marina Abramovic. But there are also plenty of humorous titbits and lip-smacking photography. Koc has rightly spotted that readers are yearning for something slower and more cerebral – after all, food is nourishing in more ways than one. This is a magazine that celebrates taking a gentle approach to the things we consume.
sumacmagazine.com

2.
Taste Lebanon
Beirut

Back in 2009, Lebanese-American cook Bethany Kehdy came up with an idea: to introduce friends to Lebanon through a seven-day "food trek", challenging images of an unsafe war zone through rosewater ice cream, backstreet bakeries and Armenian restaurants. "Food was the way you broke the barrier with people," says Kehdy.

She launched Taste Lebanon in 2010 and now runs more than 500 tours a year, mainly from the UK, Ireland, the US and the Netherlands, although there's also growing interest from as far afield as Hong Kong and Indonesia. It wasn't always straightforward. "Lebanon is not the most entrepreneur-friendly place, even though we are very entrepreneurial people," she adds.

With a core market of Lebanese expats, she has expanded her offerings to include shorter tours. The most popular is Beirut Bites, a day-long jaunt around the capital. Security improvements mean there are now opportunities in other cities too, including Baalbek, renowned for its Roman ruins – and ruinously good pastries.
tastelebanon.co.uk

3.
Vinegar Shed
London

Since launching his company in 2017, Andy Harris has built up a line of more than 80 vinegars by small, traditional producers. He now sells to everyone from deli owners to Michelin-starred restaurants, winning his brand, Vinegar Shed, a whopping 36 Great Taste awards.

It may seem like a quick turnaround but this was no overnight success: the idea had been bubbling away for 30 years. It began when Harris, then a food writer, bought his first vinegar pot from a flea market in France. Ever since he had been scouring the world for the best produce.

As a result Harris has become an expert in sourcing little-known producers of the highest standards. "I've been using vinegars from France's Banyuls region for 20 years but no one was selling them in the UK," he says. He also sells salt, oils, spices and his own vinegar. "Vinegar Shed is about bringing things that aren't available here and introducing them to like-minded people."
vinegarshed.com

4.
Vegeo Vegeco
Tokyo

Soichiro Hirabayashi had ambitions of becoming a farmer but ended up selling vegetables instead. In 2013 he founded Vegeo Vegeco, a website selling organic produce from the sun-drenched island of Kyushu: heirloom aubergines, Swiss chard, green papaya and more, all grown by 300 families.

The Vegeo Vegeco website shines a spotlight on the farmers, telling their stories alongside those of the produce they grow. In 2017, Hirabayashi launched a small vegetable stand in eastern Tokyo, conceived by interior design firm Wonderwall,

and the company also has a distribution centre in Tokyo to handle deliveries. "We collect daily from farms and deliver directly to consumers," says Hirabayashi. "They specify a one-hour window and we bring it to their door." Bypassing farm co-operatives means misshapen vegetables aren't thrown away for not meeting industry standards.

And now Hirabayashi has even realised his early dream of farming by borrowing idle land in Miyazaki. "Japan needs young people who want to be farmers," he says. "With our own farmland we can train a new generation."
vegeryorganics.com

5.
Salmarim
Castro Marim

Not many entrepreneurs make a mark on a business by reducing its output but that's what salt-maker Jorge Raiado has done with Portuguese brand Salmarim. When he joined the business in 2007 the company's annual production of its premium *flor de sal* (sea salt) was 11 tonnes; today it turns out between six and seven. "I wanted to focus on quality rather than quantity," he says.

Salmarim's salt, which is hand-harvested in the Algarve nature reserve of Castro Marim, is among the purest you'll find, with crystals that melt on the tongue. Raiado invites chefs to take part in the harvest. "Understanding the process helps them understand the quality and they give us important feedback too," he says. The company's cork packaging emerged from these collaborations. "We needed protective packaging that the chefs could use in the kitchen but we wanted to avoid plastic," he adds. The environment is important to the company: its base is free from industrialisation and pollution. "The place is ours but it doesn't belong to us; we are protecting it for the future."
salmarim.com

The world of wine
Drink it all in

What could be gentler than a glass of something to end the day? The past few years have seen shifts from industrial processes towards smaller, more experimental and characterful creations that work with rather than against nature. We all know about the boom in craft beer (some bad, some good) and how gin also got going. But what about wine's unusual about-turn?

Sandwiched between Champagne to the north and the Rhône valley to the south, Burgundy has long been shaped by the wine trade. Driving south of Beaune in the late-summer heat and past the jasmine-covered dry-stone walls that flank the road to the village of Pommard, it's easy to see why this patch of France is an attractive place to live and work.

Understanding a region that's dotted with prestigious *domaines* (châteaux are so Bordeaux) is a simple lesson in economics: demand for wine from here easily outstrips supply, prices are lofty and there's a scarcity of space to make the stuff. But things are changing.

Today there's something stirring in the soil and a new crop of vignerons, experimenters and offshoots are trying new things. Many of these upstart winemakers came to Burgundy from further afield – Japan, Australia, the US and Germany – to make the most of the famous terroir and learn from it. The fact that even here, in the bastion of old-world wine and time-tested tradition, there are green shoots of hope for organic, small-scale and unexpected producers is testament to how practices are changing. Cheers to that – and to the delicious wine with which they're filling, and refilling, our glasses.

Alcohol free?
Sorry, we didn't catch that

For better or worse, there's a move towards alcohol-free "spirits" and mocktails. Maybe we're just jealous that we didn't have the gumption to sell fruit cordial at €25 a bottle. Drinking less is fine and dandy but we still think there are certain events that will diminish if they go dry altogether.

Why change the rules of engagement? Whether you like it or not, some social occasions still very much thrive on a little lubrication. Without alcohol, for instance, weddings as we know them wouldn't be as fun, work parties would lack some lustre and you'd never have rumbled that office romance. It's all about some gentle moderation. Cin-cin!

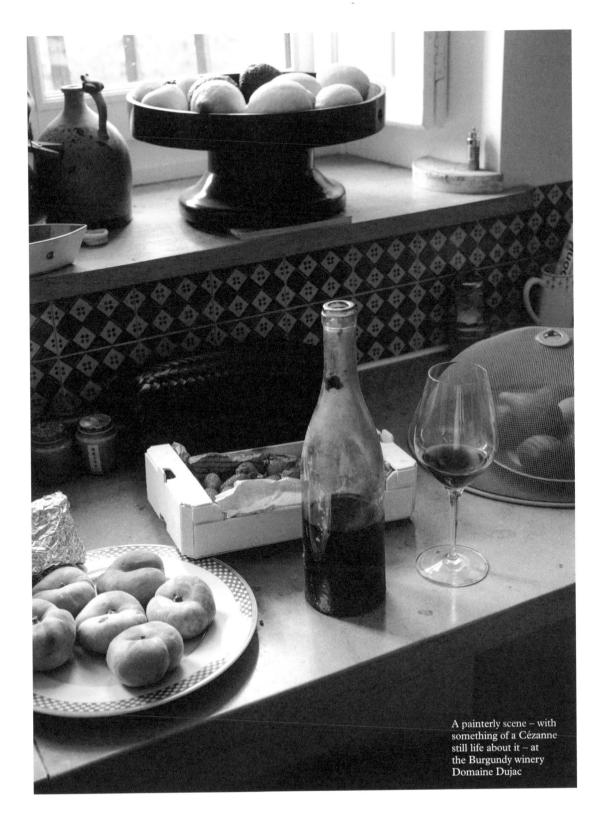

A painterly scene – with
something of a Cézanne
still life about it – at
the Burgundy winery
Domaine Dujac

Q&A with Darina Allen
The woman fixing our food habits

Irish TV chef and food writer Darina Allen has trained generations of chefs at her Ballymaloe Cookery School but fears a loss of skills in the kitchen. She talks public health, the perils of oat milk and the ongoing agrarian revolution.

For more than three decades Darina Allen has been tempting would-be chefs and curious food folk from around the world to a single bucolic corner of County Cork in her native Ireland. The lure? Her world-famous cookery school Ballymaloe, which has trained generations of international chefs and food entrepreneurs from home and abroad. Her mission? To change our relationship with food, farming and the land for the better, one step at a time.

Has the farm-to-fork movement changed our attitude to waste and given us better food?
Sadly not enough has changed because the message nowadays is that academic skills are important but practical skills aren't. We've let at least two generations out of our houses and schools without equipping them with the life skills to feed themselves, which feeds right into the hands of the multinational food companies. We've handed over complete control over the most important thing in our lives really: our health.

What's the first recipe you share with students who attend your three-month course?
Compost. I introduce them to the gardeners and the farm manager, and maybe I'll have a bunch of

carrots or something. I say, "Look at these lovely carrots. It took Eileen the gardener three months to grow these carrots so don't you dare boil the hell out of them." Eileen will have a wheelbarrow full of soil – I run my hands through it and I say to them, "Remember, this is where it all starts." I have to shock them out of thinking that food is something that comes wrapped in plastic off a supermarket shelf.

How has science helped us understand that relationship with food better?

There's been an enormous amount of work done on the link between the health of our gut and our mental and physical health. For the past five, six, seven [cookery] courses we've had at least one doctor, sometimes two; at the moment we have three doctors on the 12-week cooking course. These are medical professionals who tell me that they feel there isn't enough training in nutrition but who are now demanding the proper information so they can answer their patients' queries properly.

How do you account for the rise in gluten and dairy alternatives?

There is so much misinformation. There is a sort of desperation and huge confusion. People are trying to make sense of all the different advice. There's such emphasis on the plant-based diet now but the real problem is the whole cheap-food policy. There's no such thing as cheap food. In health terms, in socioeconomic terms, it's a complete and absolute disaster.

No oat milk in that flat white then?

I just want whole milk, please. If you go in for a coffee you've got this big, long spiel: "Do you want soy milk, coconut milk?" No. Just the real deal. That's what we all need but it's so hard to find.

Catering for kids
Cookery class

In a residential area behind Tokyo's busy Ebisu Station, Kageoka no Ie (House in Kageoka) is a home away from home. The five-floor set-up is a non-profit community centre funded by public money but run by the private sector.

Once a month it hosts Kids' Canteen, which sees schoolchildren ready themselves with a bandana and apron in the kitchen upstairs. On that evening they will be cooking their own dinner with the help of staff, mothers and volunteers. It's not just parents who are getting on board: like-minded chefs join several sessions too. "Opportunities like this change children's perception of food," says Rieko Teramoto, director of innovative vegetable shop Vegeo Vegeco (*see page 107*).

The simple act of eating around the family table has become a luxury for many busy Tokyo residents. Japan's famously punishing work culture makes striking the balance between time and cooking with kids tough – but wherever we live we should aspire to teach children the joy of cooking and some of the skills they'll need in later life. There's a takeaway for you.

Easy recipes
Fail-safe food options

Committing a few recipes to memory is a great way to build up your culinary repertoire – and your friends and family won't mind a few imperfections either. Making healthy(ish) food from scratch is excellent for entertaining and in this vein, Swiss chef Ralph Schelling offers these recommendations that are easy to follow, hearty and rewarding.

1.
Crab toast with lemon aioli

1 garlic clove, diced
3 tbsps olive-oil mayonnaise
1 lemon
4 slices of bread
5 tbsps olive oil
350g cooked crab meat (white and brown)
Bunch of chopped dill
Toasted chilli flakes
Salt and pepper

1. Preheat the oven to 175C. To make the aioli, add the diced garlic to the mayonnaise along with the juice of half a lemon and the grated zest, then set all of that aside.
2. Brush the slices of bread with olive oil and put them in the oven on a baking tray until they're crisp (about 10 minutes).
3. Season the crab meat with the remaining olive oil, salt, lemon juice, dill and toasted chilli flakes.
4. Spread the spiced crab meat evenly on the toast, add the few remaining drops of lemon juice and salt and pepper to taste, and serve with the lemon aioli.

2.
'Tamago sando' (egg sandwiches)

8 eggs
3 tbsps soy sauce
2 tbsps mirin (sweet rice wine)
2 tsps peanut oil
8 slices of bread
1 tsp mustard

1. Lightly beat the eggs and add both the soy sauce and mirin.
2. Brush a non-stick pan with a little oil, then heat it up and add some of the egg mixture. Flip the omelette and push it over to the edge of the pan, before adding more of the egg mixture and folding the existing omelette into the new one. Repeat this whole process four or five times to make a total of two omelettes. Cut each of them in half.
3. Toast the bread and spread it with a little mustard. Place the omelettes on top to make sandwiches. Trim off the edges of the toast, cut the sandwiches in half and arrange on plates. Best enjoyed lukewarm.

3.
Rigatoni with pistachio pesto and sun-dried tomatoes

50g pecorino cheese
1 garlic clove
25g basil
70g roasted pistachios
6 tbsps olive oil
500g rigatoni
150g sun-dried tomatoes
1 tsp pepperoncini (chilli) flakes
Salt and pepper

1. For the pesto, grate the pecorino and dice the garlic finely. Pluck the basil leaves. Purée everything with the addition of the pistachios, a pinch of salt, a good grind of pepper and the olive oil.
2. Cook the pasta in boiling, salted water until al dente (a minute or two less than the packet advises if it's dried pasta). Drain. Keep 150ml of the cooking water.
3. Mix the pasta with the pesto and the water, season and arrange on plates. Serve topped with sun-dried tomatoes and pepperoncini flakes.

4.
Baked plums with orange and mascarpone ginger crunch

8 plums
Juice of 3 oranges
2 cinnamon sticks
1 star anise
1 vanilla pod (seeds removed)
1/4 tsp cardamom powder
100g ginger biscuits
180g mascarpone

1. Preheat the oven to 180C. Halve the plums (and remove the pits). Put them in a pan with orange juice, cinnamon, star anise, vanilla and cardamom. Cover and bake in the oven for about 25 minutes. Turn the plums in the liquid and bake for another 25 minutes until the pulp is soft and the skin shrivels.
2. Crumble the biscuits until they form large, uneven crumbs. Next, mix the biscuits with the mascarpone.
3. Arrange the plums on a plate and serve with the spiced orange juice and the ginger mascarpone crunch.

5.
Sunday brioche

800g strong white
 bread flour
35g fresh yeast
300ml milk, lukewarm
4 tbsps white sugar
2 tsps salt
350g butter, soft
4 eggs

For the egg wash:
1 egg yolk
20ml milk

1. Combine the yeast,
 milk, sugar and salt
 with the flour. Knead for
 five minutes until elastic
 and glossy.
2. Cover and leave to
 rise in a warm place
 for 30 minutes.
3. Add the butter, bit by
 bit, and the eggs, one
 at a time, to the dough.
 Knead for another five
 minutes or mix in a
 food processor with
 a dough hook.
4. Cover and leave to
 rise in a warm place
 for 30 minutes.
5. Grease the loaf tin
 with butter and add the
 dough, then leave to
 rise (for the last time)
 in a warm place for 20
 minutes. Preheat the
 oven to 180C.
6. For the egg wash, mix
 the additional egg yolk
 with milk and apply
 it to the top of the loaf
 with a pastry brush just
 before it enters the oven.
 Bake for 45 minutes and
 leave to cool in the tin
 before turning out and
 tucking in.

6.
Panzanella (Tuscan bread salad)

1 red onion
1 garlic clove
1 chilli
300g day-old
 farmhouse bread
150ml best-quality olive oil
600g tomatoes
1-2 tbsps white balsamic
 vinegar or lemon juice
85g basil
4 small burrata (optional)
Salt and pepper

1. Preheat the oven to 170C.
 Peel the onion and cut it
 into fine strips. Dice the
 garlic and chilli. Cut or
 break the bread into large
 pieces and mix it with
 the onion, garlic, chilli
 and half of the olive oil.
 Spread the mixture on a
 tray and bake for about
 20 minutes or until crisp.
2. Remove the onion, garlic
 and chilli and put them in
 a bowl. Turn off the oven
 but put the bread back in
 so it stays warm.
3. Mix a third of the
 tomatoes with the salt,
 pepper and balsamic
 vinegar (or the lemon
 juice) and blitz in a
 blender along with the
 remaining olive oil to
 create a dressing.
4. Cut the remaining
 tomatoes into bite-sized
 pieces and mix with the
 tomato dressing and
 bread. Season with salt
 and pepper and serve
 with chopped basil and
 the remaining olive oil.
5. Serve as you wish, with
 or without burrata.

7.
Mussels with garlic breadcrumbs

100g breadcrumbs
1/2 pepperoncini (pepper)
2 garlic cloves
25g parsley
1.5kg mussels
8 prawns (with heads on)
100ml white wine
Half a lemon, sliced
6 tbsps olive oil
Salt and pepper

1. Preheat the oven to
 180C. Break the bread
 into 1CM pieces. Mix
 with half the oil and
 the sliced pepperoncini
 and garlic on a baking
 tray lined with baking
 paper. Roast in the
 oven for 15 minutes.
 Remove, cool and add
 parsley. Season to taste.
2. Clean the mussels
 and fry in a pan in
 the remaining olive oil.
 Add the prawns to the
 fried mussels, then the
 white wine, and cook
 covered for five minutes.
 Discard the still-closed
 mussels and, again,
 season to taste.
3. Arrange the mussels
 with the stock in shallow
 bowls. Scatter with
 breadcrumbs to serve
 (with a slice of lemon).
 Simple, eh?

8.
Fluffy pancakes

200g flour
1.5 tsps baking powder
1 vanilla pod, seeds removed
200ml milk
3 eggs, separated
2 tsps lemon juice
1 tsp salt
3 tbsps sugar
2 tbsps butter

To top it off:
Icing sugar, compote
or fresh berries, and
maple syrup.

1. Mix the flour, baking
 powder, vanilla, milk,
 egg yolks and lemon
 juice into a smooth
 batter. Beat the egg
 whites with salt until
 they're half-stiff, then
 gradually add the sugar
 and continue beating
 until the mixture is
 glossy and starts to shine.
 Fold the egg whites
 carefully into the batter.
2. Heat the butter in
 a non-stick frying
 pan. Add about two
 tablespoons of the batter,
 cover and bake over
 a low heat for about
 five minutes until the
 underside of the pancake
 is stable and golden
 brown, then turn it over
 and cook for a further
 five minutes.
3. Add butter, compote
 or fresh berries and a
 sprinkle of icing sugar
 – and don't forget to
 put the maple syrup
 on the table for extras.

The power of provenance
Go to where it grows

One major breakthrough for food has been recognising the importance of provenance – and that doesn't mean knowing the plane your shellfish arrived on. Connecting with the story of the produce you eat can make both cooking and eating it a richer experience. Here are three food hubs with provenance by the sack, shovel and shopful.

I.

Far from the madding crowd
Ojai, California

Ojai, a rural community an hour north of Los Angeles, is boxed in by the mountains of the Santa Ynez range. Arid, desolate valleys surround it and, in summer, temperatures can soar to 38c. But amid the scorching heat there's a peculiar lushness and a passionate food community.

It's hard to explain Ojai (pronounced "Oh-hi") without a nod to its colourful history with spiritual blow-ins. In the 1920s many were lured by the climate. Indian philosopher Jiddu Krishnamurti decided to make his home here and started a ripple effect that attracted author Aldous Huxley and even Charlie Chaplin, who would dash up from Hollywood for a spiritual session with the master. Once they got an eyeful of the rolling hills and pleasant orchards, it made sense to stick around.

"Southern California has a history of alternative food," says Steve Sprinkel, co-owner of Farmer and the Cook, a veggie-first restaurant in Meiners Oaks (Ojai's west end). "You have a century-old tradition of health nuts such as Paul Bragg and Buster Crabbe coming to the area," adds the farmer, referring to the health-food

mogul and 1933 Tarzan actor respectively. When Sprinkel founded the business with his wife Olivia Chase, a chef from Ventura, in 2001, they had a hunch that their model – a grocery store with an all-organic restaurant – would take off. Today the restaurant, housed in a 1947 food shop on West El Roblar Drive, is responsible for 60 per cent of the business's revenue.

Entering Farmer and the Cook is like walking through the left-ajar back door of a close friend's home. Mismatched hessian sacks are available for loose produce and the shouts of children compete with the whirr of smoothie blenders. Servers race between the small deli area at the front of the shop and the shaded patio, where a pianist chimes in most afternoons.

Part of the appeal is the array of characters you meet along the main street, and the energetic staff at Farmer and the Cook reflect the area's eccentricity. Sprinkel, a commanding figure with a shock of white hair, has a knack for training young farmers such as fresh-faced Luca Cuvelier (*pictured*), who tends the vegetable patch up the road from the restaurant. He moved here from New York in 2018, at 21 years of age and without knowing a soul – but he feels he's landed firmly on both feet.

2.
Unexpected haven
Tasmania

"Imagine a beautiful day like this: you're walking along the beach, the ocean waves crashing against the rocks and sea mist in the air," says George Burgess (*pictured*), the owner of Tasmania's Southern Wild Distillery. We're in the town of Devonport and he's pouring what will be the first sip from a tasting flight of Southern Wild's Dasher + Fisher gins. Burgess is encouraging his visitors to imagine they're somewhere else, taking in the Tasmanian landscape. Drinkers are whisked off to a crisp alpine crest with a sip of mountain gin with native pepperberries.

Burgess worked in the dairy industry for 20 years but lost his passion for creating a product that he felt didn't leave room for imagination. When he released his first gin in 2017, he vowed to do things differently. "Gin allows me to be creative and show off Tasmania," he says. "Regionality, building terroir into a spirit and shining a spotlight on the growers. That's what really resonates for me." Clearly his faith wasn't misplaced.

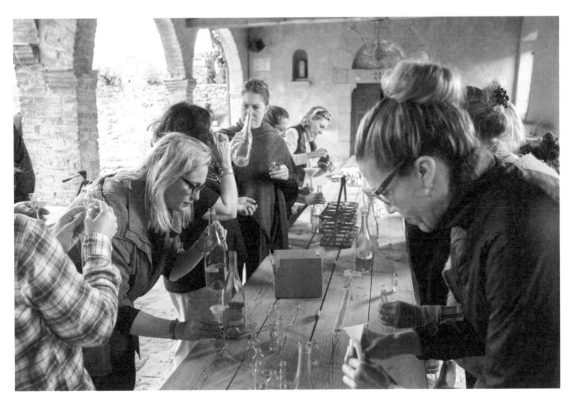

3.
Back to the land
Potentino, Italy

Rising above the unspoiled wilderness of southern Tuscany, Castello di Potentino dominates a silent emerald valley. The taming hand of humans is visible only in a few ordered vineyards and olive groves. But a little less than two decades ago the soaring stone castle, with foundations dating back 1,000 years, was in ruins. That was until Londoner Charlotte Horton, a self-confessed former punk, now a vintner and rural evangelist, turned the castle into a destination for aspiring and like-minded agrarians.

It's here on a hilltop in central Italy that many middle-class, white-collar city slickers have flocked in the hope of feeling closer to the land, to cook, drink, dig and cultivate before heading back to their laptops. Even if you never dig a ditch or turn a plot of land into a productive field of food, you can appreciate it. Of course life in the sun with dirt under the fingernails isn't for everyone. But we can raise a glass to those who have enough of Horton's punk spirit in them to try it – even once.

Essays

Why cities need a gentle steer, how to rethink your job and what can be achieved in an hour, plus more.

Essays

We're better connected than ever before but we feel further apart. The flash and flicker of email updates and bad news bulletins are relentless. Although most of us don't pass our time in imminent danger, there is an unhelpful background anxiety to modern life that's fed by a stream of messages, self-imposed deadlines and our tendency to give ourselves a hard time. In other words, we need to take back some control.

This could mean carving out more time to daydream or sleep, to make things or consider how small changes can yield bigger shifts in our attitude, behaviour and how we think about the world around us. Is it time for a gentle manifesto for building better cities? What do the recipes we cook say about us? What are the simple things we should make time for? First, forget the worrisome, Sisyphean task of emptying the inbox or "doing" the to-do list. Instead, take a few minutes to read our essays on fruitful fixes, taking time for yourself and forging some meaningful connections.

Essays
Gentle musings

1.
On analogue pleasures
by Andrew Mueller

As mobile phones and the internet become ubiquitous and our attention spans shrink, there's still value in switching off to focus on life's simplest pleasures.

The theoretical redeeming consolation of middle age – terms and conditions apply, your mileage may vary, etc – is the trade that you have made of some of your allotment of years for a reservoir of wisdom. But if you're middle-aged right now – say, 45 or older – you are among the final generation of human beings who possess one particular kind of wisdom. You are one of the last people who will ever live who will truly understand the feeling of being out of touch.

This is not, it should be stressed, "out of touch" in the sense of not liking any of the music on the radio, or being baffled by the young people with their hula hoops and yo-yos and whatnot. It's out of touch in the sense of being unavailable, uncontactable, untraceable – and of that unreachability being the default. As recently as 1993, I did a longish backpacking slog beginning in Helsinki and finishing in Tel Aviv. There were stretches of weeks during which nobody I knew had much of an idea where I was or any ready means of contacting me. This was, at the time, just how things were. Attempting to replicate the trip now, shunning smartphone and internet, would be widely interpreted as an act of whimsical eccentricity at best, catastrophic mid-life crisis at worst.

Worse even than that, it would just be plain daft, as making things unnecessarily difficult generally is. It is good, obviously, that communicating and accessing information has been made so easy. But it has also offered us a challenge to which, perhaps, we have not yet quite risen.

Humans – especially those alive since the Industrial Revolution – have a tendency to quickly begin taking marvellous technological innovations for granted. This is probably necessary, else we'd lose half of most mornings boggling that we have a magic lever in our kitchens which produces fresh water, just like that, and an enchanted jug

which boils it in seconds. But because we don't think much about the technology, we don't think much about the effect it might be having on us. Where modern communications technology is concerned, this may be because we'd prefer not to. It has lulled us into dependency, and rendered our discourse brusque: it has both softened and coarsened us.

We generally require little in the way of shepherding down the path of least resistance. This is why people now mostly listen to music on delivery systems that sound objectively worse than vinyl, or even CD or MP3, why a great deal

Show your phone who's boss: leave it at home. Unless you are in fact commanding an army at war, you almost certainly don't have anything to say that can't wait until later.

of reading gets done on screens rather than pages, and why the semi-coherent tweeted blurt has defined the tone of public conversation. Were Abraham Lincoln to deliver the Gettysburg Address now, a masterpiece of economy though it is, many of those who read reports of it would scroll irritably through its 272 words looking for the "tl;dr" (too long; didn't read) summary at the bottom.

The key, really, is adjusting our relationship to this technology – reminding it, in effect, who is in charge. And that substantially amounts to reminding ourselves that not only is this technology not actually essential to our lives but that in some respects there is much, much more to life without it.

There's no need to be fundamentalist about this – if you abjure the email in favour of handwritten messages scratched on parchment with a quill hewn from the feather of a peacock, or even harrumph at prospective correspondents for no longer owning a fax machine, you're just being wilfully annoying (I am aware that certain MONOCLE colleagues may have things to say at this point about my refusal to find out what WhatsApp even is). But you can, and should, set boundaries.

You don't really need your phone most of the time. Show it who's boss: leave it at home. Unless you are in fact commanding an army at war, you almost certainly don't have anything to say that can't wait until later. (It should go without saying by now that there is never an excuse for using one on public transport, or indeed anywhere you can be overheard at all.) If you're going out, and are

uncertain of your route, write it down. If you're worried about how to alert someone that you're running late, simply be punctual.

Where the consumption of culture is concerned, remember that what one gets out of anything is usually proportional to what one puts into it. An infinite universe of easily accessible options has changed our reflex response from commitment and curiosity to impatience and irritability. So read books and magazines on paper, beyond an arm's reach of your phone, tablet or laptop. Listen to records while sitting still in the dark. If you're watching something on television, make sure it's the only screen in the room. If you can find 30 minutes in a day to flit across Twitter or repeatedly refresh your inbox – and the likelihood is, if you're honest with yourself, that you're presently finding way, way more than 30 minutes of every day to do exactly these – then you've half an hour spare for the really good stuff.

It's not difficult to diagnose the reason why we've submitted so completely to an always-online way of living, why we've slipped so gratefully beneath the unrelenting tide of emails, texts, alerts, tweets and likes, why we leap with such distracted alacrity between the ceaselessly replenishing cornucopia of choices available to us. It makes us feel what most of us most want to be, while being most anxious that we are not: important and in charge.

But there is nothing wrong – indeed, quite a lot right – in recognising that the world will keep turning without your unstinting input. Humility and tranquility, as commodities, have both become grievously devalued but are nevertheless valuable. And it's good for us to spend time with nothing to occupy us but the contents of our own heads. You never know: you might find something interesting in there.

About the writer: Andrew Mueller is a contributing editor at MONOCLE and presenter of Monocle 24's award-winning 'The Foreign Desk'. His latest book, *Carn*, is a weird historiography of Australian Rules football, and is most certainly available in print.

2.
A room with a view
by Matt Alagiah

Whether it encompasses rambling rooftops and unfolding urban dramas or lush landscapes and sparkling seas, a sweeping vista can change our outlook in more ways than one.

At some time or another, even the most house-proud of us will experience a sharp pang of home envy. The worst case of it I ever suffered was on a reporting trip to Rio de Janeiro a few years ago. An aggressively generous hotelier had encouraged me to visit a friend of his, who lived in the historic hilltop district of Santa Teresa. The friend in question was an elderly woman who had once been married to one of Brazil's most revered 20th-century furniture designers. With little else to do that afternoon, I agreed to march up the hill to the old colonial mansion.

As my hotelier had promised, the mistress of the house was extremely charming, immediately inviting me in and offering me a full tour of the property, including the lush garden, complete with its troop of white-faced monkeys. Undoubtedly the most jaw-dropping aspect of the house, however, was the bank of floor-to-ceiling windows upstairs, which opened out onto a view across the tiled roofs tumbling down to Guanabara Bay (glittering that day despite the infamous pollution).

Whereas the view from the downstairs windows was hampered by a colossal almond tree, here we were above the canopy. Suddenly, with a fresh breeze and nothing impeding that vista, I understood why the Portuguese colonists had opted to construct their villas way up here, away from Rio's sandy beaches.

Living in an apartment (a perfectly nice one, it must be said) in North London, a view is the one thing I crave more than anything else. That sense of space, of tranquillity and escapism, and of nature being close enough to touch. Don't get me wrong, I often enjoy living in a crowded city and even like the fact that, in true Hitchcockian style, you can occasionally watch a suspenseful drama unfold from the comfort of your own sofa. But more often than not, in a city like London, sitting still inevitably involves looking at that other window onto the world: the dreaded backlit screen.

That's why, when I really want to get away from it all, I picture a room just like that one in Santa Teresa, with wooden shutters opening onto a refreshing breeze and a shimmering view.

About the writer:
Previously MONOCLE's executive editor, Matt is now editor of the London-based art and design magazine *It's Nice That*.

3.
Cookery classics
by Kimberly Bradley

We may be living in a digital age but our kitchens remain well stocked with humble cookbooks – and the ones with the best shelf life are those that inspire, delight and are bound with memories.

When I was growing up in a small town in the US, my mother used a favourite cookbook. The cover of her 1961 edition of *Joy of Cooking* sported the word "joy" in red in a jaunty font. Inside were thousands of recipes. Not only did it list ingredients and instructions, it also offered anecdotes from author Irma S Rombauer, a widow who compiled family recipes in 1930 to process the loss of her husband.

Mom used it so much that some pages were stained and splattered. But that didn't matter: the steps were so idiot-proof that I learned to cook simple dishes before I was a teenager. *The Joy of Cooking* was in every US kitchen back then and newer editions are still common. It taught generations of Americans how to cook and is a reflection of the country's culinary trends through the 20th century and beyond. It even inspired luminaries such as TV chef Julia Child, though the recipes in her seminal *Mastering the Art of French Cooking* (1961) – another iconic cookbook – are more complex.

Most nations have at least one iconic cookbook: a ubiquitous tome that teaches young cooks to make and enjoy the fare of the land. In Austria – where I lived for the four years – I saw *Die Gute Küche: Das Beste aus dem österreichischen Jahrhundertkochbuch* (*Fine Food: The Best from the Austrian Cookbook of the Century*) by Ewald Plachutta and Christoph Wagner in most homes. It's an instruction manual for specialities such as crispy veal schnitzel and *kaiserschmarrn* (an eggy, sectioned take on the pancake). Published in 1997, the book is decades younger than *The Joy of Cooking* but became the authority on Austrian cuisine before such publishing became an international affair.

Iconic cookbooks are about comfort food, national traditions and the pleasures of cooking for the family. Their appeal lies in their utter lack of pretense. But the recipes are labour-intensive

and the methods contained within require a knowledge of techniques – such as whisking egg whites or making beef stock from scratch – that our fast-paced lives are causing us to slowly lose.

Unlike the new ilk of culinary publishing, many of these cookbooks have more words than pictures. They're a far cry from so many newly published cookbooks or online recipes with imagery of oversaturated, shot-from-above health food. These newer books are undeniably attractive but are they useful? Often they zero in on one exotic cuisine, a process or a single ingredient. Other new titles are all about diets. Then there

These newer books are undeniably attractive but are they useful? Often they zero in on one exotic cuisine, a process or a single ingredient. Other new titles are all about diets.

are the shelves devoted to allergies or lifestyle choices: gluten-free, vegan and organic cookbooks. They are often sold based on the things that the dishes lack rather than what they contain.

Celebrities of all stripes often offer their expertise and preferences in chatty cookbooks that reflect their personal brand. Some of the above might become classics but they all reflect the idea that contemporary eating is more about specialisation and spectacle and less about the activity of everyday eating – the kind that happens with your family and without your phone.

In the meantime, my mother still uses her ancient edition of *The Joy of Cooking*. The last time I was home, I baked a cake using its old-fashioned narrative recipe format. My creation emerged from the oven perfectly spongy and sweet.

On that visit I found another cookbook in the family stash, one from the 1940s, bound by hand and compiled by the women in my mother's hometown. In it was a recipe for blackbird pie. Beneath an illustration of birds was the first instruction. "Wait by a telephone wire for blackbirds to arrive, then pull the wire hard to break the birds' necks and knock them to the ground." Second step: "bone them." The steps between neck-breaking and bone-removing were unclear. No colour photographs but some serious foraging; it could be the next big thing. Just one question: are wild blackbirds organic?

About the writer: Kimberly Bradley is MONOCLE's Berlin correspondent. She covers art and culture throughout Europe and beyond.

4.
Freeing plants
by Louise Wright and Mauro Baracco

The founders of Baracco + Wright Architects ponder the pros and cons of letting plants live on their own terms.

We need to put a plant in a pot because we've displaced it from its home in the ground. In a rather Victorian manner we keep it contained for our own pleasure, because it's wonderful to live among plants. Keeping a plant alive in a container is a difficult task. Just ask the gardeners abseiling down the façade of Boeri Studio's impressive Bosco Verticale in Milan. While you're there, glance over to the ivy-covered building next door, thriving with its roots in the soil, independent of human care.

At the Venice Architecture Biennale 2018 our practice, along with artist Linda Tegg, exposed the difficulty of replicating conditions in the Australian Pavilion: thousands of plants in pots grew under artificial lights. This displacement considered what's removed when we clear land. The plants in pots had to be cared for constantly, revealing how difficult it is to replace something once it's removed. Climate change played out inside the gallery, where temperature and humidity controls isolated the Australian plants from Venice's unforgiving humidity.

Reflecting on how hard it is to keep a potted plant alive might guide us in a less artificial approach to how we bring plants back to places where they have been removed through urbanisation. What if we just put plants in the ground where they can communicate with each other and share water and nutrients through their mycorrhizal networks?

Are we ready to allow plants to live on their own terms? "Weeds", lichen and moss spontaneously grow in our cities. Urban environments favour some plants more than others, but are capable of remarkable diversity. If one can't empathise with the contained plant then the growing body of evidence of the benefits of vegetation in urban development is compelling. They include an increase in property values, crime reduction, human health, urban island heat effects, storm-water management and mitigation of climate change events. Architecture and urban design simply need to make more space for plants to have their roots in the ground.

About the writer:
The two founders of Melbourne-based architecture practice Baracco and Wright are behind some of their hometown's most innovative residences. In 2019 they also designed a pop-up park downtown on the site of an old car park.

5.
Under the influence
by Mark Forsyth

We all have our own theories when it comes to alcohol – which type gets us the most drunk, which type sends us to sleep. Here we separate the truths from the myths – drink in hand, naturally.

Alcohol is a drug but a very strange one. It's like a Rorschach test: the piece of paper with the symmetrical pattern remains the same but each observer finds something different. Alcohol is a simple chemical but ultimately it acts on your brain and behaviour in the way that you believe it will act.

This is a point that can actually be tested but it's also a point that comes out clearly when you look back over the long, hazy history of drunkenness. For example, I've never been so drunk that I've seen God. This may not surprise you but an Ancient Egyptian would wonder what I had been doing wrong. Their annual Festival of Drunkenness was entirely geared towards getting so utterly trolleyed that they could, albeit fleetingly, become better acquainted with Tenenet, goddess of beer.

How did the Egyptians glimpse their beloved goddess? They drank an awful lot. They drank

How did the Egyptians glimpse their beloved goddess? They drank an awful lot. They drank until they threw up and then they drank more, had an orgy and then, at dawn, found God.

until they threw up and then they drank more, had an orgy and then, at dawn, found God. They believed that they would see a divine apparition – so they did. And they weren't alone. The Ancient Greeks were adamant that you could hallucinate from drinking wine and they weren't adding anything funny to it. They actually watered it down by modern standards.

Alcohol is a way of channelling a culture into a bottle and it seems every culture has something different to channel. In the UK, for instance, alcohol is widely blamed for violence. However, this is not universal. Students can volunteer

for an understandably popular psychological experiment involving free booze. It involves assembling said students, handing out the drinks and neglecting to tell them that half are getting full-strength beer, half of them alcohol-free. The result? For the most part students act out the cultural stereotypes that they've inherited.

A current hip tipple in Mexico is *pulque*, which is a revival of an Aztec take on beer. Mind you, if you really want to recreate Aztec drinking in a *pulqueria* you should, properly speaking, revive the Aztec punishment for being drunk, which was to be strangled in public. (Unless you were of finer stock, of course: noblemen were granted the privilege of being strangled in private. Which was much better, you would think.)

There is yet another drink-related myth that needs to be dispelled: that the type of alcohol you imbibe has some effect on the manner of drunkenness that results. Alcohol never changes. It's the same ingredient in beer, wine or whiskey. Instead the drink, and the manner in which it's served, can change your expectations and perception.

So why do we hanker after new drinks? With what do we associate mead? What will that craft gin do for us? Perhaps it's the fact that they are drinks without associations, a blank sheet onto which we can project a new kind of drunkenness. Because you always put as much into the bottle as the bottle puts into you. You, and your expectations are the master of your own drunkenness. When push comes to sozzled shove, though it's the alcohol that makes you drunk, being pissed is what you make it.

About the writer: Mark Forsyth is the author of *A Short History of Drunkenness: How, Why, Where and When Humankind Has Got Merry From the Stone Age to the Present.*

6.
On your own terms
by Kunyalala Ndlovu

Leaving the security of a steady job might be a daunting prospect but embracing your dreams and following a hunch can also reap rich rewards. So what are you waiting for?

Not long ago a category four hurricane extended my stay in Busan, South Korea, by 72 hours. I lost a day but learnt that taking things slow has advantages too. I remember sitting in silence watching the waves of Haeundae Beach. To my left, two novice surfers' initial joy at catching a lucky wave crashed quickly into failure and cries for assistance. The duo called for help and fortunately were ushered to safety. Sometimes we're in rough waters and we don't know it.

I left a steady agency job six months previously and saw little promise or potential of finding another fast. My aim was twofold and something I've seen many people attempt – to find a gentler approach to life and spend more time with my young family. As I sat there, I reflected upon the roiling waves and what I'd learnt in the first six months since taking the plunge.

To do small things
My son and I often study the soil in our Lilliputian London garden and observe the organic metropolis of living things that inhabit our vegetable patch. We dig around the bed to keep the soil aeriated and weed-free and expose the worms, snails and creatures that lie beneath. It makes our plants healthier and as a bonus, red-breasted robins often visit. They perch patiently until our industry is over, then glide down to feast upon the muddy delights we've unearthed. I like to think that this small act helps our feathered friends and that taking time to do things away from screens can have an unintended but positive impact, if not for the worms then in the time we spend together and what can grow from that.

To embrace amateurism
The smarter our devices have become the less meaningful our connections. To remedy this digital fatigue, I took pictures that I wanted to keep (rather than file away). I dug out an old Polaroid camera and stopped leaving home without it. London, my base for nearly two decades, became a city to be rediscovered, studied and seen afresh. This amateur practice is often accompanied by a chorus of nostalgia from strangers. Smart devices act more like a barrier to polite chit-chat. Switching to analogue has led to countless courteous conversations and shared moments. I learnt that it is easy to change your lens on the world.

To satisfy curiosity
With no steady job I decided to fulfil a long-term goal to start selling books. In lieu of an, ahem, books-and-mortar premises I found a berth at a Sunday market in east London, sketched a logo and amassed a small selection of second-hand books. A shared passion is the best conversation starter and my supplies would often dwindle before the stall was officially ready to open. Every encounter opened up reflection on my life as I heard others open up about theirs. Davis, Beckett, Fugard. Always Brecht. I gleaned more conversational lessons on a kinder life from strangers than I could commit to a page. Each book contains a lesson and embracing books and recommendations and strangers in markets – having a rummage in a box – shows that we are all more similar than we are different.

To have conversations
Looking into an uncertain future where speed and efficiency have tipped the scales away from slower, more meaningful interactions, aspiring to a gentler life has never been more important. Try it. Surprise your friends by calling in without calling ahead. Become a tourist in your own city for a day. Buy a book on a stranger's recommendation. Make small changes at home like planting, recycling, investing in things that will last and the effect will trickle outwards into a world that needs to produce less plastic and waste less food. Small changes today could be the things that make waves tomorrow – and if you find yourself caught between a rock and a riptide then perhaps it's time to seek out some quieter currents and get paddling.

About the writer: Kunyalala is a multidisciplinary artist and writer. He left the sun of Zimbabwe half a lifetime ago to enjoy the streets of London. He can often be seen taking photographs and making films on old cameras while sporting an array of modish hats and socks.

7.
A taste of home
by Zayana Zulkiflee

Nothing sparks joy as much a well-loved dish that transports you to your happy place. Our writer has had to make hers from scratch – and it's been quite the culinary adventure.

Moving to a smaller city has been an exercise in learning the value of quality over quantity. And in no part of my life was this clearer than in my relationship with food and cooking.

My home town of Singapore (population 5.9 million) provided a dizzying array of restaurants, bars and hawker centres serving up a myriad of different cuisines. Of course, my new base – the charming but comparatively village-like Bergen in Norway (population 280,000) – was always going to be a different kettle of fish.

That's not to say it has less to offer: the fare from long-standing delicatessen Solheim Kjøtt or the shellfish just-plucked from the North Sea at restaurant Cornelius are hard to beat, but sometimes I must allow myself to get a little homesick.

My tastebuds are used to sweet tropical fruits, rice mounted with handfuls of textural sides, and fiery curries. So every so often, I put aside my Norwegian *brunost* (brown cheese), potatoes and sweet toffee-tinted gravies, and wheel my trusty shopping cart to Bergen's speciality stores.

The staff at my favourite smile kindly – if perhaps a little wearily – as I stake out the latest stock of *pandan*, kaffir lime or *belacan* (shrimp paste) from Southeast Asia.

With none of my beloved hawker stalls within reach, I donned my apron and took my mum's advice to learn the intricate recipes at home. I used to take my favourite foods for granted – today, I'm spurred to simmer and stew for hours, learning perseverance and most definitely respect, for the cooks of Singapore's street kitchens. Nasi Lemak – once a 'quick' pick-me-up of mine – took some four arduous hours to perfect.

But the trade-up, with the addition of a group of curious new-found friends and prosecco (a delightful pairing I'm happy to report), makes the process all the richer. While I may not be able to grab Singaporean dishes on a whim, I'm now reconnecting with the recipes of my roots. Every meal is serendipitous, depending on the season and whatever shipment has arrived at the grocers. I'm slowing down, paying attention to every aisle, and every shopping jaunt becomes a treasure hunt.

About the writer: Zayana Zulkiflee is the former MONOCLE associate bureau chief in Singapore. She's proud to say that she makes the meanest chilli crab, prawn noodles and *mee rebus* in Norway (but only because she knows no one else making them in the region).

8.
Look this way
by Chloë Ashby

Works of art – whether a Bruegel or a Banksy – serve a purpose in these ephemeral times. Revisiting an old favourite or discovering something new has never felt so vital.

Mark Rothko's Seagram murals make you stop and think. Not necessarily about what they represent but how you feel. Their brooding veils of colour and blurry outlines draw you in. They're like windows and doors, portals into another realm, with dusky planes and ragged edges. The heady palette of deep maroons and sooty blacks recalls late nights, second-hand smoke, red-wine lips. Whether they leave you feeling enriched, astounded, bemused, despairing or simply drained, they demand your time and energy.

In my early twenties, while I was working in a newsroom near London's Southwark Bridge, I spent several lunch breaks in the company of these doomy canvases. Specially commissioned for the Four Seasons' swanky restaurant in the Seagram Building in New York, they now have a room of their own at Tate Modern – a better fit, Rothko decided. ("Anybody who will eat that kind of food for those kind of prices will never look at a painting of mine," he told his assistant.) I took time out from clattering keyboards and office chatter to reset in that small, low-lit room with those great, glowing panels. Being enveloped by the Seagram murals made me feel more present. Looking at the layers of paint cleared my cloudy head just in time for me to return to my desk.

It's hardly groundbreaking to say that art – like literature, theatre, film and music – can provide a form of escape. Because of course it can. Therein lies the appeal: thanks to Jane Austen, William Shakespeare, John Hughes and Fleetwood Mac we can imagine prancing around at Pemberley, falling in and out of love in Verona, enduring detention on a Saturday and, well, being "with you everywhere". But what we often fail to recognise is that art can also root us in the now. In today's highly saturated world, no sooner has an image been shared – via news outlets, advertising, social media – than another has supplanted it. There's

little time for consideration, let alone room to feel. Processing the barrage of information can be overwhelming.

Unlike here-one-minute-gone-the-next images, art is a constant. It's something physical to hold onto, albeit metaphorically; unlike a story on Instagram, it won't slip through your fingers. Within a frame, or atop a plinth, time stands still. It rewards those who revisit, who make an effort to look again, to look harder – but not better, because there really is no right or wrong way of looking. It's a means of slowing down and one on which I've long been relying.

If you can't get away from your desk, pick up a print from a museum shop and tack it to your wall. Art should be consumed in all its guises, not just in the hallowed halls of museums.

It's not just by spending time with the brooding work of America's late great abstract expressionist that you might gain some perspective. At Moma in New York there is a room that's as strikingly soulful as Tate's shrine to the Seagram murals, with a gently curving display of Claude Monet's lush lily ponds in his gardens at Giverny. From afar, the canvases shimmer, a sun-dappled vision in cream, rose, lavender, emerald and cobalt. Come closer and the daubs of paint begin to clash and collide, though the water is still, with clouds reflected on its surface. Whatever your viewpoint, you'll barely notice Monet's other admirers by your side – even if there is a little jostling – so hypnotic is his painted world of water and sky.

Of course, it doesn't take an entire room to stop you in your tracks. One work of art is all you need, abstract or figurative. If you need a jolt to bring you back to reality – a short, sharp shock – the crashing waves of an incandescent Turner seascape should do the trick. If you truly want to be kept on your toes, park yourself in front of anything roughly akin to Artemisia Gentileschi's gruesome double portrait of Judith slaying Holofernes, blood spurting from the Assyrian general's neck.

Wherever you work, it's worth locating your nearest galleries and museums – much like your nearest exit – so you know where to find some grounding when you want it. The beauty of many of the UK's major museums is that they're free. You can nip in and out without feeling the need to get your money's worth. Collections are there to be enjoyed, one work at a time, without the artificial objective of ticking things off. The British Museum can't be "achieved", nor the National Gallery "accomplished".

But the world over, art is ready and waiting to be your anchor – and not just because you've paid your entrance fee. Churches are often treasure troves of masterpieces, especially in Italy; no, you don't need to be religious to appreciate an altarpiece. Elsewhere, urban artists have taken to the streets, as every resident of Lisbon knows. Then there's the built environment itself: art you can physically inhabit. If you can't get away from your desk, pick up a print from a museum shop and tack it to your wall. Art should be consumed in all its guises, not just in the hallowed halls of museums. You can enter into the world of a postcard, no matter how small.

It's been some time since I visited the Seagram murals, partly because I no longer work on the Southbank but also because I've found other art to make me stop and think. Wherever I go, art makes me feel centred. It also delights and inspires me and my writing. Still, ruminating on Rothko has made me itch to be back in that small, low-lit room with those hazy canvases. They're tangible and tantalising, and together we make a mood.

About the writer: Chloë Ashby writes about art and culture for the *TLS*, *Guardian*, *FT Life & Arts*, *Frieze* and other publications. She wrote the art survey, *Look At This If You Love Great Art*, and her first novel, *Wet Paint*, is published by Trapeze.

9.
Gentle cities
by Andrew Tuck

Gentle. A simple word but a good one. And an oddly helpful one when you start to tackle big unwieldy ideas, projects and places that need nudging into nicer places. Take cities. There are lots of buzzwords that are used to suggest how they should be made and remade, such as resilient, sustainable, walkable and inclusive but, actually, "gentle" can take in all of these concepts and many more good ones too. That's why we have decided it's time that we started our very own Gentle City Movement. These will be a few of our demands:

1.
Let cities slow down
We need streetscapes where pedestrians and traffic share the same spaces, ensuring that everyone takes care of their pace and doesn't hit the accelerator.

2.
Let cities come to a halt too
Provide benches and park deckchairs so that citizens of all ages can watch the world edge by, take in the sun on their faces and enjoy a moment alone while surrounded by humanity.

3.
Enlist materials that soothe
Less plate-glass and glistening metallic, please. Use brick that warms in the sunshine, timber that makes connections with nature, stone that invites you to touch and also denotes a satisfying sense of permanence.

4.
Use street signs that surprise and encourage, not only admonish and warn
How about "please lock your bicycle to our railings – we will not remove it" or "you're welcome to sit on our grass"?

5.
Make a splash
Fountains are entrancing, jets of water playful, drinking taps generous. And, as water hits marble or paving, it lifts the spirits.

6.
Leave space for nature
Just seeing greenery is proven to do wonders for our mental health but go further and make your city a welcome refuge for a passing hawk or a fox-trotting nocturnal visitor.

7.
Make walking a joy
It's good for the body and the environment too. Make going for a stroll a joy with the aid of good wayfinding systems and a sense of security even after dark.

8.
Create spots where conversation flows
Boules courts, news kiosks and ice-cream stands all help turn a square into a living room for the city, where people gossip and pass the time of day with friends and strangers.

9.
Waste less
Create buildings that are well insulated and taxis that are electric. Make it easy and rewarding to recycle too.

10.
And re-use
Don't knock it down – fix it up. The patina of age appeals to everyone. A jumble of buildings from various epochs makes a city feel rich and full of potential.

Well, it's a start. And with a little push, perhaps we can start this polite, generous and forgiving urbanist movement that's good for everyone and gentle as it unfolds.

About the writer: MONOCLE's editor Andrew Tuck has been heading the magazine since its launch in 2007. He also presents Monocle 24's radio show 'The Urbanist', a chance for him to delve deeper into his interest in all things metropolitan. A part-time flâneur, you'll spot him out on the streets of London with his faithful sidekick – a fox terrier named Macy.

10.
One-hour reads
by Josh Fehnert

Hefty tomes are all well and good but there are times when nothing beats a short story or a novella that we can consume in a single sitting. When it comes to word count, less can be more.

It's a year-round phenomenon but summer is a plum time for spotting a certain breed of show-off. You'll spy them in airport lounges, on train platforms or supine on sun-loungers and always with a hefty hardback in hand. You'll recognise them by that look: faces caked in a smug, self-satisfied smile as they flick the final page of the cinder block-sized book they're finishing. And boy, are they delighted that you saw them do it.

The digital publishing boom has all but passed – there are still libraries, publishers are still printing, writers still write – and what's more, boastfully bulky books are still big business. In fact, if my dust-jacket arithmetic is to be believed then the average length of the Booker Prize-winning screeds over five recent years was a whopping 437 pages. The longest? *A Brief History of Seven Killings* by Marlon James. "How brief?" one wonders. "And did we need all seven?" I find myself muttering facetiously.

Forget 'Ulysses' (I parted company with the protagonist just after he burned his breakfast), 'Infinite Jest' (infinite pest, more like) or 'War and Peace' (the latter, please).

I say this, a little bitterly, as I am not a very patient reader. When it comes to taming broader-spined beasts of the shelf, I'm usually eyeing up a shorter option and so I start incalculably more books than I finish. Forget *Ulysses* (I parted company with the protagonist just after he burned his breakfast), *Infinite Jest* (infinite pest, more like) or *War and Peace* (the latter, please). Yes, dear reader, look for it and you'll usually bookmark a little under half-way into the biggest "must-reads" in western literature. Little marker monuments of the exact moment I gave up, lost interest and began to graze on a greener patch of literary grass.

Could it be that our flickering phones robbed us of our capacity to concent' But a more positive defence may be th... blooming of a new literary genre: the one-hou... wonder. There are the duck-egg-blue beauties from Penguin that fillet an obscure authors' oeuvre into a fifty-page flick. There's Vintage's "Mini" books, which break down canny thinker's insights on everything from money to friendship, and Faber & Faber's nattily designed "Faber Stories" collection. On a recent trip to Hodges Figgis in Dublin I discovered Paper + Ink, a company started by publishing veterans who offer fetching beer mat-sized stories that can be bought as a subscription and devoured in a single sitting.

I've always liked that oh-so laconic anecdote about Ernest Hemmingway (a maestro of the novella, short story and getting to the point). While lunching with friends he was said to bet the table that he could craft a story in six short words. After $10 each was agreed, he wrote the following sentence on a napkin before claiming his winnings: "For sale: baby shoes, never worn". Although it's oft repeated, this vignette shows that even the shortest stories derive their strength from the things left unsaid: the margins around the text in which our mind can wander, doodle and delight. And that's just fiction.

In the world of non-fiction there are treatises on power, politics, pretentiousness and pretty much everything else. You can conquer Machiavelli, Camus or *The Communist Manifesto* on the shortest-haul of European flights. Oh, and have I mentioned plays? The entire history of drama can be purchased in an entertaining episodic form, enjoyed in your own time, with works that rarely tip beyond the hundred-page mark. A little imagination goes a long way.

So, when it comes to your holiday reading list or those books you think will better yourself then here's a thought: buy four short books – mix fiction old or new with an essay and maybe a play for fun – rather than feeling bad about not finishing a gargantuan novel. Longer reads, remember, don't have a monopoly on clarity of thought, nor charm or charisma. And while I'm not claiming that everything worth knowing should be simple and easy to explain in under a hundred pages, there's an awful lot that is.

About the writer: Josh Fehnert is MONOCLE's deputy editor and the editor of this book. He now claims that he did finish 'Ulysses' in the end. Twice. Only he cheated and did so as an audiobook instead of lugging the dog-eared paperback about.

Dress with care

How what you wear influences the way you feel, shows your values and shapes the world.

Dress with care

How we dress affects more than how we're seen by others. Knowing where our clothes come from can influence how we feel about ourselves, our esteem, comfort and mood. More than that, it reveals our own implicit values. Where was your favourite floral dress made? Were the hands that stitched that hat the recipients of fair pay for their work? It's an uncomfortable truth but the choices we make – to support firms that are transparent, with provenance and short supply chains – shape the world around us.

How we buy also shapes our cities. Think about the rise of e-commerce and how it spurs the factory-and-delivery-van model of retail. Weren't we happier with a high street? Luckily, many people are waking up to good sense and a fairer model. So, what steps should we make to have a gentler impact? First, we're suggesting a careful look at what we chuck out and what can be repaired. There's no axiom that sums up the shift at play in the fashion industry but if you're looking for a mantra you could do worse than committing to buying fewer things of a higher quality.

ITEM I
The gardening jumper
Old stager

Sleeping soundly next to your muddy boots on the porch is your most treasured piece of clothing. It's old, holey and smells of bonfires, barbecues and tobacco. It's quite a good make and was woven when things lasted; it simply won't give up the ghost. Everyone has one of these old campaigners because to have one is not simply to have a garden. It's to know and love; memory wrought in lamb's wool.

The coat
That's a wrap

An all-weather coat is a thing of great comfort and importance because it's what you wear to face the outside world. It goes over everything and protects you from the elements; it's seen you through chilly days on the beach and dog walks in downpours. A jacket only gets better with age – we are particularly fond of this classic Mackintosh.

ITEM 3

The socks and sandals
Step up

Few items conjure up a sense of cosiness like woollen socks – the chunkier the better. We plumped for these mohair beauties by Rototo. Don't shy away from stripes or colour: socks are an easy way to smuggle some fun into your wardrobe. Pair with sandals or clogs such as these slip-ons by Birkenstock for an unbeatably comfy ensemble that's gentle both on your feet and on the eyes.

The boots
Walk tall

Let's face it, those sandals are not going to get you to the top of a mountain.
That's where hiking boots come in. There's something reassuringly sturdy
about a pair of lace-ups that hold your ankle firmly in place like these ones from
Amundsen. And even if you're not scaling lofty peaks, they'll keep you company
on those meandering walks through town and country.

ITEM 5
The T-shirt
Wardrobe staple

When it comes to easy, comfortable dressing, the soft cotton T-shirt triumphs.
It should have a loose fit and a sturdy rounded neckline. Aussie brand Bassike –
which makes the ones we've featured here – and LA's Lady White Co, are tough
to beat. Choose versions that will take some tumbles, not shrink in the wash, and
are carefully produced in simple cotton.

The clothes brushes and sewing kit
On the mend

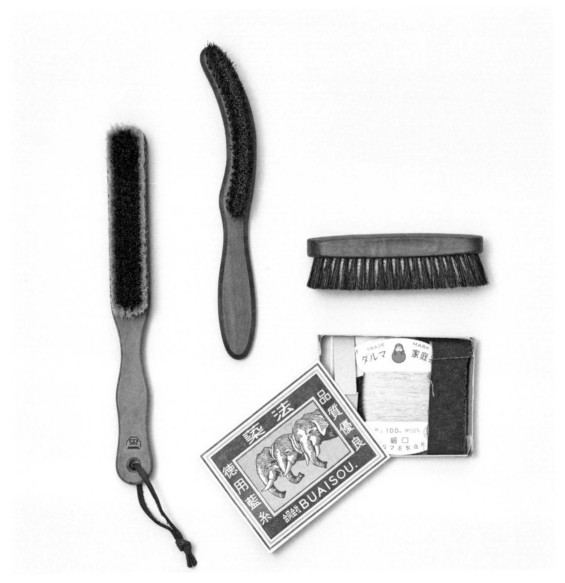

It's rewarding to care for your belongings as they age. We're talking
maintenance rather than major renovations here: a couple of clothes brushes
by the German brand Redecker should keep most scuffs in check, and a simple
sewing kit such as this one by Buaisou should look after those inevitable pulls and
tears. A patched jacket or darned elbow can add some life to your looks.

Fix and repair
As good as new

The constant churn of fast fashion would have us believe that the lifespan of our clothing is limited. Don't fall for it. Quality clothes deserve proper care and can last a lifetime if they're well looked after. Not gifted with the needle and thread? There are plenty of talented tailors and canny cobblers out there to lend a hand when it comes to granting your wardrobe a new lease of life.

There's something uniquely satisfying, and comforting, about getting your favourite brogues resoled or taking in your trusty coat for a fix-up job around the elbows. Visiting your local cobbler or tailor is a badge of honour; you must earn the right to repairs by wearing something over and over again. A well-worn shoe, jacket or pair of jeans looks better than anything you can buy off the rack; the patches and stitches are little reminders that these items have seen things – days in, nights out, train rides, holidays and birthdays.

Getting something fixed, rather than trading it in for a new model, is also good for the planet. It's a win-win situation. And, fortunately, retailers and consumers are increasingly embracing the idea of repairs. When the well-heeled residents of Milan need to breathe new life into a pair of shoes they turn to father-and-son duo Ermanno and Luca Alvisi, who specialise in re-soling high-end men's footwear. Los Angeles-based Ateliers & Repairs up-cycles worn items by adding patterned patches and pockets – making the point that repairs can become a design detail, a thing of beauty. Clothes and accessories are made to be *worn*, not confined to the wardrobe or tossed in the bin once a new trend announces itself.

Sustainability pioneer: Ecoalf
Madrid

Javier Goyeneche, founder and president of Madrid-based fashion brand Ecoalf, is a champion of sustainability in fashion. Eco-friendly processes for producing and distributing clothing have become one of the industry's biggest talking points – and Goyeneche has been leading the way.

After founding Ecoalf in 2009, he spent the next few years scouring the Spanish coastlines and speaking to fishermen and scientists. "I convinced textile-makers to produce recycled fabrics for me," he says. "I made them realise that producing fabrics from ocean waste would give them a business advantage as they would be ahead of the curve."

It wasn't until 2013 that he launched his first line of clothes and accessories created from ocean-waste plastics. It was met with instant acclaim and landed him a collaboration with Apple, propelling the brand's minimalist designs – and message – to prominence. Ecoalf has now developed more than 250 plastic-derived fabrics, including trousers made from recycled bottles and trainers created from a nasty form of algae.

Ecoalf ensures that its entire supply chain is as sustainable as possible, avoiding any unnecessary travel. Goyeneche is a tireless advocate. In addition to giving talks in his shops, which are located in five cities around the world, he takes part in hundreds of conferences about environmental action and visits schools to teach children about sustainability. "They understand that there is no planet B," he says.

Clockwise from top left:
Tailor Marly Mancou
fixes jeans at La Clinique
du Jean in Paris; a handy
crochet repair job; Milanese
gentlemen turn to the team
at Alvisi for their shoe repairs

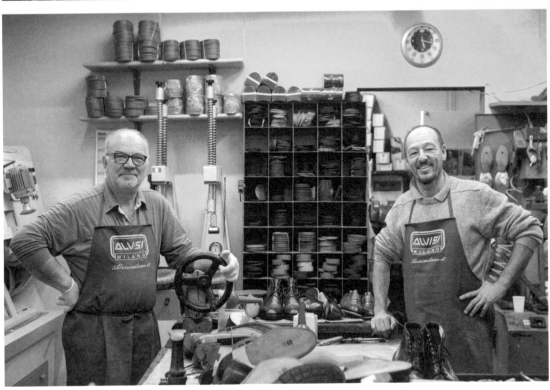

Find your style
Go your own way

Gentle needn't mean boring when it
comes to style. It could be the cut of a
hem, a hit of colour or the inclusion of
a rakish accessory, but the alchemy of
dressing well is simpler than perhaps
it appears. The key lies in difference
– there's no sense in hankering after
the just-dropped trainer or t-shirt that
everyone else owns. If you're into that
Napoleonic tricorn hat and can pull it
off then, well, hat's off to you.

Clockwise from top left: Sharp tailoring in San Tropez; young family in Osaka; relaxed fits by the river in Basel; a dog upstaging his owner in Paris; a hard-to-miss shirt that we spotted in Tulsa; father-daughter-duo on the streets of Madrid; a snappy ensemble for a shopping trip in Osaka

CHAPTER 7

Move more

Strip off, dive in and don't fret.
In praise of swimming, cycling,
hiking and healthy competition.

Move more

Our health is our most valuable commodity and keeping our bodies supple and limber doesn't just mean shutting ourselves away in airless underground gyms or paying good money to be shouted at by buff coaches. Instead, public health can be boosted by a city's decision to clean up its harbour, an individual's choice to start each day with a row on the river, or the gradual acceptance that being able to cycle to work is one true meaning of luxury to many. We don't object to you working up a sweat on a dance floor in Tel Aviv or a bowling green in Sydney either (in fact, we encourage it). Staying active – whatever your age – and even being a touch competitive are good things.

This chapter is about tucking your phone into your rucksack pocket and leaving it on the shore as you go for a dip, and heading up a mountain to find a clear mind (and maybe a *tartiflette* and a spot of skiing while you're at it). It's about undertaking a singular activity to help you focus – whether that's turning a few lengths of your local lido or joining a conga line. Ready? Let's get going.

Make a splash
Deep dive

The first glimmer of dawn creates flecks of light on the less-than-alluringly named Sulphur Channel in Hong Kong. It's 05.00 and ferries are already coasting across the panorama. Even in this city of more than seven million souls there are spaces of calm if you're willing to seek them out.

Swimming is excellent exercise, of course, but it can also be a transcendental experience: it offers us space to reflect, the sensation of water on our skin and, yes, a chance to strip off. So find somewhere to bob, duck and paddle – it's moving in more ways than you might expect.

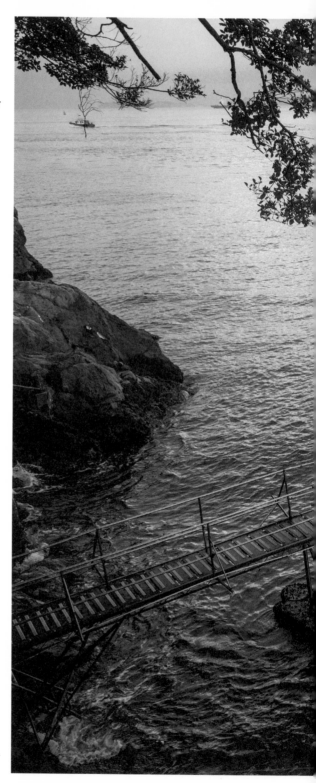

Why I swim
by Sophie Grove

I swim to escape – to feel weightless, like an aquatic astronaut. To dive into a blue sea on a hot day is to leave the wherewithal of bikes and bags and dinner plans behind and plunge into a watery otherness.

Even a few laps of my local pool and I'm in a David Hockney rectangle of turquoise – floating; completely transported. Some days I swim with sunglasses on, looking up at the trees and the sky, while others I submerge to an abstract world of limbs akimbo, goggles and sunlight filtered through chlorine.

Swimming is an antidote to screens and all-encompassing technology. It's sobering. It's also instant. Until I dive into a lake, pond, river or sea I don't feel I've really arrived. I need to be in the view – not just looking at it from a distance.

I swim to sleep more soundly, to reap the benefits of a post-dip appetite (where every mouthful somehow tastes better.) In summer, I swim to cool off, and in winter to get so cold it hurts. The buzz after a freezing dip is better than anything you could bottle. It's life-affirming, electric and intensely human.

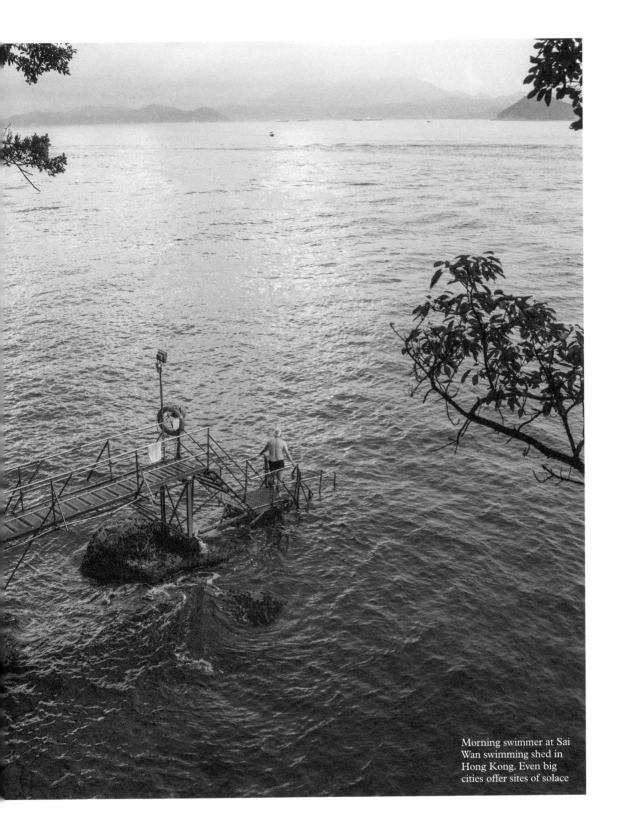

Morning swimmer at Sai Wan swimming shed in Hong Kong. Even big cities offer sites of solace

Test the waters
Enjoy an urban splash

More of us than ever now live in cities and as we've been provided with more prosperity, excitement and opportunity, we've also too often turned our back on the rivers, harbours and lakes that first gave rise to our settlements. That's changing, though.

From the clean-up of Copenhagen's harbour to unlikely urban beaches on a crook of the Vistula River in Warsaw, we're turning – like the tides themselves – towards a healthier relationship with the world around us. We need to think about how we interact with our towns and cities, and that includes with the water that keeps us buoyant as we trace their skylines from afar.

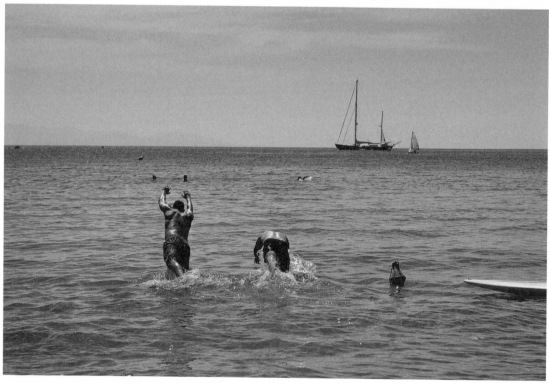

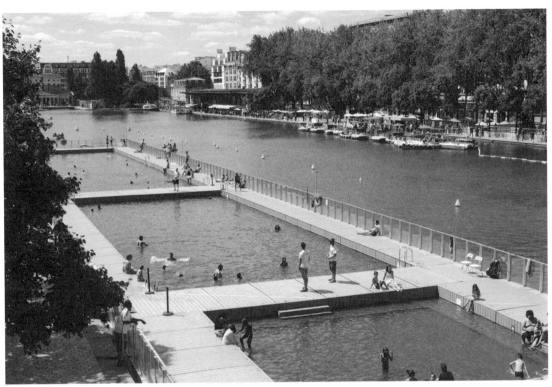

Clockwise from top left:
Railing for a dip in Zürich;
a floating pool in Bassin
de la Villette in Paris; a
Parisian bather; taking the
plunge in Switzerland's
Caumasee; a running dive
into the fresh waters of the
Mediterranean, shot from
a beach club in Beirut

Get in gear
Wheel meet again

Will the world go Dutch? Cities in the Netherlands have paved the way when it comes to reimagining how life might look with fewer cars, more bikes and streets that are built for a slower manner of travel. Very pleasant, it turns out – just mind those cobbles and that tram track, will you?

The benefits of bikes are many: they are safer, greener and less noisy than cars or trains. That said, some in the Lycra fraternity (you know the ones, you'll hear them coming with those clip-on shoes) do themselves and others a disservice by swooping selfishly over pavements and past pedestrians as if a medal depended on it. Cycling isn't inherently civilised but it's generally a more agreeable pace at which to idle and take in the sights, as well as work up a sweat, get some sun and enjoy the breeze (and it's gentler on the environment too).

Some distances don't justify a bike but much of what makes the act of cycling enjoyable is the journey as well as the destination – the taking of lanes rather than motorways and the capacity to hop off the saddle for an impromptu picnic, pint or natter. So whether you're keen to get your expensive carbon-fibre racer on the road on a sunny Sunday with the Fietsclub Ledig Erf cycle troupe in Utrecht (*pictured*) or you just fancy covering a few kilometres with friends on your rickety old Bianchi, remember, go easy.

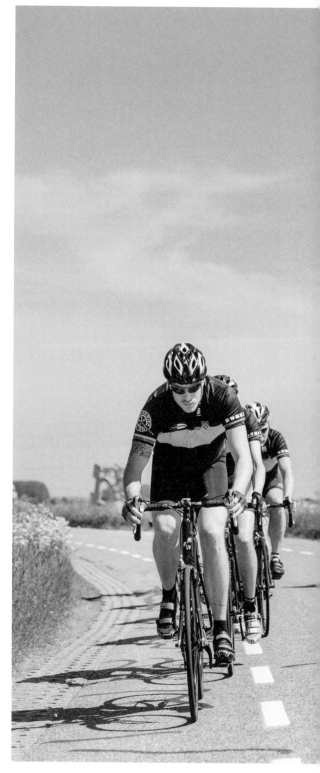

Why I cycle
by Hester Underhill

I firmly believe that the speed at which you spring out of bed in the morning directly correlates with the enjoyment level of your impending commute. I used to take the London Underground to work and spend 45 minutes with my cheek pressed firmly into the armpit of a fellow commuter. Needless to say, I would snooze my alarm for a while before slumping out of bed. Everything changed when I got a bike.

My route now consists of pedalling over Vauxhall Bridge, a quick spin through Westminster before heading past Buckingham Palace and nipping down a tree-lined avenue along the edge of Hyde Park. Not only am I saving the money I would have been spending on a sweaty tube ride but my commute has become a pleasure rather than a chore (if it isn't raining, that is). And no, I've never worn Lycra.

Thanks to my bike – a rusty-but-reliable secondhand bargain – I'm getting to know London better and have even begun to smugly notice a glimmer of definition on my calf muscles. Riding a bike is the best way to discover a city – and you might even burn a few calories while you're at it.

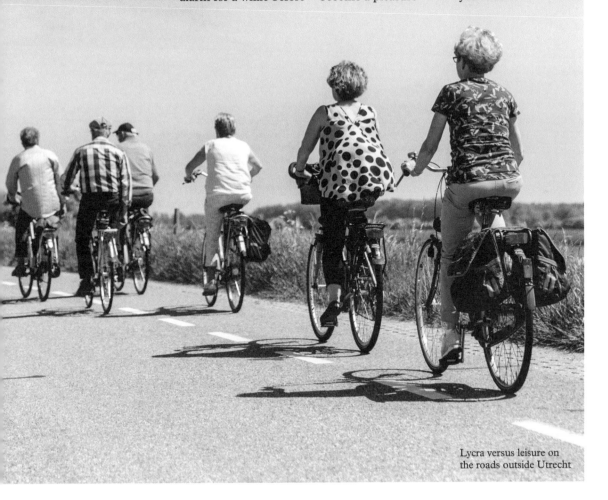

Lycra versus leisure on the roads outside Utrecht

Brake the cycle
On your bike

That weekend cycle is a nice way to get out of town and make some pleasant tracks but inroads are also being made to improve the plight of bikes within our cities. What was once the dangerous trail blazed by a principled few is now becoming a safe and desirable pastime. City halls are realising that safe spaces to cycle are making people happier and healthier too.

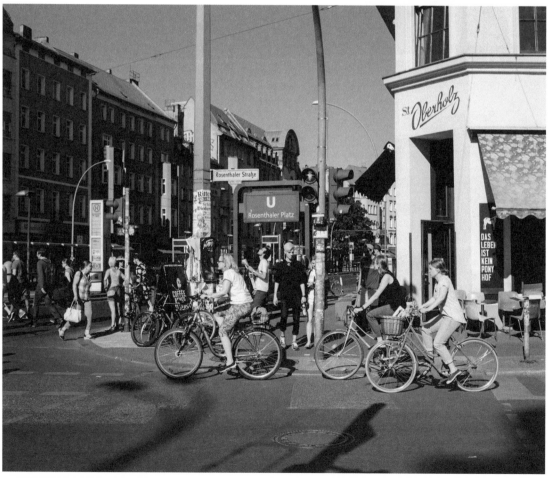

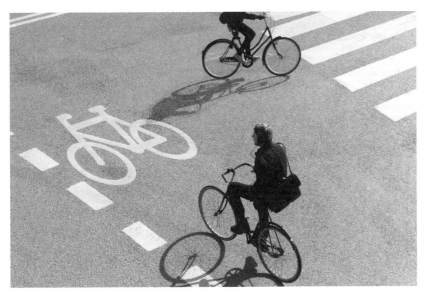

FOUR BIKE SHOPS

1.
Rossignoli, Milan:
All models are welded, painted and assembled entirely in Milan.
rossignoli.it

2.
Freddie Grubb, London:
This petite shop stocks sleek steel-framed city bikes.
freddiegrubb.com

3.
Monochrome, Buenos Aires:
Customisable designs complete with Argentine leather saddles.
monochromebikes.com

4.
Pedalers Fork, Los Angeles: This restaurant-cum-bike shop offers full custom builds and US brands.
pedalersfork.com

Clockwise from top left: Thumbs up to seeing Rio de Janeiro on two wheels; more than 60 per cent of Copenhagen's population commute by bike; a team outing in Addis Ababa;

a bicycle made for two in Berlin; cyclists cross Berlin's Rosenthaler Platz

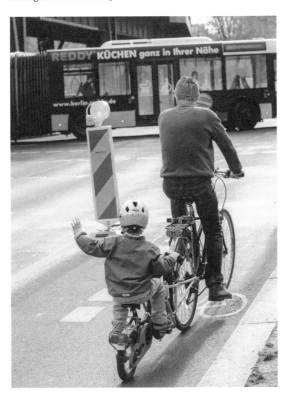

Head to the hills
Get high

In common metaphors the mountain is an obstacle to be scaled – but that needn't always be the case. Heading to a higher altitude doesn't have to mean topping K2; instead, it could be a day on the slopes of Mount Fuji with the family or a ramble up Scafell Pike in the British Lake District with a pooch. Mountains, remember, offer vantage points both literal and figurative and can be places of beauty to hike or ski. Most things – mountains included – depend rather a lot on your perspective.

Why I love the mountains
by Victoria Cagol

It's high up in the mountains where I feel most at home. I was born in the heart of the Italian Alps, just a few kilometres from the Austrian border.

Growing up, we would head into the mountains on long family hikes – nothing reminds me of my childhood more than the sound of gently clinking cowbells. On these adventures I picked up an armoury of new skills, including how to identify edible mushrooms and how to determine north by looking at the moss growing on a rock (a skill I should probably add to my CV).

When the city's frantic pace becomes too much, I grab my hiking boots and hop on a plane home. Once there, I head straight for the hills – to breathe in the crisp air and bask in the rugged beauty and quiet that envelops those ancient peaks.

Time seems to flow more slowly up there and, somehow, food tastes better at altitude too. You can't beat a big meal in a snug wooden cabin followed by a glass of homemade schnapps – best enjoyed with a sunset backdrop and warm bed waiting.

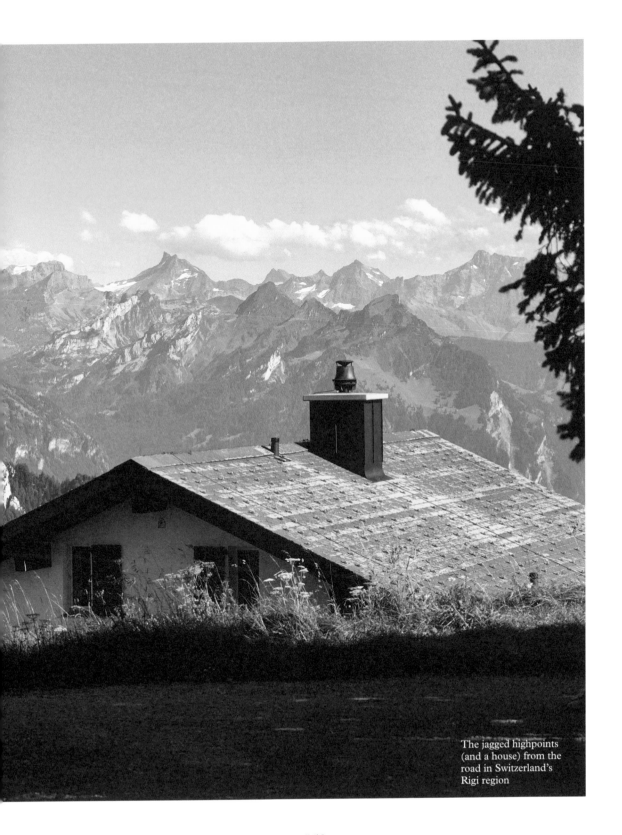

The jagged highpoints (and a house) from the road in Switzerland's Rigi region

Take a hike
New outlook

Anyone who has hot-footed it up to Griffith Park and seen Los Angeles at sunset knows the value of an urban hike. A healthy hike from the coffee shops of pretty Los Feliz, you'll see the city anew. A glimpse one way shows the rolling Santa Monica Mountains – what this patch of California looked like before the city shot up – while in the other direction you'll see what makes the city special today. Just be careful of the coyotes.

Why I hike
by James Chambers

Hong Kong is hiking mad so it didn't take long after moving here before I was at the outdoor sports shop buying my first pair of hiking shoes. Some people go all out, and dress themselves up as if they are tackling Everest, but most trails in Hong Kong are cemented, well-signposted and can be taken on straight out of the gym.

My allergy to treadmills is one reason why I went running for the hills; the other is to get away from the crowded city. Don't get me wrong, I love the hubbub of Hong Kong. I just love it even more that I can leave my high-rise apartment, walk up some steps and continue going uphill until I reach the sylvan slopes of Hong Kong island – a convenient and incredible contrast.

Hong Kong's hiking trails are surrounded by amazing scenery and the nature can be as wild as what goes on in Wan Chai, from monkeys and water buffalo to the odd wild boar. Looking down over modern Hong Kong and Victoria Harbour never gets dull; nor does the reward for climbing up hundreds of steps: ending up on one of the city's beaches for a refreshing dip in the sea.

1.
Beirut
Beside the seaside

The Corniche is the perfect ambling spot in a city choked by traffic and with little public space. This sun-drenched seafront promenade is one of the few places where Beirutis can stretch their legs, so it's usually filled with everyone from hawkers to children learning to cycle. For your sunbathing fix, keep going towards Raouche for Sporting Club, a city institution that dates back to the 1960s.

2.
Rio de Janeiro
Double trouble

The best way to discover Rio's tropical topography is by hiking Morro Dois Irmãos (the Two Brothers Hill). These twin peaks sit at the end of Leblon Beach and are synonymous with Rio's skyline. To reach the trail take a taxi to Vidigal then a van or a motorbike to the top of the favela. The 1.5km-long trail weaves through rainforest, breaking occasionally to reveal sweeping views. Awaiting you at the peak is arguably the best panorama in a city with many contenders.

3.
Seoul
Dress the part

Don't let Seoul's concrete towers fool you: the tallest structures in the land are the mountains that frame the city. On weekends the capital's denizens grab their trekking poles and fill backpacks with rice cakes and *makgeolli* (sweet rice wine) before heading out on hiking trails that range from leisurely strolls to gruelling feats of strength. For the adventurous, Seoul's highest peak in Bukhansan National Park (reaching almost 850 metres) is worth the challenge.

4.
Vienna
Take your pick

Vienna boasts easy access to nature in all its forms: there are hills, lakes, rivers and great plains all to be found within the city limits. A favourite destination is Döbling, Vienna's 19th district. From there, you can set out on different trails taking you through rolling vineyards and the Vienna Woods. In the summer months, many end their hike by cooling off in the scenic Krapfenwaldlbad swimming pool.

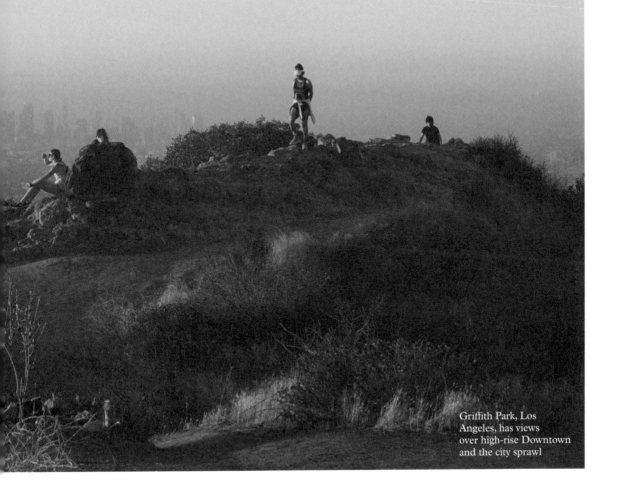

Griffith Park, Los Angeles, has views over high-rise Downtown and the city sprawl

Shake a tail feather
The way you move

Not everyone knows every language but we all know one universal way of communicating, even if we lack practice or finesse: dancing. That odd, rhythmic congruence of limbs is life-affirming and fun. Evolutionarily it's a waste of energy but just try telling that to these folks in Milan. Forget the cliché about dancing as if no one's looking – life is a social experience. People *are* looking, which is all the more reason to put on a show and shake what you've got.

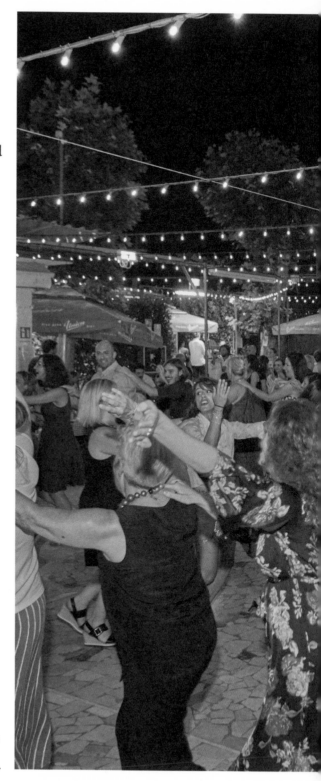

Why I dance
by Holly Fisher

I recently fell into an exercise rut until a friend introduced me to a dance class: 45 minutes of high-energy aerobics to 1990s pop. I beam my way through every routine. It shouldn't come as a surprise; I love to dance. It's a way of physically connecting to my favourite songs and other people.

The dance floor holds some of my most beloved memories. I think of those I've graced on Miami rooftops, Belgradian boats and in Milanese museums, and the less fancy: nightclubs, festivals, weddings and sticky-floored kitchen discos.

At every great event there's a dance floor, somewhere to let loose, where endorphins fly high and where friendships are made – shimmying up to someone is just another way of starting a conversation. It often starts out awkwardly but soon enough you sense people physically shaking off whatever weighs them down.

There is a unique elation that comes from dancing that's as addictive a high as any other. That moment where it clicks and you're in the groove and it's just you and the music (and maybe a partner, if you're lucky).

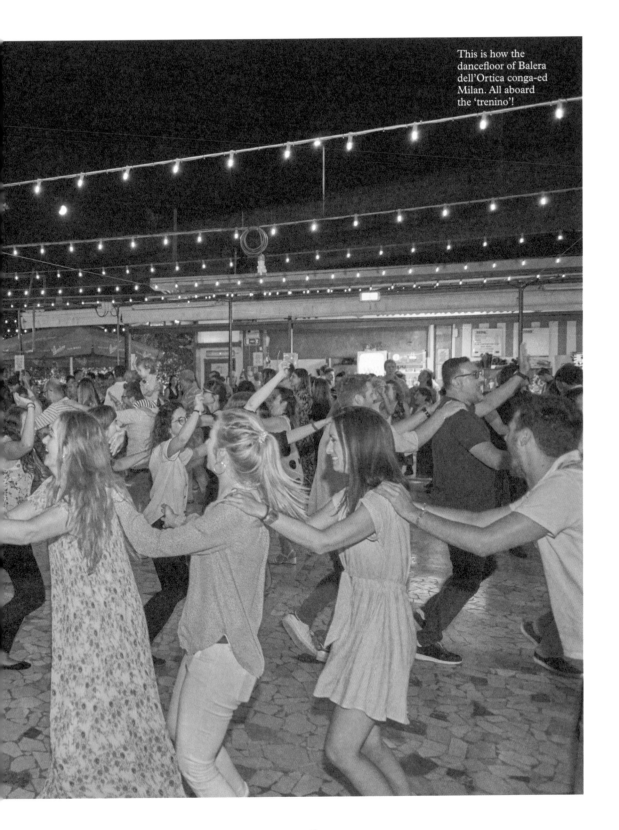

This is how the dancefloor of Balera dell'Ortica conga-ed Milan. All aboard the 'trenino'!

Pick up a racket
Holding court

Fancy a game? If there's a metaphor here to rally around it's that tennis, like life, is a game of reaction as much as action. Success is partly about being prepared, well-drilled (and passably fit) but it's as much about what you return and how well you react to what comes your way. Being agile, competitive and engaging in a (hopefully good-humoured) dialogue with your opponent is a challenge we all face each day at home and work. So what can tennis teach us? For starters, there's the idea of a 'let' – you know, when the ball hits the net on a serve and it's no-one's fault: the server merely gets another go. Shouldn't we take this idea to heart in our off-court dealings too? That little moment of forgiveness despite the desire to win and be right? There's a net gain for all of us in this line of thinking.

So, whether you've secured a spot at the court of LA's modernist Sheats-Goldstein Residence (*pictured*), are practicing backhand at the beguiling Palma Sport & Tennis Club, or more likely, playing somewhere more homespun, then do take time to acknowledge your faults as well as others'. Get it? Let's bounce.

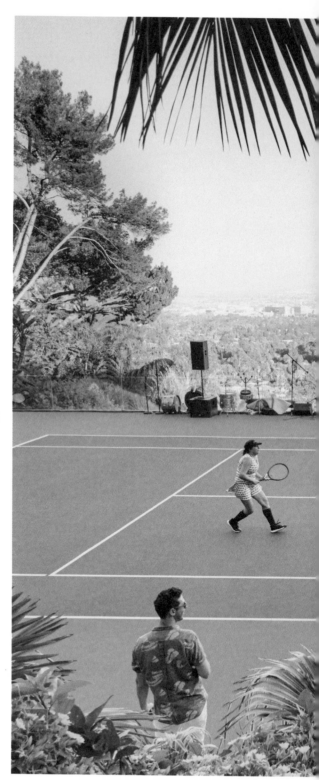

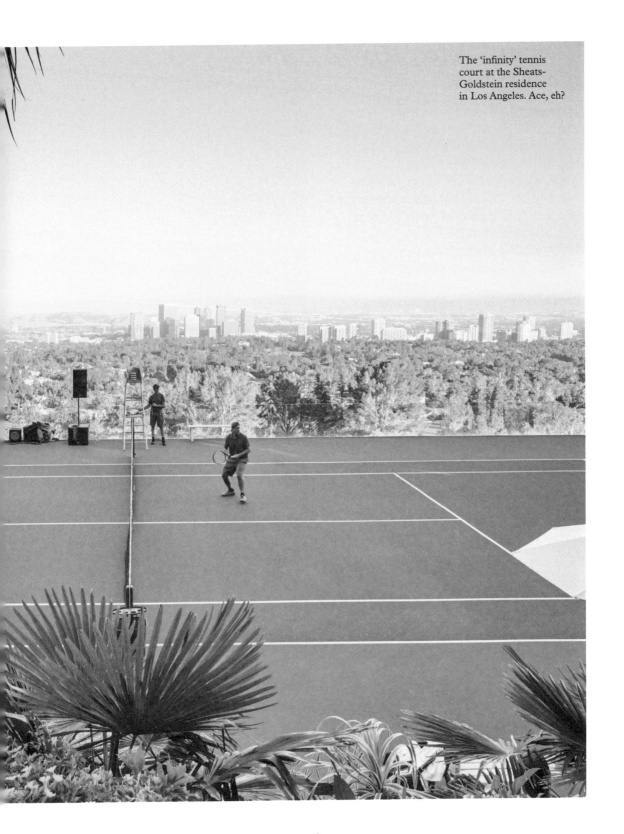

The 'infinity' tennis court at the Sheats-Goldstein residence in Los Angeles. Ace, eh?

Get competitive
In it to win it

Drive 40 minutes south from Sydney's central business district, through the Edwardian neighbourhoods of the Inner West and down along the south coast, and you'll find yourself in Cronulla, a quiet suburb where it seems that little has changed in the past 50 years. It's here that you'll find the South Cronulla Bowling Club.

The clientele may be longer in the tooth than you might expect from a sporting organisation but the competition is fearsome in its own way. Here life-long friends vie with new competitors to steer their lawn bowls alongside that illusive jack and nab the bragging rights for the week to come. Competition, remember, is good for us: it drives us to better things and increases our focus.

Done too boisterously, though, and it can overshadow the game and make everyone miserable. If we're going to take one thing from the residents of Cronulla it should be this: winning is one thing but the spirit in which a game is undertaken is usually the deciding factor in how it ends up. Shall we get rolling then?

Join the club
by Josh Fehnert

The internet is full of communities and "friends" but few that seem to help us forge the sort of connections that we find truly meaningful. This sad fact is borne out by research that shows many people today feel more lonely than ever before.

So what to do? Well, trust the Danes to come up with a simple but ingenious solution. Studies suggest that they are among the happiest nations on Earth and attribute some of this to a high level of participation in clubs. This doesn't just mean heading down to a squash court once a week but could include meetings of board-game aficionados, group sojourns to the sauna (clothing optional) or even architectural tours on the third Wednesday of every month.

The thing to recognise is that joining a club helps create the social capital that we've lost. So go on, get some skin in the game. If you can't join the local team then support it. Or, if you can't stand them, start a club to express your disapproval.

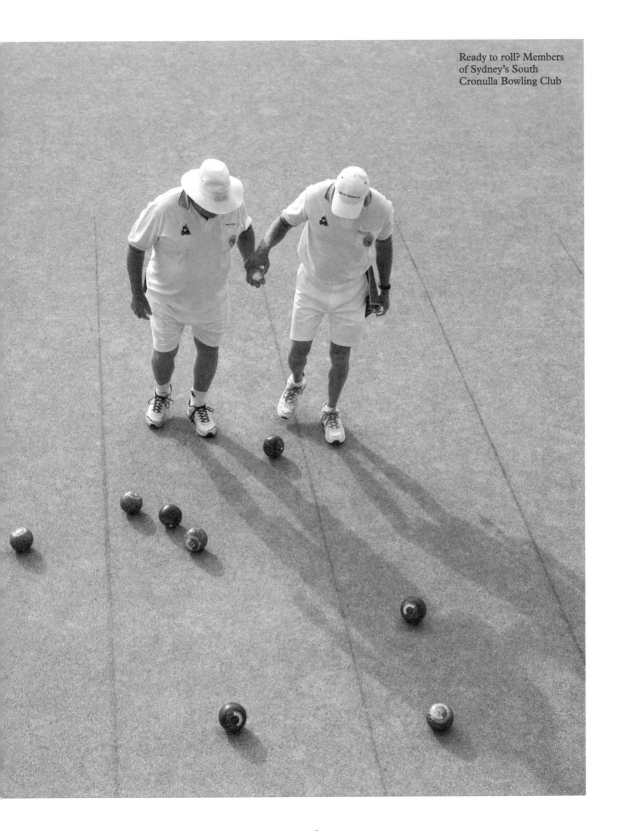

CHAPTER 8

Get lost

By rail or road, and to places
unknown and paths unexplored.
We chart a few roadtrips to relish.

Get lost

If this book were a journey it would most likely be a road trip – maybe in a convenient, uncomplicated but beautifully kitted-out camper van. As we unpack what it means to live a gentler life we've decided against the disorientating world of transcontinental travel and opted instead to document itineraries that unfold like the track before us.

Whether it's a dusty road through the Atlas Mountains or a sojourn across the US/Mexico border that sees glimpses of a shared food culture rather than talk of walls, we've chosen journeys that are life-affirming, atmospheric and inspiring. MONOCLE's origins lie in a love of travel, of taking the window seat – or, in this instance, the wheel – and getting going, hitting the road, sleeping under new skies and meeting new people in fresh settings. Here we set out a series of ideas for trips that celebrate the journey as much as the destination. You better start packing – it's almost time to leave.

Rail for change
Just the ticket

One of the comforts of train travel is that it's grounding – you can't wrest control from the conductor or change course. You have no choice but to sit back and enjoy the journey. So go on, put your feet up (metaphorically, of course).

All change, please. Shifts in how we move around have opened up the entire world to us but there's plenty to be said for seeing the world for yourself – through a train window, for instance. We cover more distance than any previous generation but, as a result, are we further from that frisson of excitement that travel once imparted? Maybe it's all those overnight business trips and intercontinental meetings. Luckily, although it's more important than ever to be present, people are finding a better balance between scratching their itch to travel and not flying too wantonly.

There's much to be said for taking the slow lane sometimes, completing a journey at a pace that allows you to glimpse fields, mountains, lakes and people. And before you say it, this isn't indulgent nostalgia or misplaced Victoriana. Rail offers a very modern take on our transport conundrum. It's relatively cheap, public-spirited and much more sustainable than taking to the skies. It's seeing a resurgence too, particularly in Europe where Austrian rail is reconnecting continental cities with clean carriages and even sleeper services that celebrate service, hospitality and having a comfy place to kip before you pull up in Vienna, Berlin or Prague for your morning *ristretto*.

No matter your destination, train travel offers a helpful steer – to acknowledge the signal changes, delays and delights that you can't control and to simply enjoy the ride. We're sure there's a life lesson in their somewhere. All Aboard!

Clockwise from top left: Anyone else getting into the Spirit of Munich?; the Semmering Railway passes over a viaduct in Austria; evening light illuminates passing landscapes and passengers alike on a train ride through France; views on Switzerland's Glacier Express, which runs from Zermatt to St. Moritz through Andermatt

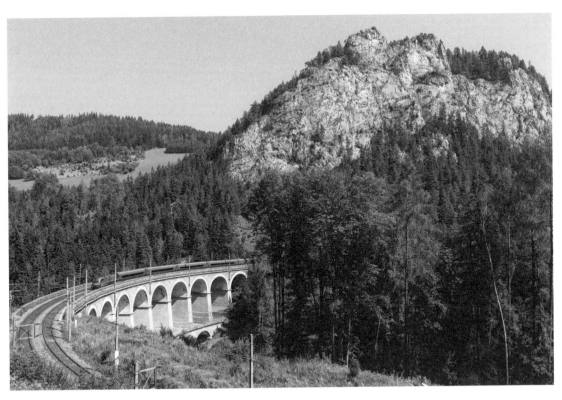

FIVE TOP TRAIN TRIPS

1.
Moscow to Beijing: The Trans-Mongolian railway follows an ancient tea-caravan route through the wilds of rural Russia and the Gobi Desert.

2.
Glognitz to Mürzzuschlag, Austria: The UNESCO-protected Semmering railway was built in the mid 1800s – it runs along viaducts and through spectacular mountain landscapes.

3.
Pretoria to Cape Town, South Africa: The luxurious Blue Train boasts views of the Karoo desert, Hex river pass and Table Mountain.

4.
Los Mochis to Chihuahua, Mexico: The Copper Canyon Railroad weaves through the dramatic scenery of the Sierra Tarahumara, passing through 86 tunnels and over 37 bridges.

5.
St Moritz to Zermatt, Switzerland: Passengers on The Glacier Express enjoy panoramic Alpine views through specially-designed sightseeing windows that extend along carriage roofs.

Happy campers
Pitch perfect

Few activities embrace the adventure – and independence – of a good old camper van. It's a reminder that sometimes the simple option – that gets you from A to B then leaves you alone to enjoy the stars – is the seemliest.

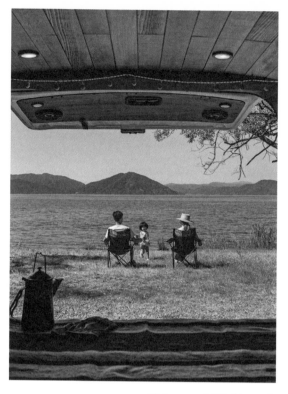

This spread: Takahiro and Yuki Fujita set up camp next to Japan's Lake Biwa with their son Natsukia

Not so long ago, any mention of the words "motorhome" or "RV" might have conjured images of the silver set manoeuvring ugly and unwieldy homes-on-wheels into laybys or fed-up families on cut-price escapes. But times are changing – and few things encompass that shift more than the downsizing in vehicles that's happening around the world. Many are asking the question: do we *need* a gas guzzler to get around? What are the costs (beyond that hefty price-tag) of travel that's bad for us and by turn for the planet? Are there delights closer to home that can be explored without a long flight or tedious transfers?

Enter the camper van. Convenient and uncomplicated (you drive somewhere nice, get out, have a picnic maybe), the popularity of these scaled-down holiday solutions has sped up over the past few years as families or young couples set out to explore the countryside – often of their own country. So whether you're investing in an Airstream or taking to the road in your Volkswagen Westfalia (or "Westies" as devotees and surfers dub them), there's an element of independence that these cosy quarters afford travelers.

Another shift is towards a more conscious manner of tourism. Anyone who's been to Venice, Barcelona or Reykjavik in peak season can tell you that these great cities can quickly lose their sheen when the crowds descend. Is it better then to aspire sometimes to a simpler escape? The sort when you might cook on an open flame, see the starry sky at night or spend a little time with your loved ones in nature? Sounds like an escape to us.

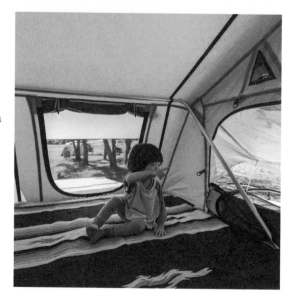

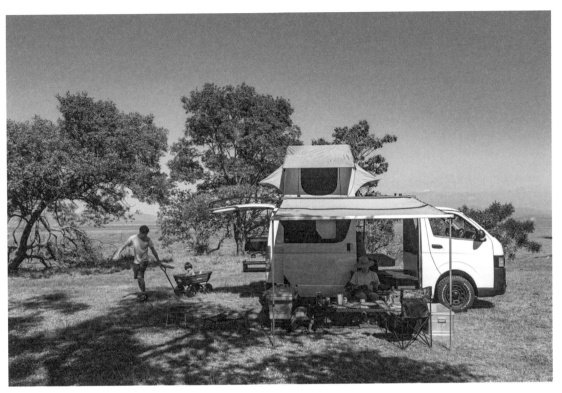

ROAD TRIP I

Baja California

Crossing borders can highlight change and difference – but it can also be a reminder of what unites us, wherever we hail from. The frontiers of the US-Mexico border may grab headlines from time to time, but our trip discovers a shared food culture in bloom and a landscape saturated with escapism.

ROUTE: San Diego — Tijuana — Popotla — Ensenada — Valle de Guadalupe — Tijuana

DISTANCE: 298km

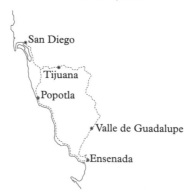

DAY 1.
San Diego to Tijuana

As international borders go, there are few more contentious than the one that separates Mexico and the US. But you'd be forgiven for forgetting about any tension during the short drive from San Diego in California to Tijuana, the largest city in Baja California – Mexico's westernmost state, which stretches south from the border, like a tendril, into the Pacific. The drive is swift; our car cruises along the winding highway beneath the wide welcome sign bearing the word "México" in cheerful red letters. Mexican and American pop tunes merrily compete, with radios audible from cars with windows wound down in the sweltering heat. The road is lined with colourful canopies of street carts that have been set up to take advantage of hungry and thirsty drivers and their passengers. Food and drink, such as candied fruit and juices, have come to define this cross-border area. And the culinary experience continues in Tijuana, the first stop on our journey along the state's west coast, where food culture and entrepreneurship have found a way to flourish.

DAY 2.
Tijuana to Ensenada via Popotla

The next call on our road trip is the port city of Ensenada, 100km south of Tijuana. This highway too is dotted with food stops, as well as convenience stores and billboards for Tecate, the first Mexican brewery to can beer in volume; it was founded in Baja in 1944. After a 30-minute drive along a road that hugs the rocky slopes down to the shore – the tuna-fishing nets visible far out in the marbled blue water below – make a pit-stop at Popotla's fish market and order a handful of clams dressed with zingy salsa.

DAY 3.
Ensenada to Tijuana via Valle de Guadalupe

The poetically named Ruta del Vino stretches languidly northeast from Ensenada into the mountains of Valle de Guadalupe, Mexico's wine-making hub. After a light lunch of cactus tostadas, oysters and a glass of sparkling rosé at nearby Bruma – a vineyard-hotel opened by David Castro Hussong in 2015 – it's time to begin our 90-minute drive back to Tijuana, forgoing the coastal highway for the picturesque route inland.

Clockwise from top left: Serenaded over ceviche in Tijuana; fresh catch at Popotla; on the road again; poached octopus at Deckman's, Valle de Guadaloupe; lunchtime crowd at Deckman's; service with a smile

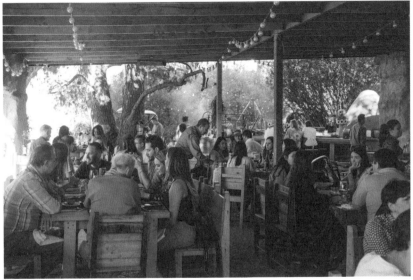

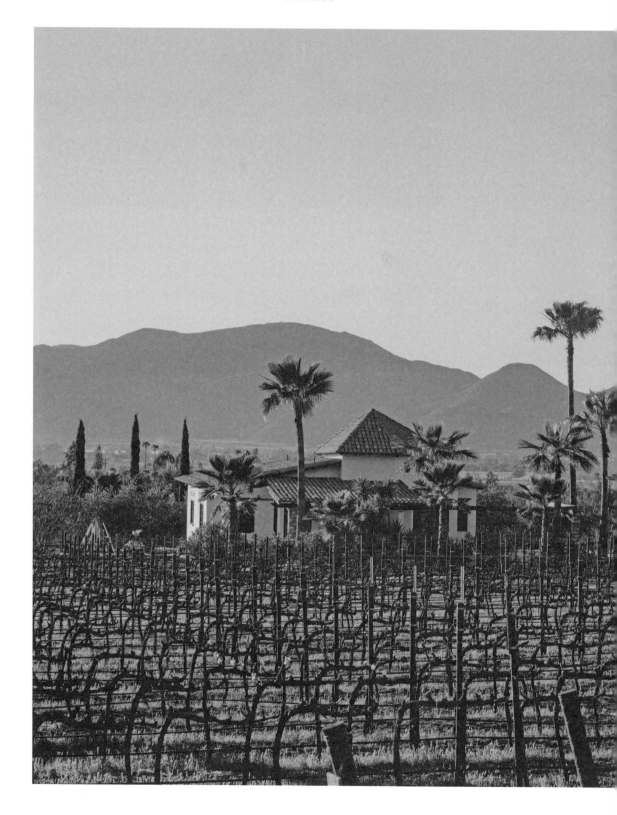

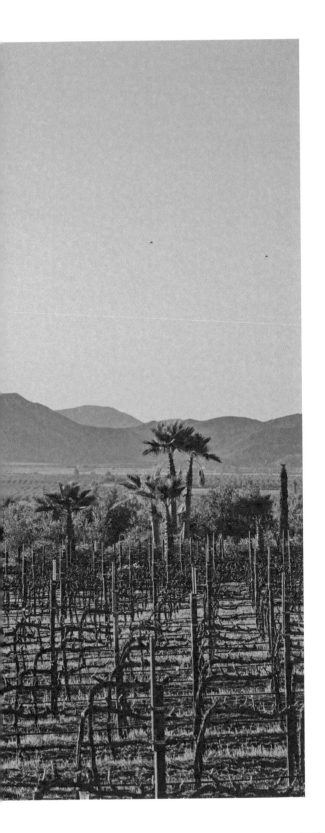

Left: Lechuza winery
Above: Mixed ceviche lunch at Popotla fish market

ROAD TRIP 2
Northern Spain

Many who travel to northern Spain are eyeing up pintxos and the Basque Country's crop of world-famous restaurants – some fulsome, others fussy. We take a bit of a detour, through the northern regions of Cantabria, Rioja and Navarra before arriving in Santander in time for dinner.

ROUTE: Pamplona — Estella — Logroño — Villoldo — Santander

DISTANCE: 493km

DAY 1.
Pamplona to Estella

Depending on who you ask, the region of Navarra is either an estranged extension of the Basque Country or a fiercely independent nation in its own right and the area's towns have seen borders drawn, dissolved and disputed for centuries. We start by pulling up a chair at a café in one such town – Pamplona – and ordering the early-morning staple: a tortilla, sliced and stuffed like a sandwich with lettuce, ham and mayonnaise. Fed and on the road, a 40-minute drive southwest is Estella, founded in 1090 by King Sancho Ramírez to cater for the pilgrims travelling along the Camino de Santiago. The 12th-century French scholar Aymeric Picaud raved about the town's bread and wine in the *Codex Calixtinus*, which is regarded as one of the first tourist guidebooks. Fortunately the food here has evolved since then, thanks in part to Taller Gastronómico Casanellas – a small family-run restaurant that also offers cookery classes. Stroll down the stone-paved streets and you'll find Lerma Heladeria, an ice-cream shop that churns out flavours such as cheese, fig and dulce de leche.

DAY 2.
Estella to Villoldo via Logroño

Continuing southwest over the border and into La Rioja – Spain's most renowned wine region – we arrive in the capital, Logroño, just before lunch. The city centre brims with bustling *taperías* (tapas restaurants) and food halls flogging *chistorra* (chorizo with sweet paprika and garlic). The countryside flattens out during the two-and-a-half-hour drive southwest to Castile and León, a region dotted with small villages. In Villoldo, the Estrella del Bajo Carrión hotel and restaurant – a Scandi-style institution run by three sisters, who inherited it from their parents – is best for food.

DAY 3.
Villoldo to Santander

Charting a winding course through Cantabria's inland mountains, we arrive at Santander in a shade under three hours. The coastal capital has been attracting new attention since the sea-facing Centro Botín arts centre was unveiled in 2017. The modern addition has added some sparkle to a city that saw much of its heritage devastated by a blaze in 1941.

Clockwise from top left:
Varietals from Castillo de Cuzcurrita winery; the Comillas Pontifical University; Estrella del Bajo Carrión's lounge room; market time; 'ensaladilla rusa' (Spanish potato salad); Pamplona's Café Iruña; chef Borja San Martín Casanellas at Taller Gastronómico Casanellas

Overleaf, left to right:
Santander anchovies; watching La Rioja's grass grow

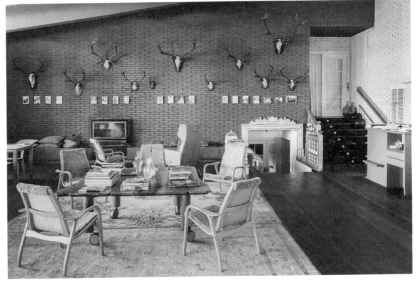

ROAD TRIP 3
West Morocco

Morocco can be vivid and unpredictable – not what many might call gentle, but hear us out. Our winding way across the nation uncovers some of its mysteries along with dreamy, ancient landscapes, hidden coves in which to hit the waves and plenty of charm to boot.

ROUTE: Essaouira — Imsouane — Taroudant — Tafraoute — Marrakech

DISTANCE: 811km

DAY 1.
Essaouira to Taroudant via Imsouane

It's easy to make plans and promises but the Moroccan road will surely break them. In Essaouira after a warm, thick night drinking Stork and smoking kif at Le Trou, crêpes and *café nus-nus* (half espresso, half milk) and the stiff Atlantic breeze make it a fresh morning on the roof terrace of the Villa de l'Ô hotel. The view is one of the finest in town: the old kasbah and the cold, rolling ocean unbroken until the Americas. The road fires due south from Essaouira to the surf town of Imsouane – a sort of promenader's dreamland and a super-sun microclimate. From here, the road inland to Taroudant is a rare, flat thing. We follow the Oued Sous past palms, fields, farms and donkeys led by women in hijabs and djellabas. Taroudant is all "old town", still happily hemmed in by mud city walls, dwarfed by the soaring High Atlas to the north and shading the green plain to the south. The kasbah is a moribund maze but the souk is electrically mercantile with heat and dust, meat and fruit and veg, carpets, cafés and spice. Of course we buy rugs.

DAY 2.
Taroudant to Tafraoute

The next day – after the first azan is called at 05.21 by a muezzin in Willard White's bass-baritone – we rumble south through the Anti-Atlas to the oasis of Tafraoute. We roll and roll and the heat is hot and the ground is dry but the air is full of sound. Grasshoppers and songbirds and goats and, by now, the crackle of everything underfoot, crisp under the sun. Our road pours us downhill into the relative verdure of Tafraoute, the jewel of the lush Ameln Valley, beautiful as the dusk hits the red and granite of its rocks.

DAY 3.
Tafraoute to Marrakech

We follow a new road towards Agdz then curve back up towards Marrakech. As elsewhere we stop for tea and talk French to locals and roadside men. We're late and the dim lights are flickering. The stops and the photographing of camels, the issuing of sweets to children, the lying against the dusty car, all means that our date with the final destination soon approaches. We make a wide U-turn and stop; it's the end of the line.

Clockwise from top left:
Keeping cool in the kasbah; Moroccan produce; fresh from the tailor; glimmer of light; the surf town of Imsouane; craggy hilltop settlements

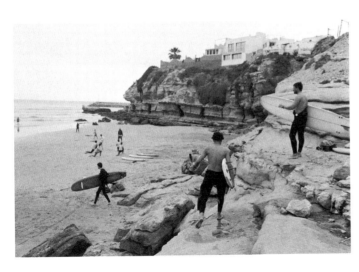

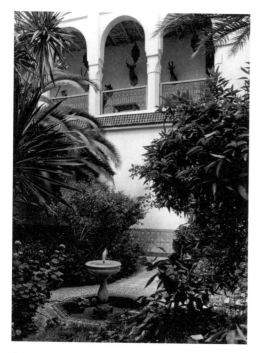

Above: A riad's palm and fruit garden
Right: Misty morning on the road to Agdz

ROAD TRIP 4
The American South

Our journey from Louisiana to Texas takes in gumbo, drive-thru liquor stores and vast stretches of not very much at all. But there is life and soul to be found in the vastness and stories to be told over bottles of beer and games of eight ball. Fix your eyes on the horizon, and we're off.

ROUTE: New Orleans — Natchitoches — Navasota — Del Rio — Marfa
DISTANCE: 1,674km

DAY 1.
New Orleans to Natchitoches

We begin in the quarter of New Orleans called Algiers, an irregular grid of pine-boarded shotgun houses and grand mansions fighting to stay tidy against nature's tropical tide. Then we take the road north towards Baton Rouge. It starts as a thrilling loop of high road on concrete stilts over dark water, swamp and half-sunken trees. We thunder on through big, flat countryside north to Natchitoches, a pretty town of porches and hanging baskets and three barn-sized drive-through liquor stores.

DAY 2.
Natchitoches to Navasota

The flatness recedes and rolling hills and trees become pines and the deep, dark water of Sabine Lake as we cross the state boundary between Louisiana and Texas. The Davy Crockett National Forest is big, dark, evergreen and endless. Eventually we reach Navasota but the grill at the Western Club is bust so it's fried stuff only.

DAY 3.
Navasota to Del Rio

Driving at dawn does things to the mind: the rush of adventure, the paradise of going somewhere that's still so far away. The countryside opens again and never stops. It's 100 degrees as we bomb southwest on the small roads south of Austin to Del Rio, which is nominally on the Rio Grande but is really a border town, cut in half by a line rather than a natural wonder of the world. The Rio is not so Grande here and the town is one of boarded-up hopes.

DAY 4.
Del Rio to Marfa

We finally arrive in Marfa, the town where Donald Judd bought a house to get away from the high society of New York's art scene. He loved the town, better still the craggy and inhospitable high desert beyond. Las Casas, a three-hour drive from Marfa along rough tracks, is Judd's most remote ranch, unfinished in his lifetime. Coming back into town for a night of pool and beer at the Lost Horse saloon is a relief – but, man, it feels busy after the hills.

Clockwise from top left:
Tahona Yolanda Garcia
Lohan Rodriguez
Amarindes de Montoya and
his owner David Sleeper;
giddy-up; winding through
White Sands, New Mexico;
early-morning pick-
me-up; Las Casas, Judd's
unfinished masterpiece of a
ranch 130km outside Marfa;
strike a pose; a longhorn,
stuffed yet nonchalant, at
the Mission-style Hotel
Paisano in Marfa

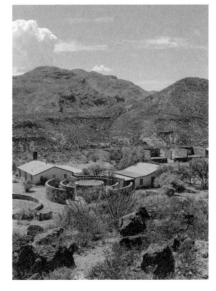

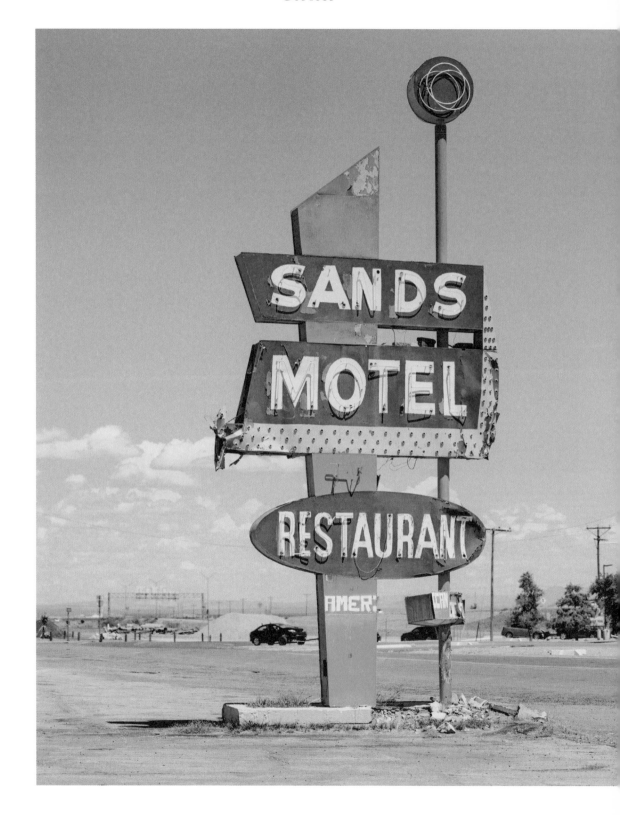

Left: The beckoning finger to a night of rest
Below: Blowing brass at the Spotted Cat Music
Club on Frenchmen Street in New Orleans

ROAD TRIP 5
Western Honshu

Most restaurants in Japan are in cities but in rural Hokuriku (in the northwestern part of the main island) a young crop of restaurateurs are hoping diners will follow them into the wild. The fish found in the frigid waters of the region are reportedly the tastiest of any netted around the country – come with us to find out.

ROUTE: Toyama — Hakusan — Komatsu — Kyoto
DISTANCE: 355km

DAY 1.
Toyama to Hakusan

Japan may be known for its spotless Shinkansen train service but driving around the country also reaps rewards, as we learn in the west of the central island. We begin our day early, getting up in time to admire the rising sun illuminating the mountain-ringed bay of Toyama from the Amaharashi coast. Then we hit the road south to the coastal city of Kanazawa, which has long been a centre of the seafood trade and is where many traditional methods of preserving and preparing food were forged. The waters of the Sea of Japan are cold and the tide is fast, making the fish from this stretch the most sought-after for sushi. We press on southwest to the small seaside town of Mikunichosaki where we sample some of the region's famous seafood for ourselves at Lull, a surf'n'turf restaurant in an old wooden house overlooking the ocean. Then it's inland towards the snow-capped Hakusan mountain range, stopping off en route at our home for the night. The remote Furari Inn is nestled beside a stream that provides owners Keisuke and Ayako Takagi with fresh *ayu* (sweetfish) for their guests. We tuck in hungrily and head to bed with full stomachs.

DAY 2.
Hakusan to Komatsu

Back on the road, we roll down the valley to the Noguchi Naohiko Saké Institute, led by the legendary *toji* (master maker) after whom it's named. The brewery uses the mountains' glacial waters to create some of the country's finest saké, which we sample (responsibly) before heading back towards the coast. In Komatsu we enjoy a meal of contemporary Japanese dishes at Shokudo Yarn then continue the night at the cosy jazz *kissaten* (coffeehouse) Parlour Ako.

DAY 3.
Komatsu to Kyoto

We take the scenic route 305 to Tsuruga, which curves around the craggy coastline with the dazzling blue ocean on one side and thick pine forests on the other, before shooting south along the western bank of Lake Biwa. After a cooling dip in Japan's largest freshwater lake at Omimaiko Beach, we carry on towards Kyoto. An authentic *terahaku* (temple stay) at the elegant Myogo-in in Miidera means we're well-rested and raring to explore our final destination.

Clockwise from top left:
Strolling the streets of
Toyama; dinner in Kyoto;
Toyama Castle sits in a
park in the centre of Kyoto;
stepping out in style; Furari,
a small Japanese inn near
Mount Hakusan; 'Inoshishi
nabe' (boar hotpot) being
prepared at Furari

Overleaf: A view over
Mount Haku

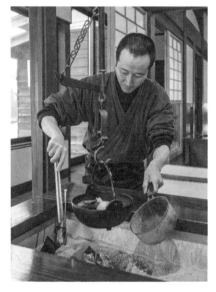

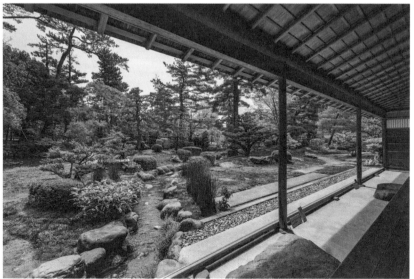

CHAPTER 9

See new places

For a weekend or for the foreseeable.
We profile the patches that promote
a gentler pace of life.

See new places

A change of scenery can do wonders for our mood. These outposts of opportunity, idealism and escape all offer two things: space to unwind and experience some quiet reflection but also to meet people who changed their lives and swapped city living for a slower pace. From a windswept island off the Danish coast and a surprisingly serene seaside resort in the Gulf of Thailand to a sandy Australian outpost in New South Wales and an artsy city in Mexico, these laid-back destinations offer a glimpse of what life can be like.

Never mind if you're not quite ready to quit your office job to make blueberry jam from local fruit on Orcas Island in the Pacific Northwest – but maybe you'll have a clearer idea of whether it could be for you one day if you visited for a weekend? In that spirit, we've laid on a spread of places that, to us, sum up both the advantages and opportunities of a life lived in a lower gear. Calm seas and balmy climes are beckoning.

Orcas Island, Washington State
USA

Cast adrift in the Pacific, this easy-going island has attracted people looking to start small, honest food businesses. Whether you fancy joining for a weekend or settling in for longer, here's why island life is so alluring.

Just off the northwestern coast of Washington state, in the Salish Sea, is Orcas Island. It's the largest of the San Juan Islands by size – although not population – and it has long attracted hikers, rowers and nature lovers to its pebbled shores. The cobalt-blue ocean unfolds at its edges while emerald-green forests climb mountains and freshwater lakes are scattered across nature reserves.

As you might expect, Orcas Island is laid-back – almost impossibly so. That fact is made abundantly clear to visitors upon arrival: a natural-wine bar is found at the ferry dock. It's just one stop among the island's vibrant and fast-growing food and drink scene. Most of the restaurateurs and producers (of which there are many for an island of 4,500) arrived for similar reasons: to run a business in a place with a mellow pace of life. That, and they had their sights set on the island as an escape.

Best of all, while the Pacific Northwest is often associated with rain – endless rain – Orcas Island is often bathed in sun. The reason being that it sits proudly on the northeastern side of the Olympic Mountains, firmly in the "Olympic Rain Shadow".

Despite its understandable growth in popularity as a weekend getaway for Seattlites, it also hasn't changed much according to locals, most of whom are glad to have the extra business. The island remains home to a tight-knit, like-minded community of people who moved there for a gentler existence – and it's not difficult to understand why.

ADDRESS BOOK

1.
Stay: *Outlook Inn:* Book one of the waterfront suites at this small hotel on the edge of town.
outlookinn.com

2.
Eat: *Doe Bay Café:* Eat fresh oysters on the sun-soaked deck while gazing at the ocean.
doebay.com

3.
Drink: *Champagne Champagne:* Located at the ferry dock, this low-key bar serves natural wine.
champagnechampagne.me

4.
Shop: *Girl Meets Dirt:* Audra Lawlor abandoned a career on Wall Street to make zingy preserves from local fruit.
girlmeetsdirt.com

5.
Do: *Mount Constitution:* Hike to the island's highest point for the views.

GETTING THERE

Seattle-Tacoma International Airport is a two hour drive from Anacortes, where you can catch an hour-long ferry to Orcas Island – or, if you're feeling flush, a private boat or seaplane.

Hua Hin
Thailand

The image of the country propagated by Pattaya and its party-prone islands couldn't be further from the reserved way of life in this small seaside resort on the Gulf of Thailand.

Since the 1920s, when the Southern Railroad connecting Thailand to the Malaysian border was built, Hua Hin's red-and-gold-coloured wooden station has welcomed Bangkok residents decamping to the seaside resort city. For decades, they've arrived in search of relaxation, which can be found in bucket-loads along the sandy waterfront.

With few beach nightclubs, Hua Hin has a tranquil poise that sits in stark contrast to its racy eastern cousin, Pattaya. The focus here – thankfully – is more on what happens during the day. People come to be beside the sea and play golf, but mostly to relax. Mornings on Hua Hin's beach find sunbathers spread on the white sand while Thais shun the intense early-afternoon heat in favour of shady pool-side umbrellas and beachfront cafés. At this time of day sleek bistros are packed with patrons enjoying coffee or cocktails with a touch of *sabai sabai*: a Thai expression equivalent (though less irksome) to the Danish concept of *hygge*.

Along the pier you'll find Swedish, Swiss, German, Norwegian and Russian flags adorning restaurants that cater for homesick travellers. Many of their owners came here to wait out long winters back home, but eventually stayed and now support foreign-language newspapers and radio stations, as well as a healthy property market. When the clock tower chimes 16.00 it's time to head back to the beach, lemongrass mojito in hand. These last few daylight hours may not help the tan but that's not really a priority in Hua Hin: *sabai sabai* is a much breezier affair.

ADDRESS BOOK

1.
Stay: *Hyatt Regency:* Say hello to a teak reception area, gardens and a spa. Book into The Barai: a hotel within the hotel.
huahin.regency.hyatt.com

2.
Eat: *Jek Pia:* Be prepared to queue (it moves fast) for a table at Jek Pia.
+66 (0)32 511 289

3.
Drink: *Let's Sea:* Family-style Thai dishes are on the menu with breakfasts served on the seaside patio.
letussea.com

4.
Shop: *Seenspace:* A beachside mall offering homeware, fashion and stationery produced by small Thai businesses.
seenspace.com/huahin

5.
Do: *Hua Hin Beach:* This 4km long white sand beach along the Gulf of Thailand is a good spot for swimming, lounging and sunrise.

GETTING THERE

Hua Hin is a three-hour drive, or a four-hour train ride, from Bangkok. Air-conditioned buses depart every 30 minutes and have ample space for bags.

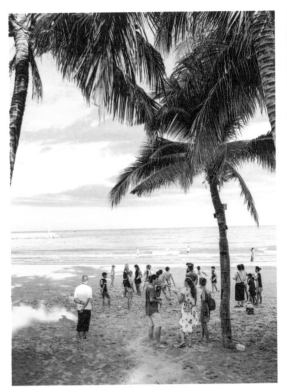

Fanø
Denmark

This windswept Danish island is blessed with lashings of seafood, much in the way of hospitality, a national park and a bountiful shoreline along which to amble and unwind.

Evidence of the occasionally wild weather along Denmark's coast is everywhere on the island of Fanø. The wide sandy beaches are flat and wind-worn; the spindly grass is low and hardy. The North Sea coastline might not seem appealing to visitors but that's where we're happy to correct you: this small island off Denmark's west coast has been charming visitors and in-the-know blow-ins for decades.

Lapped by the Wadden Sea, Fanø was long a mooring point for mariners but has always attracted a trickle of landlubbers too. It was in the late 1800s when seaside stopovers such as the Great Spa Hotel, Strandhotellet and Hotel King of Denmark first opened their beachfronts to sunseekers (the people, not the yachts) and the area is now a Unesco World Heritage site.

Despite the weather and a lack of homegrown ingredients (the ground is little more than sand), Fanø has become revered for its food. The salt air lends flavour to lamb and wild herbs, while island traditions such as smoking and salting fish – once a necessity to preserve them over long winters – are now considered delicacies.

On the south of the island, in the village of Sønderho, sits one of Denmark's oldest and best-preserved inns. Sønderho Kro has a 300-year history and started as a haven for fishermen; now it's an inn and restaurant run by chef Jakob Sullestad. After enjoying the culinary heights of its old-world dining room there's a welcoming bed in the 13-room inn, with its low ceilings, wooden beams and paisley wallpaper. Not much has changed in Fanø – and that's for the best.

ADDRESS BOOK

1.
Stay: *Kellers Badehotel:* A restaurant and inn with nine sunny loft-style rooms. *kellersbadehotel.dk*

2.
Eat: *Sønderho Kro:* Delight in dishes such as cod with garlic and crispy sage. *sonderhokro.dk*

3.
Drink: *Fanø Bryghus:* Housed in a former power plant, this brewery produces some of Denmark's best beers. *fanøbryghus.dk*

4.
Shop: *Rudbecks:* The place to pick up cheese, jams and other island delicacies to take home. *rudbecks.dk*

5.
Do: *Wadden Sea National Park:* Denmark's largest national park is home to tidal flats and sand dunes.

GETTING THERE

Billund Airport is 45km from Fanø. A shuttle will take you to the seaport town of Esbjerg, where you can catch a 12-minute ferry to the island. Local buses will meet you on arrival.

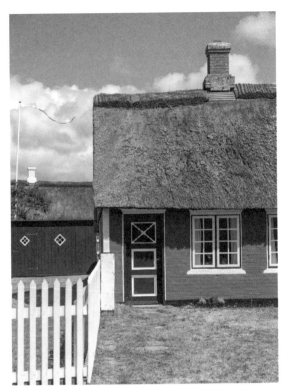

Yamba & Angourie
Australia

These two coastal communities in New South Wales
are celebrated as much for their café culture as their surf.
Oh, and everybody's on first-name terms.

Yamba and Angourie, on the northern coast of New South Wales, have been on Aussies' radars for some time. But it's only in recent years that the neighbouring outposts have come into their own.

Yamba has been pegged as a new – albeit smaller and humbler – Byron Bay by some but we're not keen on such comparisons. It has the same charm minus the hordes of backpackers and the (sometimes tiring) bohemian vibe. With a population of 6,000, it's the kind of place where the bakers, farmers and surfers are all on first-name terms. Fishermen sell catch from their boats, while a flurry of acclaimed restaurants – many founded by returning locals – have sprung up. The result is a destination whose draw is as much about the food and café culture as it is the beaches, surf and wildlife.

And there's plenty of that. Yamba is celebrated for its idyllic surroundings: there are no less than six beaches to be found a short stroll from the centre of town. In winter, walks along the nearby Yuraygir National Park coastline are perfect for whale watching. Kangaroos hop down the main drag at dusk and sea eagles soar overhead.

With a population of a few hundred, neighbouring Angourie is tiny, but people make the pilgrimage both for the Green and Blue Pools – former quarries that are now popular swimming spots – and, of course, the surf. Surrounded by a national park, the town remains charming partly due to the fact that it can't grow any larger. But Yamba is changing for the better – it's no longer just a seasonal tourist destination but a place to lay down roots.

ADDRESS BOOK

1.
Stay: *Private rentals:* For views over Convent Beach, try for an apartment on Ocean Street.
Yamba

2.
Eat: *Karrikin:* Yamba's most inventive restaurant reworks classic dishes.
karrikinyamba.com.au

3.
Drink: *Paradiso:* Grab a cocktail and some dumplings in this surf shop turned bar.
paradisorestaurant.com.au

4.
Shop: *Rooster and Rabbit:* Former Moulin Rouge dancer Merindah Byrne Prétet mainly sells clothes from European designers.
1/16 Coldstream Street, Yamba, 2464

5.
Do: *Green and Blue Pools:* Residents leap off the surrounding rocks into these freshwater ponds.
The Crescent, Angourie, 2464

GETTING THERE

Yamba is a two-hour drive from the Gold Coast Airport and various regional airports, and a three-hour drive south of Brisbane. From Yamba, it's a speedy eight minutes to Angourie.

Mérida
Mexico

Some places have a magnetic pull – a gravity that attracts like-minded people. This Yucatán town was in ruins until recently but a renaissance in small businesses and the arrival of independents have made it an artsy escape.

Found on the western tip of the Gulf of Mexico, Mérida – the capital of the state of Yucatán – has long absorbed outside influences. Take Cuba, just a short hop away, with which Yucatán shares a penchant for the guayabera shirt. As the shirt suggests, the heat in Mérida means life is best lived at a leisurely pace.

Luckily it's a pleasing place to be, which might have something to do with the way hours amble past this city, which appears to be stuck in a time warp. Or perhaps it's thanks to the Yucatán region's strong sense of identity – it twice declared independence from Mexico – which has resulted in food and culture that feel very much its own.

Whatever the case, Mérida, with its population of 900,000, has been undergoing some changes of late. There has been an influx of Mexicans from other states, attracted by the city's safety, and foreigners lured by a sense of adventure (and a bargain if you're used to US house prices). A creative crowd – from artists to chefs – has introduced new galleries, restaurants and hotels, some in repurposed haciendas.

Those in need of further adventure can visit the Mayan pyramids of Uxmal, make the most of the countless *cenotes* (natural swimming holes) in the area or take a short drive to the coast. But there are few things more pleasant than sitting in a cantina in the city's charming, crumbling centre sipping on fragrant, house-made gin with a *sotol* (a northern Mexican spirit) chaser in the humid, sticky air of Mexico's sunny southeast.

ADDRESS BOOK

1.
Stay: *Urbano Rentals:* Josué Ramos and John Powell have restored a collection of seemly colonial houses. *urbanorentals.com*

2.
Eat: *Taqueria La Lupita:* Head here for a meaty breakfast of slow-cooked *cochinita pibil* (pulled pork) tacos. *taquerialalupita.com*

3.
Drink: *La Negrita Cantina:* This bar has live music every day and is always packed. *+52 (999) 924 6591*

4.
Shop: *Lagalá:* Refuel at Te Extraño Extraño in this shopping centre, a restaurant that serves first-rate *chilaquiles* (corn tortillas). *lagala56.mx*

5.
Do: *Paseo Montejo:* Stroll along this street and ogle the mansions of Mérida's gilded age.

GETTING THERE

Most international flights stop off at Mexico City on their way to Mérida's Manuel Crescencio Rejón International Airport, a 20-minute taxi ride from the centre of town.

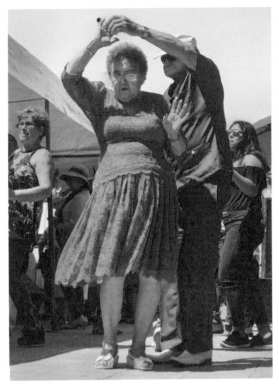

Thessaloniki
Greece

Thessaloniki is a village. Or at least that's how everyone who lives there describes Greece's second city: a laid-back, low-rise jumble where all the tree-lined roads seem to nudge you towards the turquoise waters of the Aegean. But this "village" is home to more than a million people, has a thriving hospitality and creative scene, and is filled with life and laughter even late on a weeknight (gentle doesn't mean boring, remember).

Cheap rents and an affordable cost of living have transformed Thessaloniki into a spot for small businesses looking to, ahem, test the waters. Many have opened small hotels and restaurants, both capitalising on northern Greece's abundance of tasty produce.

GETTING THERE

Thessaloniki Airport Makedonia, 16km outside the city, is served by several international airlines. Alternatively, fly to Athens and either rent a car or catch a bus (both of which take about six hours) or hop on a train (which takes four and a half hours).

Locarno
Switzerland

When you picture a Swiss city, you might envisage trams gliding past prim and proper façades. Then you visit Locarno, a sun-kissed settlement of palms and piazzas where winding streets lead to pastel-coloured palazzos exuding old-world charm. That's not to mention the unspoiled valleys, mountain peaks and the deep-blue waters of Lake Maggiore.

Despite being home to fewer than 16,000 people, Locarno rivals major European cities with an enviable cultural calendar. The undisputed star is the Locarno Film Festival, which sees the main piazza converted into an open-air cinema and draws an A-list crowd who come for the relaxed approach that's light on glitz. This is Swiss living but with an Italian twist: a winning combination.

GETTING THERE

Trains run from Zürich to the canton of Ticino (an hour away from Locarno by car) every hour, and every morning direct from Basel to Locarno itself. Lugano Airport, a 40-minute drive from the city, offers only a few seasonal flights.

Yilan
Taiwan

Visitors driving to Yilan emerge from the Xueshan Tunnel and are immediately struck by a stunning vista: the deep blue of the Pacific Ocean and the variegated greens of the plains of Yilan stretching all the way to a distant mountain ridge. No wonder the city has a reputation for being the garden of Taipei.

Yilan was mostly thought of as a pleasant place for a summer weekend sojourn from the capital but in 2006 the Xueshan Tunnel halved the journey time between the two and turned this east-coast destination into a viable place to live and work. The city of fewer than 500,000 residents covers almost the same surface area as Taipei (which has more than two million), so those searching for room to breathe often end up here.

GETTING THERE

While Taiwan Railways Administration connects Taipei to Yilan (the fast train takes up to 80 minutes), the quickest option is to travel by bus. After 15 years of construction, the 13km-long Xueshan Tunnel opened, making it an hour's ride between the cities.

Annecy
France

Annecy can't be pigeonholed. While this small alpine city is home to traditional restaurants and the requisite number of ski-sea shops, these humdrum offerings brush shoulders with artful independents and smart brunch spots too. The city of 130,000 is thriving – and for good reason. Plenty of ex-Parisians and Lyonnais now call Annecy home, drawn by the lake, the mountains, the climate and, of course, the languid pace of life.

Annecy's boom of new businesses – from cafés to florists – has been fuelled in part by the buying power of the city's residents. While many still commute across the border to Switzerland, those who choose to stay home and set up shop can enjoy a lunchtime picnic by the lake or a late-afternoon cycle through the mountains.

GETTING THERE

By plane, your best bet is to fly to either Geneva Airport (50km away) or Lyon–Saint Exupéry Airport (125km away) and hop on a train or bus – or rent a car if you fancy having a bit more freedom. The TGV from Paris's Gare de Lyon takes up to five hours.

Boulder
USA

It's worth rising early in Boulder to drive the short distance to the start of the Chautauqua Trail. As the sun comes up you can take in vistas of the city and the breathtaking Flatirons: jagged rockfaces that dominate the scenery. If any proof were needed of the quality of life in this city of 108,000, nestled in a valley near the Rockies, it's here. With sunshine about 300 days a year, Boulderites are an outdoor tribe.

Almost all native and adoptive residents say the sense of community and talent pool were decisive factors in staying. There's something fascinating about the currents moving through this place, from tech start-ups to regenerative farming projects via health-food brands. Boulder seems to have perfected the work-life balance.

GETTING THERE

After flying into Denver International Airport, which is roughly 65km from the city, your best bet is to rent a car to make the 45-minute drive north. Alternatively, the RTD's SkyRide bus connects the airport to Boulder, and there are also various shuttle services.

Bergen
Norway

Tucked away in southwest Norway and book-ended by rolling mountains, Bergen is the gateway to the fjords that splinter the country's western coast. Naturally, recreation options abound. Besides hiking, residents take summer dips in crystalline seawater pools; in winter, picturesque train lines whisk them inland to ski resorts in Voss and Geilo.

Forewarning: the wet weather can be tiresome. But for those who don't mind a bit of damp, the climate has also proven useful in creating a buzzy hospitality scene that's enlivening the city's once-tame nightlife. With a population nearing 300,000, Bergen isn't a big city – but its creative industries are thriving, new hotels are opening and reasons to visit are rising.

GETTING THERE

You can fly directly to Bergen Airport Flesland, a 30-minute bus ride from the city centre, or catch the train from Oslo. Alternatively, take one of the high-speed ferries that zip along the Norwegian coast, or rent a car and wend your way there via the country's scenic fjords.

Madeira
Portugal

Closer to Africa than Europe, Madeira – an autonomous region of Portugal – enjoys sub-tropical weather, an ocean breeze and, increasingly, tourists coming to explore its wonders both natural and man-made. The island's regional government has invested in a network of new roads and tunnels that better connect outlying coastal towns to the capital, Funchal, and Madeira is showing signs of moving beyond the nation's financial woes of the late 2000s.

But the magnetic charm of Madeira lies in the fact that, while other holiday destinations succumb to the desires of visitors, this island paradise remains a place for residents. It maintains a tight-knit community feel and that's its greatest draw.

GETTING THERE

There are regular direct flights from Europe to Cristiano Ronaldo Madeira International Airport (really), as well as quick and easy flights via TAP Air Portugal from Lisbon to Funchal, the capital of the Madeira archipelago, if you're coming from the mainland.

Naha
Japan

The residents of Naha are known for their bright, individualistic nature and sunny disposition – no doubt fostered by the city's warm climate and tropical landscape (sandy beaches lapped by emerald waters tend to have that effect). The weather has had a strong influence on Naha's architecture too. Constructing in concrete is the norm and the once-vivid-now-faded, box-shaped homes are reminiscent of the work of both Luis Barragán and Tadao Ando.

In recent years many people have relocated to Okinawa from the mainland and the blend of influences is creating an entirely new culture: the region is one of the few coffee-bean production areas in Japan and Naha is now home to several world-class roasters and exceptional coffee stands.

GETTING THERE

Visitors touch down at Naha Airport, located on the southern island of Okinawa; a flight from Tokyo's Narita Airport takes up to three hours. While in town, the Okinawa Urban Monorail makes getting around easy and there is also a large bus network.

Find a balance

Do something you adore but don't forget to do it generously – and take some time away from it too.

Find a balance

Forging a positive relationship between your life and livelihood will improve both immeasurably. Does the job you do leave you feeling fulfilled at the end of the day? Can you square your beliefs with the behaviour of your employer? Is there a business idea that you've long pondered but kept putting off? Now's the time to answer. Whether you're a bookkeeper bent on becoming a beekeeper or you just want to carve out an hour to have lunch at home with your family a few times a week, we've got advice, ideas and suggestions galore.

If you can live gently, you can work gently too. So, how can you tweak your workplace to make your team happier and why does breaking bread together (away from phone and laptop screens, please) improve morale, focus and productivity? We're not saying that you need to start again to be happy (you'd know better than us if this were the case, anyway) but we are insisting that we all ask a few searching questions about what we do and why we do it.

Take the gentler approach to business
By Sophie Grove

In our adrenaline-fuelled world of billion-euro unicorns and big exits, it's easy to get swept up in the race. But fast isn't always better. Here we explore the advantages of taking it slow and how, in the long run, it pays to be the tortoise instead of the hare.

Why go into business? Is it to secure a global brand, to brave the slings and arrows of venture capitalism and create a market monopoly? Or is it quite a different impulse; a yearning to create something that will propel you out of bed in the morning? To build something that does good, that gives you purpose, fulfilment and even a palpable sense of joy?

There will always be that business archetype, the suited CEO hell-bent on chasing unicorns. Or the sleek, single-minded leader intent on flipping a profit. And there's no doubt that cutting corners can offer quick rewards. Yet many entrepreneurs are choosing to nurture close-knit businesses and expand them at a more gentle pace. They are creating projects anchored in communities with the aim of restoring pride in neighbourhoods. Rather than voracious growth, these enterprises are a slow-burn, happy to do one thing well. Whether it's retail, hospitality or design, they're led by a robust set of values rather than complex consumer research and spreadsheet projections.

A sense of altruism is no barrier to profitable success – quite the reverse. Rather than clouding business acumen, a clear sense of ethics brings a galvanising clarity to a new venture. "If you have a really strong set of corporate values then strategic decision-making actually becomes very simple," says Celia Moore, professor of organisational behaviour at Imperial College Business School. "That efficiency drives sustainability and profitability. There's a lot of waffling that happens when you want to look ethical but you really want to cut corners. You end up doing this wiggle – trying to thread a needle that really doesn't exist."

It's easier than it appears to circumvent the waffle – a clear mission can be as good as any complicated business plan. "I set out to revive a factory," says Corinne Jourdain Gros, who gave up her job as a publicist to purchase Digoin ceramics, a sprawling factory complex in rural Burgundy, in 2014. The company's brown glazed stoneware was once a firm fixture of every French kitchen. Digoin employed hundreds of locals to produce brown glazed vessels used for making cassoulet and commercial mustard and even by butchers for cooking terrines. Plastic saw the demise of Digoin's fortunes and the company was recently shuttered when Jourdain Gros stepped in.

Her vision for the business began with an urge to save skilled jobs in the local community and preserve a way of life she feared might disappear. "In France there used to be a specific dish for every regional speciality," she says, adding that her reimagined Digoin stoneware is now stocked

by everyone from The Conran Shop in London to Merci in Paris. "There's a new generation that wants to use our vinegar-making urns, our pots for preserving cornichons. This is part of a movement."

A strong mission statement is a steady steer for expansion when and if a business starts to grow. "It's about doing things that feed the mission, and that mission feeds the business," says Lucie Basch, who co-founded the anti-food waste app Too Good To Go in 2015 (and now runs 15 offices across the world with 600 employees.) Basch admits that she never planned on running a global company. When her platform quickly took off, the company fell back on the strength of its conviction as a guide. "A lot of people think and then do," she adds. "We went for it."

With their teenage growth spurt behind them, Basch says the team have spent time defining their philosophy and integrating it into every strategic decision. "Now because we're growing so fast it's super important for us to work on our values," she says.

There's a growing sense that a strong, benevolent philosophy, which puts a premium on employee wellbeing, can reap rewards for businesses. "Working somewhere that does good and is good feels good," adds Moore. "Research

This isn't just about designing an HQ that offers beanbags (or even architectural talking points). It's a question of liberating employees from their desks

shows that if you have an organisation with a strong social mission you can get excellent employees and they will stay for longer; they will have higher levels of commitment. Leaders who are courageous recognise what a powerful force this can be."

Clever business owners realise that the wellbeing of their staff is key. Companies are investing in space and resources to give them room for contemplation away from the clatter of keyboards, from rooftop vegetable gardens to in-house yoga. This isn't just about designing an HQ that offers beanbags (or even architectural talking points). It's a question of liberating employees from their desks and allowing them to meet, talk, sit outside and feel good about work.

Umberto Napolitano, who co-founded the Paris-based LAN architecture studio, believes there is value in encouraging staff to contemplate in

beautiful surroundings. He opened a new Paris headquarters in 2018 and designed two-thirds of the space to feel like a home. While there are desks-in-rows on one floor, above there's a sitting room with indigo sofas, a kitchen, a refectory, a lush courtyard and some big sunny rooms with no stated purpose. Above that, there's even a flat roof laid out with outdoor seating. "You have to invent the way you use the space and that freedom brings creativity," says Napolitano, who admits that unshackling the staff from their desks took some time to reap rewards. "In the first period there was a lack of concentration. It's a bit like a Montessori education: we have this freedom, what do we do with it? But step-by-step people have become very reactive. Now, after a year, I can see the results."

Napolitano has created a way of life for himself and his 34 employees. His Parisian practice – like many offices, workshops and factories – is a cause, a calling and a reflection of his and his partner's ideals. With some iconic projects under his belt he feels that now is the time to consolidate rather than expand. "Society has been driven by the idea of progress and capital gain but now we're thinking about an alternative kind of life,' says Napolitano. "How much time do you want to spend with your family? How do you want to live?"

The challenge for him, as for many successful business owners, is how to preserve the practice's size and unique dynamic. It's a philosophy that's not about growth but the quality of each working moment. "Now there's a deep and complex question, which is, 'How do we experience this level of architecture without becoming a machine?' How do we keep in context with the world without being in our own prison of results and economy."

Napolitano's answer? To open a Sicilian restaurant on the ground floor of his practice called Pianoterra. Rather than adding more staff, this project is about widening the project and engaging with the neighbourhood. "It's the idea of creating an ecosystem that allows us to eat well, to have a meeting over a coffee in a public space," he says. "It will also be an art gallery. You should come down."

Preserving the humanity, the joie de vivre and the authentic essence of a business is just as challenging as rolling out a global franchise. So, perhaps it's time to raise a glass to those small, gentle, perfectly balanced businesses which have plotted a careful path to expansion – and perhaps it's time to join them.

Improve your workplace
Time for an update

We were told that workplaces would become less relevant but the opposite is true. Here's how to improve your lot – and the happiness and efficiency of your staff while you're at it.

We can't escape the niggling feeling that our offices aren't all that we had hoped they would be now. The hollow promise that the internet would liberate us from desks to work feet up, cocktail in hand, on a distant sandy shore was perhaps, in retrospect, a stretch. But what's worse is that a swathe of data-driven consultants and over-excited architects have prompted the rise of all manner of sinister, sensors-on-seat style solutions to the perceived problem of inefficiency.

We have a sunnier take on what a well-run workplace should look like and we've pinned up some metaphorical Post-it notes here with suggestions for reintroducing a touch of humanity into humdrum offices. Our ideal workplace would provide modest spaces for staff to share a meal while enjoying each other's company – but also places for silence, where workers could escape the let-me-tell-you-about-my-app milieu that thrives in open-plan offices. Workplaces should be seen as embassies – buildings that reflect a company's ethos, not second homes with ping-pong tables.

So, here are our suggestions for a healthy company culture and happier workforce. The offices of the future might not resemble the fantasies of the past but follow our advice and that needn't be a bad thing.

1.
A shorter workweek
Call time

You won't meet many dissenters if you float a (slightly) shorter workweek – and the benefits can be manifold. Efficiency spikes when people are better rested; they become more focused (and plain friendlier) the further they are from their wit's end. Be sensible with it, mind: endless out-of-office replies or phones left ringing won't be good for business. Instead, foster a balance between presenteeism and professionalism that works for you.

2.
A sense of perspective
Money matters

Fairer wages and incentives for professional development will keep staff fulfilled, particularly in sectors such as retail or hospitality. These are careers, remember, not stop-gaps – and the people forging them should be respected by being remunerated fairly. Also, it's great that you've got some students in to help, but don't forget that age brings benefits too.

3.
A little security
Friendly faces

A convivial doorman – the kind who waters plants while keeping an eye out for interlopers – is better than CCTV cameras. The sense of safety you provide can be more visible and human too.

4.
A boardroom
Table talks

Sealing the deal doesn't have the same gravitas on beanbags, so invest in a space with business-clinching potential. A sophisticated meeting room will project an air of trust – just make sure you avoid the frosted glass and high-shine steel.

5.
An office to be proud of
Swish setting

Your office is an embodiment of your brand and the work you do. Plants, natural materials and plenty of light help; a nice neighbourhood offers diversions after work. No one will think you're savvy or trustworthy if you're working from a corridor on the 13th floor of a dingy tower block.

6.
A canteen
Eat up

Do you have a space that your staff can use to escape their desks and cook together? Use it. Crumbs in keyboards and crinkled cans cramping desktops are off-putting, especially when you're showing clients around. A modest communal kitchen will get the team talking (*see overleaf*).

7.
An affable staff
In good company

At the risk of offending HR professionals, why not hire people who are qualified *and* pleasant, someone you can also stand to socialise with? Going with your gut can pay dividends.

8.
A little help
Let them eat cake

A housekeeper – or homemaker, if you prefer – is great for a little dessert diplomacy when things get fraught. She or he will also be on hand when it comes to replacing light bulbs or stepping in when a meeting room needs a last-minute spruce.

9.
A no-nonsense title
Noble calling

A confession: We're not sure what your "new experience guru" or "retail Jedi" actually does. Will this "global changemaker" live up to the grandiloquent title? Less jargon and fewer acronyms will help charges understand and fulfil their roles, rather than relentlessly gasbagging about innovation and getting nothing done.

10.
An office dog
Ruff justice

A dog in the office is a metaphor for loyalty, acceptance and care. It adds levity, signifying openness and shared responsibility in an environment that can reduce colleagues to cogs and to-do lists. Can't face Fido? Why not commission a fun company mascot?

Eat with your colleagues
That's lunch

Eating at work doesn't have to mean a sad supermarket sandwich served in the glare of a screen. Encouraging workers to take a break away from their desks increases productivity in the long run and making lunch a communal activity can be an excellent morale booster with just as many benefits for employers as employees. We stop by a few staff get-togethers for inspiration – tuck in.

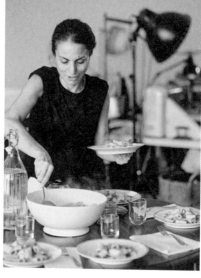

Reinhard Plank
Lunchtimes at the Florentine base of South Tyrolean hat-maker Reinhard Plank are a communal affair and pasta with peppers and *rigatino* (herb-cured Tuscan pancetta) is a favourite.

Agrarian Kitchen Eatery
As paying guests wind up their lunch at Tasmania's Agrarian Kitchen Eatery, the chefs are already preparing for the staff meal that follows. It's a chance for dishes to be trialled.

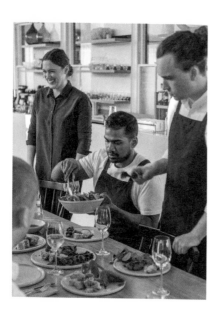

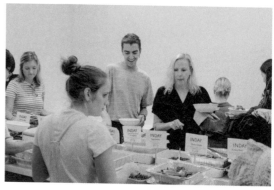

Warby Parker
Despite its size (with some 2,000 employees), eating together is an important part of life at eyewear brand Warby Parker's Manhattan headquarters. Every Tuesday the company has a meal catered for its staff and partners with nearby restaurants to devise the menus.

Bureau F
Employees of Viennese design agency Bureau F are regularly spotted taking coffee breaks and hosting barbecues on their spacious rooftop.

Cobe
At the offices of Danish architecture studio Cobe, the team often comes together for informal meetings, strong coffee, and Friday after-work drinks.

Here Design
Much of what London-based graphic-design studio Here Design does is about food, so it's natural that lunch is a big deal. Every Friday there's a company-wide banquet cooked by different staff members.

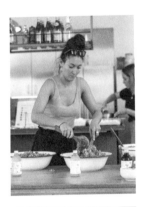

CASE STUDY I

Anne-Virginie Schmidt
Canada

Quitting her office job as a bookkeeper to learn
beekeeping turned out to be a sweet deal for the new
co-owner of Canadian apiary Miels d'Anicet.

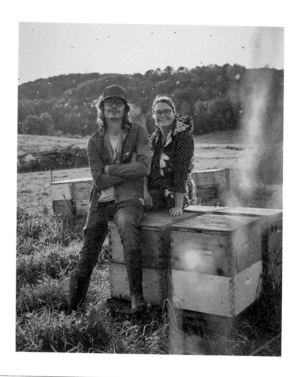

Accountant ————————————————————————— Beekeeper

Miels d'Anicet, an apiary that's home to 70 million bees and, arguably, Canada's best honey, can be found 250km northwest of Montréal. It was founded in 2000 by Anicet Desrochers (*pictured, left*) and in 2002 received a boost in the form of a new owner: Desrochers' partner, Anne-Virginie Schmidt. The pair fell in love when Schmidt was an accountant at auditing firm KPMG. "I wasn't happy," says Schmidt. I was part of different businesses, learning different processes, but my hands weren't on the product." So she quit and moved north to learn beekeeping.

Today, Miels d'Anicet is buzzing. It's Canada's largest Queen-bee breeder, supplies honey to top-class restaurants and has its own range of skincare products. Despite its remote location, the farm receives more than 20,000 visitors each summer. "People from all over the province come to learn about the different kinds of honey we're making," says Schmidt, who handles marketing, finance and sales. While the demands of the job are significant, she's much happier than when she was stuck in an office. "This is a perfect lifestyle for us," she adds. "We've had a happy life with nice projects and challenges – and there's plenty in front of us too."

Kim Heeju and Lee Sanggyu
South Korea

For the founders of furniture brand Daoom, swapping
Seoul's 'bali bali' (hurry hurry) work culture for the beach
town of Yang Yang was a shore thing.

Account executive and an engineer ——————————————— Furniture brand owners

Kim Heeju and Lee Sanggyu's favourite meal is *mak-guksu* (buckwheat noodles), a speciality of Gangwon province where they now live. The married couple relocated from Seoul to Yang Yang on South Korea's east coast and their biggest lifestyle change has been the chance to have dinner together.

The idea of changing careers and coasts first arose when Kim, formerly an account executive at a marketing agency, noticed that her engineer husband was increasingly anxious about work. Lee resigned in 2016 and spent two years studying the carpentry trade before moving to the beach town

(a popular weekend getaway for stressed Seoulites) to set up furniture-making business Daoom.

After two decades of Seoul's *bali bali* ("hurry hurry") work culture the pair is now enjoying a slower pace. Lee fashions cabinets and other items out of walnut, maple and black cherry, while Kim manages sales and marketing from the adjoining office and works as a freelance editor. Downing tools at 18.00 means Lee now has time to cook. His signature dish? *Tteok-bokki* (spicy stir-fried rice cakes). "No matter how old you are, it's never too late to do something you like," says Lee. "It's worth taking a risk to be happy."

CASE STUDY 3
Philipp Humm
UK

It may not be the standard career path for an artist but this former CEO juggled a corporate job and his creative side for some time before focusing solely on art.

Big-brand CEO ————————————————————————————————————— Artist

After studying philosophy and failing to get into art school, Philipp Humm opted for a career in business. He quickly rose to the upper echelons of corporate culture, became vice president for Amazon in Europe, then CEO of T-Mobile USA and finally CEO of Vodafone Europe. But he couldn't suppress his artistic instincts, at one point working 60 hours a week and spending another 40 creating art. In 2015 he left his job and decided to become a full-time artist.

Since then Humm has painted, sculpted, taken photographs and even ventured into film-making, with a feature-length movie version of

Goethe's play *Faust*. Although still very much at the beginning of his career, he has also been lucky enough to have enjoyed solo exhibitions at London's Saatchi Gallery and Riflemaker.

It's given him a new lease of life. "As a CEO you have lots of freedom but it's not the same," says Humm. "Being an artist is about doing something you're really burning to do. I don't have more time now, I just spend it creating things, which brings a different kind of fulfilment." His day job may have changed but his work ethic is the same: "Whatever you do, either do it with passion or don't do it at all."

Hawa Hassan
USA

This former model had no idea that when she traded the latest fashion designs for traditional Somali recipes she – and her chilli sauce – would end up being a hot ticket.

Fashion model ———————————————————————— Hot-sauce brand owner

In 2014, Hawa Hassan left her home in Brooklyn to spend some time living with her mother in Oslo. She had been modelling from the age of 16 and the move was a chance to reconnect with her mother and discuss what she wanted to do next with her life. "I had pretty much maxed out my feeling of wanting to model," says Hassan. "I'd gone into modelling with all these big ideas of changing the industry and having conversations that were really important. But I didn't feel like I was fully utilising my brainpower or my creativity."

Encouraged by her entrepreneur mother, she began developing ideas for a chilli sauce based on traditional Somali recipes. "I didn't know how I was going to do it but I knew that if I kept putting one foot in front of the other things would come to pass," says Hassan, who moved back to Brooklyn to launch the brand Basbaas (the Somali word for "chilli"). Her smoky tamarind-date sauce and spicy coconut-coriander chutney proved a hit with the city's culinary community, winning her stockists up and down the country as well as a deal to co-author a recipe book on African cuisine.

CASE STUDY 5
Hopie Stockman
USA

When she quit her job to attend Harvard Business School,
the co-founder of Block Shop not only set up a new
company – she reunited with her sister in the process.

Investment consultant ———————————————————— Textile brand owner

While working as an investment consultant in San Francisco, Hopie Stockman had got her morning routine from alarm clock to work down to 17 minutes – a way of countering the long hours and early mornings by maximising her time in bed. She admits that she had no interest in her job, it was just the best-paying position she could get after graduating. It wasn't until a mentor at the company encouraged her to apply to Harvard Business School that things began to change. She quit San Francisco for Cambridge, Massachusetts to study, and reunited with her sister Lily, who was teaching undergraduate painting there.

Stockman wanted to get back to her creative roots so the pair hatched "a loose plan" to launch Block Shop, a firm selling block-printed textiles from India. It started as a passion project, with the duo posting orders to clients in between classes. Today it has grown into an all-female business of eight based in Los Angeles that Stockman runs full-time with her sister – quite a change from the world of private equity. She says it may not promise the same salary as before but it makes her feel fulfilled every day. "We never thought it would become our life and our source of employment."

Ryoma Yabu
Japan

Little did this former Tokyo resident know that a quick
visit to his parents in Okinawa would lead to him settling
on the island and starting two businesses.

Trainee architect ——————————————————————————— Sweet shop and café owner

Tokyo-born Ryoma Yabu had his sights set on a gentler lifestyle from a young age. "My father comes from Okinawa and our family used to visit there every year to see relatives," he says. "Growing up in Tokyo, I always had a yearning for Okinawa's steady pace." For a while after finishing at design college, he juggled multiple jobs at an architecture studio by day and restaurants by night. Mentally exhausted, in 2001 he quit everything and planned to take a break in Spain; he just had one quick thing to do before going. "I visited my parents in Okinawa and never left," he says. "I got hooked."

Yabu ended up opening popular café Ploughmans Lunch Bakery in 2009 and a Japanese sweet shop, Yoyo, in 2018. The country's southernmost island may be its poorest prefecture but residents rave about the more relaxed way of life. "In Tokyo you can fall into this mentality of just making money," says Yabu. "It's possible to strike the right work-life balance in Okinawa." The 41-year-old now spends three days a week working and the rest of the time being with his family at home, in the park or on the beach. "For me, it's about keeping the business small and making good things."

CASE STUDY 7
Zhang Tingshu
China

Drinking tea may come hand in hand with retirement –
but not so much setting up your own tea brand. At least
that's what we thought until we met this ex-soldier.

Soldier ————————————————————————————————— Tea brand owner

An hour after sunrise, Zhang Tingshu leaves home and drives to his farm. He stays until 17.30, inspecting the facility, checking the stock and looking after the 700 *pu'er* (black tea) trees that grow there. It's Zhang's energy that allows him to run a successful tea company in his seventies. The retired soldier launched his brand, Yiyou, in 2006 when he was just two years shy of 60. The product originated from Yunnan province but back then "the market was full of overpriced, fake *pu'er* tea", says Zhang.

Investing much of his pension, he set out to create a high-quality tea brand with authenticity and provenance at its heart. To start with he moved to the remote countryside of Mangshui in the untouched mountain range of Yunnan and acquired hundreds of tea trees. He then built a production workshop and convinced his son to quit his job and join the family start-up. Today Yiyou has a team of 21 employees of varying ages and its annual production of 20 tonnes of tea is sent to 11 cities across the country. Zhang junior has started an in-house design team to work on packaging and branding, while Zhang senior travels to dozens of trade fairs each year to meet wholesalers and retailers.

Ruth Barry
Germany

Despite working in the art world, this caterer's appetite for creativity was only truly sated when she swapped contemporary art for cookies and cakes.

Project manager ——————————————————————— Baker

At first glance, Ruth Barry's shop in Berlin's Mitte district might be an art gallery. But when you look closer, the elegant displays of bread, cakes and jars of cookies reveal that this is very much a bakery, just one influenced by her previous career in the corporate art world.

Barry first worked as a museum educator for the Guggenheim in New York and then in London as a project manager at Counter Editions, which produces special editions of contemporary art. "I was working with some amazing artists but began to miss making things," she says. Ready for a change of gear, she left her job in 2012 and

trained as a baker instead. "I didn't enjoy being part of the machine," she adds. "Leaving it, I was stepping away from the parts I found oppressive to my creativity."

She originally founded Black Isle Bakery as a catering business in London before moving to Berlin and hasn't looked back since, even upgrading to a bigger shop on a busier street. "Producing something that people eat to nourish their bodies or for pleasure feels very good to me," says Barry. "Building something from nothing and watching it blossom is wonderful. I definitely felt that I was being kind to myself."

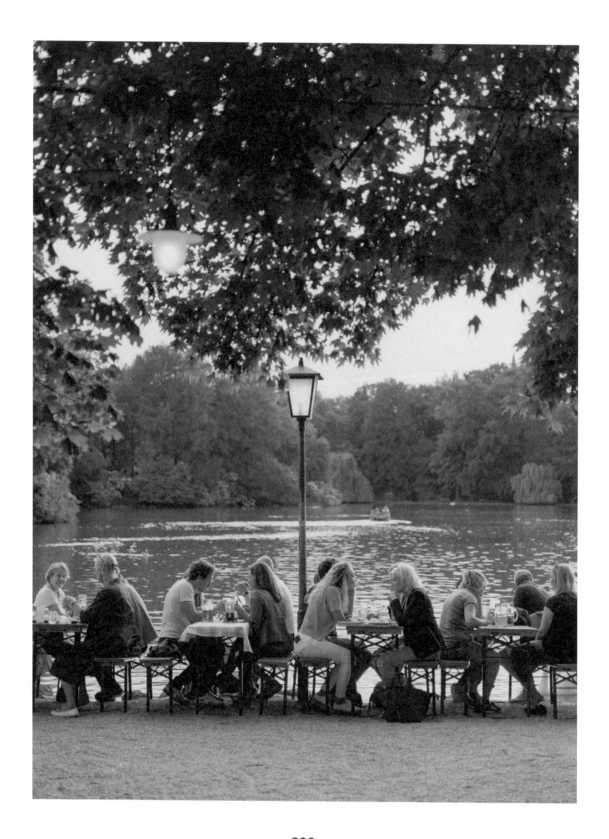

So there it is: the case
for finding a balance,
being kinder to yourself and
to others and seeking out
a slower pace of life
(and perhaps a bench
and a beer).

Gently does it, now.

Acknowledgements

The Monocle book of Gentle Living

EDITOR
Josh Fehnert

DESIGNER
Maria Hamer

PHOTO EDITORS
Matthew Beaman
Shin Miura
Victoria Cagol

PRODUCTION
Jacqueline Deacon

Chapter editing

HOW TO LIVE A GENTLER LIFE
Josh Fehnert

HAVE A GOOD HOME
Nolan Giles

MAKE TIME TO...
Chiara Rimella
Hester Underhill

EAT WELL
Josh Fehnert

ESSAYS
Josh Fehnert

DRESS WITH CARE
Jamie Waters

MOVE MORE
Hester Underhill

GET LOST
Joe Pickard

SEE NEW PLACES
Will Kitchens

FIND A BALANCE
Venetia Rainey

Monocle

EDITOR IN CHIEF
& CHAIRMAN
Tyler Brûlé

EDITOR
Andrew Tuck

CREATIVE DIRECTOR
Richard Spencer Powell

PRODUCTION DIRECTOR
Jacqueline Deacon

BOOKS EDITOR
Joe Pickard

ASSISTANT BOOKS EDITOR
Hester Underhill

DESIGNERS
Sam Brogan
Maria Hamer
Giulia Tugnoli

PHOTO EDITORS
Matthew Beaman
Shin Miura
Victoria Cagol

Writers
Matt Alagiah
Liam Aldous
Chloë Ashby
Mauro Baracco
Justin Bergman
Kimberly Bradley
Robert Bound
Victoria Cagol
Beatrice Carmi
Ivan Carvalho
James Chambers
Annabelle Chapman
Tom Edwards
Josh Fehnert
Holly Fisher
Mark Forsyth
Nolan Giles
Sophie Grove
Laetitia Guillotin
Kenji Hall
Aimee Hartley
Mary Holland
Daphne Karnezis
Alicia Kirby
Will Kitchens
Alexei Korolyov
Tomos Lewis
Kurt Lin
Trish Lorenz
Andrew Mueller
Kunyalala Ndlovu
Lizzie Porter
Venetia Rainey
Carlota Rebelo
Chiara Rimella
Laura Rysman
Clarissa Sebag-Montefiore
Andrew Mueller
Alex Schechter
Ralph Schelling

Florian Siebeck
Ed Stocker
Junichi Toyofuku
Andrew Tuck
Hester Underhill
Jamie Waters
Annick Weber
Fiona Wilson
Louise Wright
Zayana Zulkiflee

Photographers
Adam Amengual
Yves Bachmann
Matthew Beaman
Peter Bohler
Jamie Bowering
Felix Brüggemann
Max Burkhalter
Jesse Chehak
Silvia Conde
Rose Marie Cromwell
Ana Cuba
Luigi Fiano
Joe Fletcher
Keisuke Fukamizu
Stefan Fürtbauer
Víctor Garrido
Daniel Gebhart de Koekkoek
Orlando Gili
Alexandre Guirkinger
Ramon Haindl
Véronique Hoegger
Gregor Hofbauer
Younès Klouche
Nelson Kon
Simon Koy
Romain Laprade
Wilson Lee
Salva Lopez
Mark Mahaney

Trevor Mein
Lianne Milton
Conny Mirbach
Shin Miura
James Mollison
Felix Odell
Jonas Opperskalski
Alana Paterson
Ian Patterson
Nathan Perkel
Thomas Prior
Ben Quinton
Robert Rieger
Ricky Rhodes
Ricardo Simal
Gareth Sobey
Jan Søndergaard
Martin Stöbich
Kohei Take
Polly Tootal
Brad Torchia
Jonathan De Villiers
Trisha Ward
Dan Wilton
Christopher Wise
Julian Wolkenstein
Samuel Zeller

Illustrator
Grafilu

Special thanks
Tom Edwards
Peter Milne
Ralph Schelling

Researchers
Audrey Fiodorenko
Zayana Zulkiflee

Index

Print to audio – the MONOCLE story

In 2007, MONOCLE was launched as a monthly magazine delivering a briefing on global affairs, business, design and more. Today we have a thriving print business, radio station, shops, cafés, books, films and events. At our core is the belief that there will always be a place for a brand that is committed to telling fresh stories with a calm voice.

We're headquartered in London and Zürich and have bureaux in Hong Kong, Tokyo, Los Angeles and Toronto. Over the years our editors and correspondents have come to understand what constitutes a gentler approach to life. This knowledge is unpacked in this book and throughout our reporting on Monocle 24, in film at *monocle.com* and, of course, across our print products.

1.
Monocle magazine
MONOCLE magazine is published 10 times a year, including two double issues. We also have annual publications covering business and the year ahead. Look out for our special edition newspapers too.

2.
Monocle 24 radio
Our radio station delivers global news and shows covering foreign affairs, culture and more.

3.
Monocle Café and Kioskafé
We have cafés in Tokyo, London and Zürich serving coffee, breakfast and lunch. And if you're in London's Paddington, visit our newsstand and coffee shop: Kioskafé.

4.
Books
Since 2013, MONOCLE has been publishing large-format books – like the one you're reading now. Across the editions you can find out, among other things, which hotels we rate and what makes a nation tick. We have also produced more than 35 guidebooks to take you from Sydney and San Francisco to London and Lisbon.

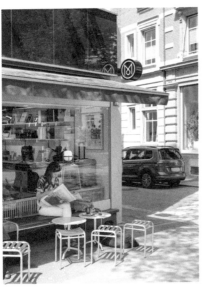

JOIN US

There are lots of ways to be part of the ever-expanding MONOCLE world, whether in print, online or on the radio.

Read the magazine

You can buy MONOCLE at newsstands in more than 60 countries around the world – or get an annual subscription at *monocle.com/subscribe*.

Listen to Monocle 24

You can tune in to Monocle 24 radio live on our free app, at *monocle.com* or on any internet-enabled radio. You can also download our shows as podcasts from iTunes or SoundCloud to stay informed as you travel from nation to nation.

Subscribe to The Monocle Minute

Sign up today at *monocle.com* to receive The Monocle Minute and Weekend Editions, our free daily news-and-views email. Our website is also where you'll find our online shop and regular updates about everything we're up to.

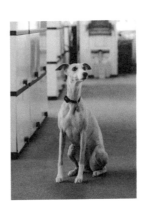

Thank you